A concise history of
MODERN PAINTING

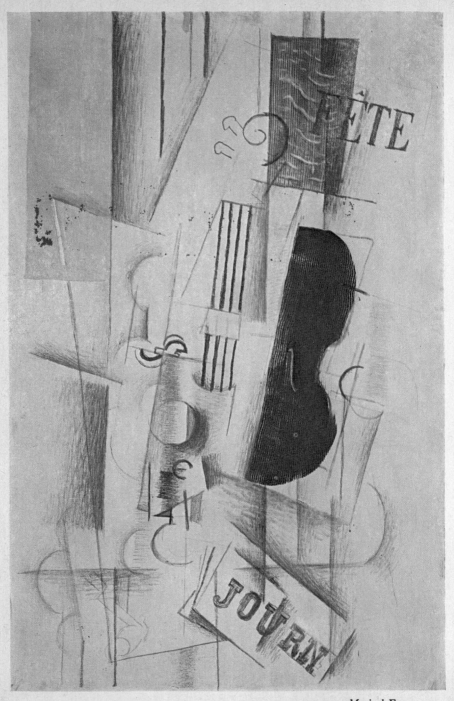

GEORGES BRAQUE *Musical Forms 1913*

A concise history of

MODERN PAINTING

Herbert Read

Frederick A. Praeger, Publishers
New York · Washington

Typographic design and layout of the book by

G. E. ADAMS

BOOKS THAT MATTER
Published in the United States of America
in 1959 by Frederick A. Praeger, Inc., Publishers
111 Fourth Avenue, New York, N.Y. 10003
Revised and enlarged edition 1968

Library of Congress Catalog Card Number: 68–9164

Printed in Great Britain by Jarrold and Sons, Ltd., Norwich

CONTENTS

PREFACE

A comprehensive history of modern painting is not at present possible, if only for the reason that such history has not yet reached the end of its development. But it did seem worth while to attempt, for the general public and within the strict limits set by the publisher, a concise account of the movements which together constitute the extremely complex change that has taken place in the art of painting during the past half-century. In order to avoid the tedium of a list of names and dates (which alone might have occupied the space allotted to me), I had to take drastic action, purging the narrative of many minor items that would have clogged its flow. The selection I have made, of names and events, will inevitably betray a personal bias, but I have taken some care to correct such bias when it became evident to myself, and I hope that any emphasis that remains is judicious.

Certain omissions that might be mistaken for prejudice must be explained. For example, I have not included Henri Rousseau among the precursors of modern painting, in spite of the high reputation that he has enjoyed among modern painters. My excuse is that the naïvety of his style is not in any sense a 'modern' quality, and the same is true of all the naïve painters of our time —Morris Hirshfield, Ivan Generalič, Joseph Pickett, John Kane, Louis Vivin, André Bauchant, Camille Bombois—a considerable and enchanting group that nevertheless does not affect the main trend of painting in our time.

For a similar reason I have excluded realistic painting, by which I mean the style of painting that continues with little variation the academic traditions of the nineteenth century. I do not deny the great accomplishment and permanent value of the

work of such painters as Edward Hopper, Balthus, Christian Bérard, or Stanley Spencer (to make a random list); they certainly belong to the history of art in our time. But not to the history of the style of painting that is specifically 'modern'. I have already described this style as 'complex', but for all its complexity (which also implies variety) it has a unity of intention that completely distinguishes it from the painting of earlier periods: the intention, as Klee said, not to reflect the visible, but to make visible. That is, at any rate, the criterion of modernity I have adopted, and my exclusions are determined by it.

Nevertheless, there are certain artists one omits with a somewhat guilty feeling of neglect. Maurice Utrillo, for example, is one of the most renowned of contemporary painters, but his aim was certainly to reflect the visible, and he remained true to the style of an earlier age. Jules Pascin is another great artist who refuses to fit into our category. More open to criticism, no doubt, is my omission of the contemporary Mexican school—Diego Rivera, José Orozco, and Alfaro Siqueiros. Like some of their Russian contemporaries, they have adopted a propagandist programme for their art which seems to me to place it outside the stylistic evolution which is my exclusive concern.

A concise history such as this is admittedly a synopsis of existing knowledge. Such knowledge remains for the most part scattered, but within recent years a beginning has been made towards the necessary synthesis. In this connexion I would like to express my great indebtedness to the publications of the Museum of Modern Art, New York, and to the admirable bibliographies compiled by its librarian, Mr Bernard Karpel. It is a curious but well-known fact that contemporary records are often inconsistent, and even the artists sometimes contradict themselves in their recorded statements. In such circumstances I have in general accepted the published records of the Museum of Modern Art. Apart from this source of information, there are two scholars, both connected with this Museum, to whom any student of the period is perforce indebted—I refer to Mr Alfred Barr, Jr., and to Mr John Rewald. Mr Rewald's Histories of Impressionism and Post-Impressionism

are based on wide and patient research, and can be accepted as authoritative. The same is true of the monographs which Mr Barr has devoted to Matisse and Picasso, and the many catalogues he has edited have been an invaluable source of information. I would also like to mention the similar pioneer work which Professor Will Grohmann has done for German Modern Art and especially his authoritative monographs on Paul Klee and Kandinsky.

In the Bibliography I have tried to give some guidance to the general reader who wishes to proceed from this outline to a more detailed study of the various phases of modern painting, but again I must emphasize that it is a list for the general reader rather than the specialist.

I would like to thank all those artists, collectors and art galleries who have helped me in assembling the many photographs required for the illustration of this book. The works of nearly 400 painters are illustrated in the text or pictorial catalogue. No doubt there are omissions due to oversight, but it will be appreciated that beyond a certain point the task of selection inevitably becomes arbitrary, and I must apologize to those artists whose work is not illustrated, but who, in my opinion as well as in their own, might have had an equal claim to representation.

* * *

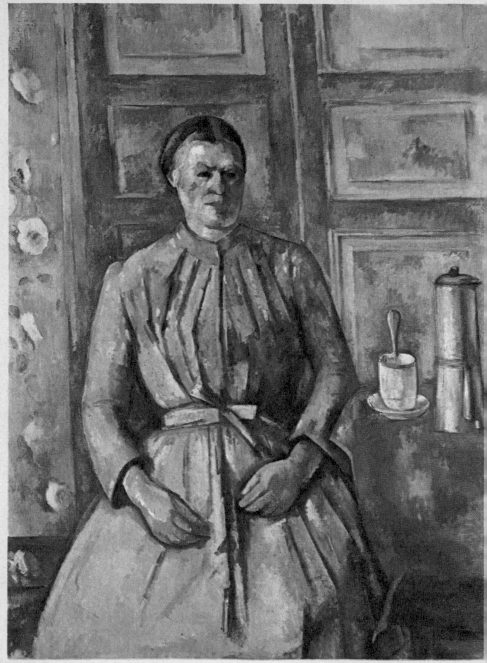

PAUL CÉZANNE *The Woman with a Coffee Pot. 1890–4*

CHAPTER ONE

The Origins of Modern Art

'To the historian accustomed to studying the growth of scientific or philosophical knowledge, the history of art presents a painful and disquieting spectacle, for it seems normally to proceed not forwards but backwards. In science and philosophy successive workers in the same field produce, if they work ordinarily well, an advance; and a retrograde movement always implies some breach of continuity. But in art, a school once established normally deteriorates as it goes on. It achieves perfection in its kind with a startling burst of energy, a gesture too quick for the historian's eye to follow. He can never explain such a movement or tell us how exactly it happened. But once it is achieved, there is the melancholy certainty of a decline. The grasped perfection does not educate and purify the taste of posterity; it debauches it. The story is the same whether we look at Samian pottery or Anglian carving, Elizabethan drama or Venetian painting. So far as there is any observable law in collective art history it is, like the law of the individual artist's life, the law not of progress but of reaction. Whether in large or in little, the equilibrium of the aesthetic life is permanently unstable.'[1]

So wrote one of the greatest modern philosophers of history and one of the greatest philosophers of art. The same philosopher observed that contemporary history is unwritable because we know so much about it. 'Contemporary history embarrasses a writer not only because he knows too much, but also because what

he knows is too undigested, too unconnected, too atomic. It is only after close and prolonged reflection that we begin to see what was essential and what was important, to see why things happened as they did, and to write history instead of newspapers.'[2]

The present writer can claim to have given close and prolonged reflection to the facts that constitute the history of the modern movement in the arts of painting and sculpture, but he does not claim that he can observe any law in this history. On the contrary, the fundamental self-contradiction that is inherent in all history, according to Collingwood, is nowhere more apparent than in the history of our subject. Modern art, we might say, begins with a father who would have disowned and disinherited his children; it continues by accident and misunderstanding; and can only be given coherence by a philosophy of art that defines art in a very positive and decisive manner.

This philosophy defines art as a means of conceiving the world *visually*. There are alternative methods of conceiving the world. We can measure the world and record our measurements in an agreed system of signs (numerals or letters); we can make statements about the world based on experiment. We can construct systems that explain the world imaginatively (myths). But art is not to be confused with any of these activities: it is 'an ever-living question, asked of the visible world by the visual sense',[3] and the artist is simply the man who has the ability and the desire to transform his visual perception into a material form. The first part of his action is *perceptive*, the second is *expressive*, but it is not possible in practice to separate these two processes: the artist expresses what he perceives; he perceives what he expresses.

The whole history of art is a history of modes of visual perception: of the various ways in which man has *seen* the world. The naïve person might object that there is only one way of seeing the world—the way it is presented to his own immediate vision. But this is not true—we see what we learn to see, and vision becomes a habit, a convention, a partial selection of all there is to see, and a distorted summary of the rest. We see what we want to see, and what we want to see is determined, not by the inevitable laws of

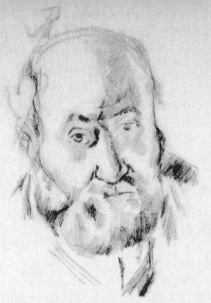

PAUL CÉZANNE *Self-portrait*. C. *1886*

optics, or even (as may be the case in wild animals) by an instinct for survival, but by the desire to discover or construct a credible world. What we see must be made real. Art in that way becomes the construction of reality.

There is no doubt that what we call the modern movement in art begins with the single-minded determination of a French painter to see the world *objectively*. There need be no mystery about this word: what Cézanne wished to see was the world, or that part of it he was contemplating, *as an object*, without any intervention either of the tidy mind or the untidy emotions. His immediate predecessors, the Impressionists, had seen the world *subjectively*—that is to say, as it presented itself to their senses in various lights, or from various points of view. Each occasion made a different and distinct impression on their senses, and for each occasion there must necessarily be a separate work of art. But Cézanne wished to exclude this shimmering and ambiguous surface of things and penetrate to the reality that did not change, that was present beneath the bright but deceptive picture presented by the kaleidoscope of the senses.

Great revolutionary leaders are men with a single and a simple idea, and it is the very persistency with which they pursue this

idea that endows it with power. But before I relate the stages of this pursuit, let us ask why, in the long history of art, it had never previously happened that an artist should wish to see the world objectively. We know, for example, that at various stages in the history of art there have been attempts to make art 'imitative'; and not only Greek and Roman art, but the Renaissance of Classical art in Europe, were periods of art possessed by a desire to represent the world 'as it really is'. But there always intervened between the visual event and the act of realizing the vision an activity which we can only call *interpretative*. This intervention seemed to be made necessary by the very nature of perception, which does not present to the senses a flat two-dimensional picture with precise boundaries, but a central focus with a periphery of vaguely apprehended and seemingly distorted objects. The artist might focus his vision on a single object, say a human figure or even a human face; but even then there were problems such as, in a painting, that of representing the solidity of the object, its place in space.

In every instance, before Cézanne, in order to solve such problems the artist brought in extra-visual faculties—it might be his imagination, which enabled him to transform the objects of the visible world, and thus create an ideal space occupied by ideal forms; or it might be his intellect, which enabled him to construct a scientific chart, a perspective, in which the object could be given an exact situation. But a system of perspective is no more an accurate representation of what the eye sees than a Mercator's projection is what the world looks like from Sirius. Like the map, it serves to guide the intellect: perspective does not give us any glimpse of the reality.

One might have concluded from the history of art that reality in this sense is a will-o'-the-wisp, an actuality we can see but never grasp. Nature, as we say, is one thing: art quite another. But Cézanne, though he was familiar with 'the art of the museums', and respected the attempts of his predecessors to come to terms with nature, did not despair of succeeding where they had failed, that is to say, in 'realizing' his sensations in the presence of nature.

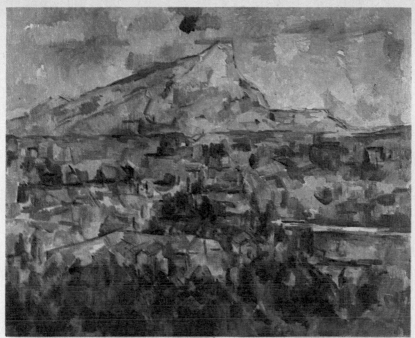

PAUL CÉZANNE *La Montagne Sainte Victoire. 1904*

Paul Cézanne was born at Aix-en-Provence on 19th January 1839; he died at Aix on 22nd October 1906. Most of his life belongs to the history of Impressionism, and it is only what is unique in him, and caused a break with the Impressionists, that should concern us now. He exhibited with his fellow Impressionists for the last time in 1877. He contemplated exhibiting with them the next year, but the exhibition was postponed and by 1879 Cézanne had decided not to exhibit with them again. His decision was conveyed in a brief letter to Camille Pissarro, dated 1st April of that year. His excuse was 'the difficulties raised by the picture he sent to the Salon', but though Cézanne undoubtedly resented more acutely than his fellow-painters the public ridicule that the Impressionist exhibitions had aroused (he always had the ambition to be accepted by the public), yet we may be sure that he had begun to experience a growing feeling of divergence from their aims. To the end of his life he retained a respect for Monet and

Pissarro, but more and more he retired within himself, to develop his own 'recherches', and it was this isolated and concentrated effort that led to his revolutionary achievement.

Cézanne was not a revolutionary by temperament, and it is not easy to explain why his work should nevertheless have become so significant for the future development of art. The explanation depends on the proper understanding of two words frequently used by Cézanne—words which are perhaps deceptive in that they are superficially identical in English and French—the words 'realization' (*réalisation*) and 'modulation' (*modulation*). '*Réaliser*' means to bring into being—in Cézanne's use of the word it has no overtones of a literary or academic 'realism'; '*moduler*' means to adjust a material (in this case paint) to a certain pitch or intensity (in this case, of colour). Cézanne's method of painting was first to choose his 'motif'—a landscape, a person to be portrayed, a still-life; then to bring into being his visual apprehension of this *motif*; and in this process to lose nothing of the vital intensity that the *motif* possessed in its actual existence.

To 'realize' his visual apprehension of the *motif* was the first problem, because of the difficulty, already mentioned, of finding a focus, a structural principle of any kind. The first stage in the solution of the problem was to select a suitable *motif*. The typical Impressionist, like Monet, was prepared to find a *motif* anywhere—in a haystack or a lily-pond—it did not matter because his primary interest was in the effects of light. This led eventually to a degree of informality in his painting that was only to be fully appreciated and developed by another generation of artists half a century later. This was precisely one of the tendencies latent in Impressionism against which the 'temperament' of Cézanne instinctively reacted. Cézanne's temperament was fundamentally classical. He was for *structure* at any cost, that is to say, for a style rooted in the nature of things and not in the individual's subjective sensations, which are always 'confused'. He felt he could not 'realize' his vision without an organization of lines and colours that gave stability and clarity to the image transferred to the canvas. The 'sensations' which the Impressionists were so concerned to represent—subtle

effects of changing light and movement—seemed to him to defeat the proper aim or probity of art, which was to create something as monumental and enduring as the art of the great masters of the past. Not that one should imitate the great masters—they had achieved their monumentality by sacrificing the reality, the intensity of the visual image. His ambition was to achieve the same effect of monumentality while retaining the intensity of the visual image, and this is what he meant by 'doing over Poussin entirely from nature', 'painting a living Poussin in the open air, with colour and light, instead of one of those works created in a studio, where everything has the brown colouring of feeble daylight without reflections from the sky'.[4]

Cézanne always insisted that human perception was inherently 'confused'—he refers in a letter to Joachim Gasquet[5] to 'those confused sensations that we bring with us at birth'; but he thought that by concentration and 'research' an artist should be able to bring order into this confusion, and art was essentially the achievement of such a structural order within the field of our visual sensations. He spoke of art being 'theory developed and applied in contact with nature';[6] of treating nature 'by the cylinder, the sphere, the cone, everything in proper perspective so that each side of an object is directed towards a central point'.[7] 'To achieve progress nature alone counts, and the eye is trained through contact with her. It becomes concentric by looking and working. I mean to say that in an orange, an apple, a bowl, a head, there is a culminating point; and this point is always—in spite of the tremendous effect of light and shade and colourful sensations—the closest to our eye; the edges of the objects recede to a centre on our horizon.'[8]

One might say that Cézanne had discovered a contradiction inherent in the very process of art—a problem that was evident to the Greeks as we may gather from Plato's discussion of *mimesis* or imitation. The desire is to render the image of what we see, without any falsity due to emotion or intellect, any sentimental exaggeration or romantic 'interpretation'; indeed, without any of the accidental properties due to atmosphere and even light—

Cézanne declared more than once that light does not exist for the painter.[9] But the field of visual sensation has no precise limits, the elements within it are scattered or confused. So we introduce a focus and try to relate our visual sensation to this selected point. The result is what Cézanne himself called an 'abstraction',[10] an incomplete representation of the field of vision, a 'cone', as it were, into which the objects focused fall with a sense of order or cohesion. This is what Cézanne meant by 'a construction after nature'; this is what he meant by the realization of a *motif*; and this is what made him 'the primitive of a new art'.

The solution reached by Cézanne will seem to be too structural, too geometrical, unless we give full force to the other significant word in his vocabulary—modulation. The Impressionists had purified colour—had taken out 'the brown gravy', the artificial chiaroscuro, so that colours could vibrate with their natural intensity. But their desire had been to create what has been called a visual cocktail—that is to say, a juxtaposition of colours that merged and produced an effect of vividness in the very act of perception. Their use of colour was as 'impressionistic' as their use of line, and in the case of a painter like Renoir, their development was to be towards a *modelling* use of colour, which is not what Cézanne meant by modulation. Modulation means rather the adjustment of one area of colour to its neighbouring areas of colour: a continuous process of reconciling multiplicity with an overall unity. Cézanne discovered that solidity or monumentality in a painting depends just as much on such patient 'masonry' as on the generalized architectural conception. The result, in terms of paint-application, is an apparent breaking up of the flat surface of a colour-area into a mosaic of separate colour-facets. This procedure became more and more evident during the course of Cézanne's development, and is very obvious in a painting like *Le Jardin des Lauves* in the Phillips Collection or in the late water-colours, such as the *Landscape with Mill* formerly in the Vollard Collection. An isolated detail from almost any painting done after 1880 will show the same mosaic surface-structure. It must be appreciated, however, that what we thus isolate to dissect into its

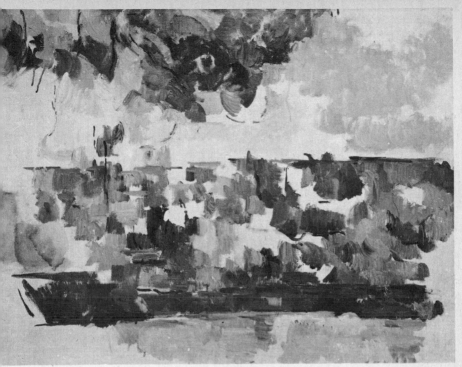

PAUL CÉZANNE *Le Jardin des Lauves. 1906*

constituent planes is, in the whole picture, completely integrated into the picture as a whole—the justification of such a technique for Cézanne is that it is 'a good method of construction'. As in a completed architectural monument, we should not be aware of the units that together constitute the unity.

* * *

Before proceeding to estimate the influence of Cézanne on the future development of painting, it is very necessary to recall a warning expressed by Lionello Venturi in the critical study which he devoted to the artist in 1936.[11] It would be the gravest of errors, he suggested, to see in Cézanne a precursor of all the tendencies of painting that came after him: as it were, a seed from which a whole forest has grown. Venturi quotes Baudelaire: 'The artist is responsible to no-one but himself. He donates to the centuries to come only his own works; he stands surety for himself alone. He dies without issue. He was his own king, his own priest and his own God.'[12] In that sense Cézanne died without issue—he was a

unique artist, the style was the man himself, and he founded no school. To quote Venturi again: 'The error into which nearly all critics of Cézanne fall is exposed in his last letters, in the light of his enthusiasm when confronted with nature, of his contempt for everything in art that is not an individual intuition, fundamental, free from all preconceived academic ideas. . . . The time has come to affirm that the spiritual world of Cézanne, to the last hour of his life, was not that of the symbolists, of the Fauves, or of the Cubists; but it is the world which we associate with Flaubert, Baudelaire, Zola, Manet, and Pissarro. That is to say, Cézanne belongs to that heroic period of art and literature in France that thought to find a new way to the natural truth by passing beyond romanticism itself in order to transform it into an enduring art. There is nothing decadent, nothing abstract, no art for art's sake in the character and work of Cézanne; nothing but an innate and indomitable will to create art.'[13]

This is well said and is one more illustration of the desire to escape from what Collingwood calls the permanently unstable equilibrium of the aesthetic life. Nevertheless, as Venturi would be the first to admit, the course of modern art is inconceivable without the achievement and example of Cézanne, and no other artist stands in such a significant relationship to his successors. There is no 'School of Cézanne', but there is no considerable artist of the twentieth century who has not been influenced by some aspect of Cézanne's work. These influences were sometimes superficial—even, as in the case of Cubism, based on a misunderstanding of certain characteristics of Cézanne's paintings. Cézanne's intention was to create an order of art corresponding to the order of nature, independent of his own confused sensations. It gradually became obvious that such an order of art has a life and a logic of its own—that the confused sensations of the artist might crystallize into their own lucid order. This was the liberation for which the artistic spirit of the world had been waiting; we shall see to what deviations from Cézanne's intentions it has led, and to what new dimensions of aesthetic experience.

* * *

Cézanne's heroic attempt to pass beyond romanticism (which does not necessarily mean to take a different direction) was in opposition to certain more general tendencies of the period. These acquired, towards the end of the century, a generic name—in Germany *Jugendstil*, in France *art nouveau*, in England and America, the modern style. It was not so much a style as a mannerism, and was manifested chiefly in the applied arts—in interior decoration, architectural ornament, typography, and graphic art. Nevertheless the manner can be detected if only superficially in the work of several artists who remain to be mentioned as predecessors of the Modern movement. Gauguin, van Gogh, Munch, Seurat, and Toulouse-Lautrec were active and created their most characteristic work between 1880 and 1900, and diverse as they are, there is yet a common element which they all unconsciously betray. It is precisely that element which Cézanne decisively rejected: the decorative element. Cézanne once contemptuously referred to Gauguin as 'a maker of Chinese images', and in this phrase dismissed the sophisticated symbolism which, in some form or other, is characteristic of European painting in the last two decades of the nineteenth century. It is easy to classify Gauguin and Munch as symbolists, but neither van Gogh nor Toulouse-Lautrec were makers of symbolic images of the kind dismissed by Cézanne; nevertheless there is an element which they possess in common with Munch and Gauguin.

One returns to the visual and technical clues, which alone make sense of the history of art. The clues in this case come from two quite distinct and unexpected sources—from Japan and from Great Britain. From Great Britain came an influence which, though manifested for the most part in architecture and the applied arts, nevertheless, in spreading to the Continent from about 1890 onwards, merged its stylistic influences with those active in painting and sculpture. This was the arts and crafts movement begun by William Morris (1834–96) about 1870, which apart from the furniture, tapestries, wall-papers and illustrated books produced under his immediate supervision, was manifested in the architecture of Charles Rennie Macintosh

(1868–1928) in Scotland, and Charles Voysey (1857–1941) in
England. The diffusion of this influence, through a medium like
the art magazine *The Studio*, has never been traced in detail,[14] but
there is no doubt that it was world-wide, and can be found not
only in the architecture of Belgium (Van de Velde), Holland
(J. J. P. Oud), Austria (Adolf Loos), Germany (Peter Behrens),
France (Auguste Perret), and the United States (Frank Lloyd
Wright), but in the graphic and ornamental arts everywhere.[15]
Influences are transformed as they spread outwards and meet
other influences in different environments, but it is quite certain
that an element common to the architects and decorators I have
mentioned is also to be found in the paintings of Edvard Munch,
Ferdinand Hodler, Puvis de Chavannes, Toulouse-Lautrec, and
many others. It is not too fanciful to suggest that there are
decorative elements in the paintings of Gauguin and van Gogh,
and certainly in the later work of Vuillard and Bonnard, which
perhaps unconsciously derive from this diffused style. Van Gogh
was in England from 1873 to 1875 and again in 1876, which was
too early to learn anything of Morris's activities; but he was
working for a fashionable art dealer (Goupil) and must have been
aware of the awakening spirit around him (though Millais and
Seymour Haden are the only contemporary English painters he
mentions in his letters from England). Camille Pissarro and Monet
fled to England in 1870, and in 1883 Pissarro's son Lucien settled
in London, where he set up the Eragny Press. He was soon to meet
Morris, as well as artists like Charles Ricketts, Charles Shannon,
and even Whistler, and the correspondence of father and son
shows what a lively interest they both took in the English arts and
crafts movement.[16]

Again it should be realized that such influences, diffused
gradually and even unperceived over a period of twenty or thirty
years, are not to be traced in detail; indeed, to detail them is to
distort the historical reality, which is a pervasion of minute and
particular influences, absorbed as soon as they fall on dry ground,
and least significant when most direct and obvious.

It is somewhat different with the other source of stylistic change

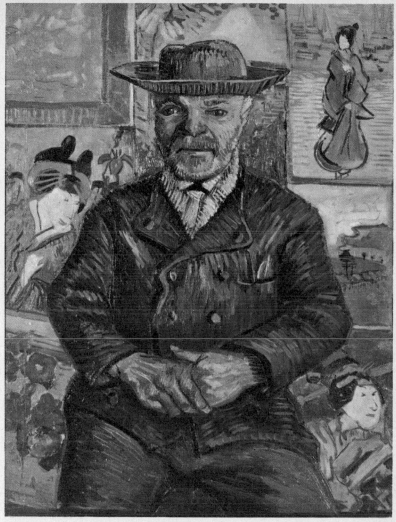

VINCENT VAN GOGH *Le Père Tanguy.* c. *1887*

at this time. From Japan came just one of those apparently trivial but decisive technical interventions which change the course of art. With the opening up of trade with Japan in the middle of the nineteenth century, Japanese 'curios' began to flood the European market, and among these curios the Japanese woodcut print was immediately appreciated for its artistic merits. Many French

artists became enthusiastic collectors of the work of Hokusai and Utamaro, and it was not long before the influence of such Japanese masters became apparent in the work of many of the Impressionists. A Japanese print appears in the background of Manet's portrait of Zola (1868); another in van Gogh's *Le Père Tanguy* (1886–8) (*p. 23*), still another in his *Self-portrait with a bandaged ear* (1889) in the Courtauld Institute; Gauguin's *Still Life with a Japanese Print* (1889) is another example.[17] But this is merely evidence of the popularity of the prints: their influence is apparent in the changes which gradually took place in the *style* of the French painters—the use of linear arabesques to enclose flat areas of unmodulated colour, the abandonment of three-dimensional perspective, and a conception of painting as heraldic, allegorical, or symbolic.

Though many of the Impressionists were influenced superficially by Japanese prints, the full impact of this art became evident only in the work of van Gogh and Gauguin. Both painters felt the desire to create an equivalent form of art in the terms of oil-painting. It is true that a painter like Whistler had imitated the structural or compositional features of Japanese prints, but he superimposed upon this framework an atmospheric impressionism which could conceivably have owed something to Chinese painting, but which did not depart essentially from the style of Monet or Degas. When, about 1886, van Gogh began to copy Japanese woodcuts, not in the woodcut medium but in oil-paint, he was trying to transfer to the European medium the aesthetic virtues of the Japanese style. He even went so far as to use Oriental reed pens for his ink drawings in order to simulate the technique of the Japanese.[18] But his main purpose was to reproduce in oil-painting the expressive force of flat areas of pure colour. He said of his painting *The Artist's Bedroom at Arles* (1888): 'It's just simply my bedroom, only here colour is to do everything and, giving by its simplification a grander style to things, it is to be suggestive here of *rest* or of sleep in general. . . . The shadows and the shadows thrown are suppressed, it is painted in free flat colour washes like the Japanese prints.'[19] Let us note, for further comment later

on, that it was for the sake of its *expressive* function that van Gogh adopted this particular feature of Japanese art.

Gauguin adopted these or other features of Oriental art for a somewhat different purpose. He appreciated the expressive value of large areas of pure colour no less than van Gogh. But he had also studied medieval art (sculpture, tapestries, and stained glass), primitive woodcuts, and certain types of exotic art which he had seen at the World's Fair of 1889, and he knew that colour could be used symbolically as well as expressively. This was a favourite subject of discussion with the group that used to gather in Marie-Jeanne Gloanec's inn at Pont-Aven and in Marie Henry's inn at Le Pouldu, both villages in Brittany—a group that included Paul Sérusier and Émile Bernard, painters preoccupied with the theory as well as the practice of art. Several other painters joined them—Émile Schuffenecker, Louis Anquetin, and Meyer de Haan. Though Gauguin dominated the group, by the force of his personality, by his restless exploratory energy, and by his intelligence, nevertheless the group style that emerged—their own name for it was *Synthétisme*—was not essentially the personal style of Gauguin. It owed too much to those sources just mentioned, sources available to and acting on not only the group as a whole, but artists throughout Europe. We have only to compare the work of Gauguin and his group with the work that was going on independently, both in France (Seurat, Puvis de Chavannes, and Toulouse-Lautrec) and farther afield (Munch in Norway; Hodler in Switzerland) to become aware of a period-mannerism, whose sources were in some profounder change of the spirit. We can see now, seventy years later, that a new will to abstraction was beginning to emerge in European art, and although we must leave any further description of this phenomenon to a later chapter, we may note how fragmentary and apparently unrelated were its first manifestations. The attraction which Japanese woodcut prints had for the Impressionists, the similar attraction which primitive art had for Gauguin and the synthetists, Seurat's search for a geometrical structure for his pointillist technique, Munch's subordination of his realistic vision to an arabesque rhythm—in

each case there was a search for a new art formula, and this
formula had to be in some sense super-real, some archetypal form
in which the disinherited spirit of man could find stability and
rest. Art had lost all its sanctions—its divine sanction in the service
of God (for God was dead), its human sanction in the service of
the community (for man had lost all his chains). In so far as they
possessed any ability to express themselves in philosophical terms
(and both van Gogh and Gauguin had this ability in a consider-
able degree, as their letters indicate) the whole of this generation
was aware of what we now call the existential dilemma. Cézanne
could not express himself in such metaphysical terms; nevertheless
he, more than any of his contemporaries, was aware of what had
to be done; and Gauguin was aware of what Cézanne was doing,
and forcibly as he rejected the technical means adopted by
Cézanne, was wont to say, when he began on a new canvas: 'Let's
make a Cézanne.'[20]

The clearest indication of the direction which the art of the
twentieth century was to take is found in the work of a genius
whose early death left his achievement incomplete—Georges
Seurat (1859–91). He was born twenty years later than Cézanne,
and if he had died at the same age as Cézanne would have lived
through the Cubist period—indeed until 1926. He might be called
the Piero della Francesca of the modern movement. More con-
sciously than Cézanne, more deliberately and more intelligently
than any of his contemporaries, he accepted the scientific temper
of the age, and gave precise expression to its ideal of objectivity.
While still a student at the École des Beaux Arts he read the
available scientific treatises on optics and colour, especially those
of Eugène Chevreul on the division of light into its constituent
colours. On the basis of this theory Seurat elaborated—he can
hardly be said to have *discovered*—the technique that came to be
known as *pointillism*, though he himself preferred the name
divisionism. This involved breaking down the colours present in
nature into their constituent hues, transferring these to the canvas
in their pure or primary state, as tiny brush strokes or dots, and
leaving to the spectator's retina the task of re-constituting the

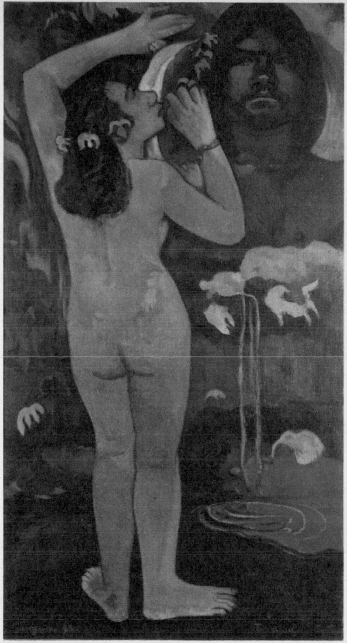

PAUL GAUGUIN *The Moon and the Earth. 1893*

hues as an 'optical mixture'. The object, of course, was to preserve the colours of nature in all their actuality and vividness—an ambition as old as Constable and Delacroix. If Seurat had stopped at his researches into colour he would have gone no further than his fellow Impressionists (Pissarro and Signac in particular): but his researches into colour were followed by researches into line and generally into the scientific basis of aesthetic harmony. 'If,' he asked, 'with the experience of art, I have been able to find scientifically the law of pictorial colour, can I not discover an equally logical, scientific, and pictorial system to compose harmoniously the lines of a picture just as I can compose its colours?'[21] In 1886 he met a young scientist, Charles Henry, who had the answer to this and to many other questions. Henry, a polymath of extraordinary brilliance and productivity, seems to have conceived the ambition of reconciling science and art in some higher intellectual synthesis—what Paul Valéry, who knew him, called 'a unified system of human sensibility and activity'.[22] Long and absorbing were the discussions that ensued, for there were artists present, Pissarro in particular, who were intelligent enough to perceive that the whole intuitive basis of aesthetic values, as hitherto accepted, was in question. But Seurat himself—and this is proof of his greatness—was not ready to surrender this traditional basis, and his uncompleted task revolves round the necessity for finding a solution of the dialectical problem involved. It is unfortunate that one of the *means* used by Seurat—pointillism or divisionism—should have obscured his real aim, which was 'an art of harmony'. Harmony can be resolved into elements of tone, colour, and line, as he said in his famous 'Aesthetic',[23] and these harmonies can express feelings of gaiety, calm, or sadness. The means must be calculated, but the effects are incalculable, since they operate on the infinite gamut of human sensibility. As in van Gogh's adoption of flat colour washes and other elements of the Japanese woodcut, the *expressive* function of the work of art was recognized and preserved.

Twenty years after his untimely death, at a crucial stage in the development of modern art, Seurat was to exercise a decisive

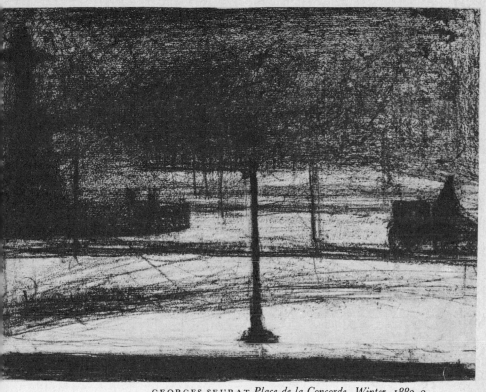

GEORGES SEURAT *Place de la Concorde, Winter. 1882–3*

influence on Picasso, Braque, and Gris. To a sympathetic contemporary like Camille Pissarro it seemed at the time of Seurat's death that pointillism was finished—'but I think', added the perspicacious Pissarro, 'it will give rise to other effects which later will have great artistic significance. Seurat really brought something.'[24] This 'something' was not pointillism, which Pissarro had at first adopted as a technique and then decisively rejected, nor even a scientific foundation for aesthetic harmony in the art of painting, but an awareness of dialectical problems in the very process of art which could be solved only by a revolutionary transformation of its cognitive status. The old language of art was no longer adequate for human consciousness: a new language had to be established, syllable by syllable, image by image, until art could once more be a social as well as an individual necessity.

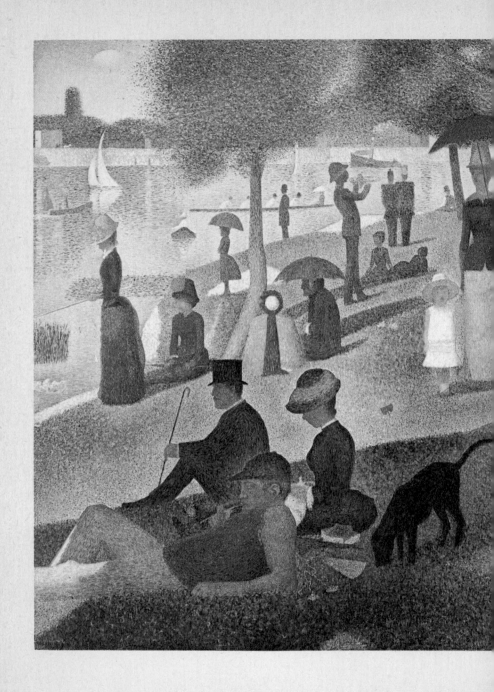

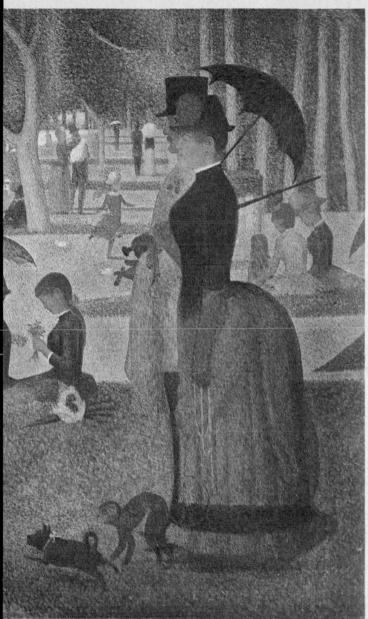

GEORGES SEURAT *An Afternoon at La Grande Jatte. 1884*

CHAPTER TWO

The Break-through

At the beginning of the new century European art had reached a stage which is best described by the French phrase, *reculer pour mieux sauter*. There was no suggestion of retreat, but there was a pause. In 1900 Maurice Denis painted the *Hommage à Cézanne* which is now in the Musée d'Art Moderne, Paris. It shows among others Bonnard, Vuillard, Redon, Roussel, Sérusier, and Denis himself gathered round the man whom they recognized as their master—a sedate group. In this same year Gauguin retired to his final exile—the Marquesas—he was to die there in misery three years later. Van Gogh and Seurat were dead and Toulouse-Lautrec was dying; Degas was going blind, and though Monet was still to paint a series of pictures of the greatest significance for the future, his ponds and his waterlilies, he too was threatened with blindness. Renoir was also a sick man, though in the nineteen years that remained to him he was to paint some of his greatest works.

In spite of this apparent arrest of the movement, a position had been established from which there was no retreat: and what had been achieved was so dazzling in its glory that every young artist in Europe and America turned towards Paris with unbearable longing. At the Great World Exhibition that was held in Paris in 1900 the Impressionists and Post-Impressionists had been admitted in strength, and though the public was still far from fully accepting them, their fame was now world-wide.

From every direction young artists made their way to Paris. In the first ten years practically every artist who was to become a leader of new movements in the new century visited Paris, and many of them came to stay. Some of them were born in or near Paris—Rouault, Picabia, Delaunay, Utrillo, Derain, and Vlaminck; other French artists moved in from the provinces— Braque and Léger in 1900, Arp and Marcel Duchamp in 1904. Picasso came to Paris for the first time in 1900 and soon returned to stay. Brancusi came via Munich in 1904, Archipenko in 1908, Chagall in 1910. Kandinsky visited Paris in 1902 and again in 1906–7; and Klee in 1905. Juan Gris came and settled there in 1906. From Germany came Nolde in 1899, Paula Modersohn-Becker in 1900, and Franz Marc in 1903. From Italy came Carrà in 1900, and Boccioni in 1902; Severini and Modigliani in 1906. Even from America a pioneering artist, John Marin, came in 1905; and in the same year Max Weber left Paris and established an outpost of the new movement in New York.

At the same time another concentration of forces was taking place in Munich. The history of this first decade in Munich has never been adequately written, and no doubt it is not strictly comparable with the history of the same decade in Paris. The German Impressionists, Lovis Corinth and Max Slevogt, were active in Munich at the turn of the century, but it was the academic fame of Munich that attracted such foreign artists as Wassily Kandinsky and Alexei von Jawlensky, Naum Gabo and Paul Klee; and though Munich was alert to all that was happening in Paris, the Bavarian capital radiated a more philosophical spirit with a consequent desire to justify the practice of art in theoretical terms. Two of the decisive documents of the modern movement were written in Munich at this time—Wilhelm Worringer's *Abstraktion und Einfühlung* (1908),[1] in which for the first time a will to abstraction in art was postulated as a recurrent historical phenomenon; and Kandinsky's *Über das Geistige in der Kunst* (1912)[2] in which also for the first time an abstract 'art of internal necessity' was proclaimed and justified as a contemporary phenomenon.

In Paris the painters who reacted against Impressionism were known as 'les fauves' (the wild beasts), a name first used as a witticism by the critic Louis Vauxcelles at the time of the Autumn Salon of 1905. The name was apt because the means used by these painters were decidedly violent. These painters were in effect Expressionists, as we shall see, and although the final outcome of each movement was to be very different, there was for a time a close parallel between the concurrent developments in Paris and in Germany (particularly those in Munich). But parallels, it should be remembered, have a distinct point of departure, and never meet.

Fauvism, if we are to believe the statements of the painter who became the leader of the group, Henri Matisse (1869–1954), began as a revolt against the deliberate methodism of Neo-Impressionists like Seurat and Signac. 'Fauvism shook off the tyranny of divisionism,' Matisse once declared, and further explained:[3]

'Neo-Impressionism, or rather that part of it which is called Divisionism, was the first organization of the method of Impressionism, but this organization was purely physical and often mechanical. The splitting up of colour brought the splitting up of form and contour. The result: a jerky surface. Everything is reduced to a mere sensation of the retina, but one which destroys all tranquillity of surface and contour. Objects are differentiated only by the luminosity that is given them. Everything is treated in the same way. In the end there is nothing but tactile animation, comparable to the vibrato of a violin or voice. Turning more and more grey with time, Seurat's paintings have lost the programme quality of their colour arrangement and have retained only their authentic values, those human, painterly values which today seem all the more profound.'

Matisse had abandoned a career in law and at the age of twenty-two, in the winter of 1891–2, came to Paris to study under Bouguereau, then at the height of his popularity. He soon discovered that he had made a mistake and transferred himself to the more romantic but still academic studio of Gustave Moreau.

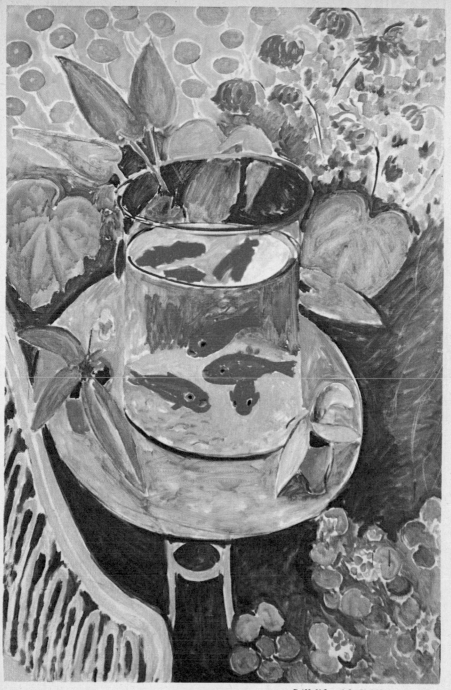

HENRI MATISSE *Still-life with Goldfish. 1911*

There he met as fellow-students Georges Rouault (1871–1958), Albert Marquet (1875–1947), and several others who were to remain associated with him in the struggles ahead. It is difficult to see what any of them owed to Moreau as a teacher, unless it was the virtues of application and self-discipline (the 'orientalism' of the Fauves which is sometimes ascribed to Moreau, certainly had a different origin). Matisse's particular illumination was to come, not in Moreau's studio, but from a direct contact with Pissarro and other Impressionists. His son-in-law, in a footnote which is too important to be left in typographical obscurity, relates that 'It was Wéry, one of Bonnat's pupils [Léon Bonnat was another teacher under whom Othon Friesz and Raoul Dufy were to study], who introduced Matisse to Impressionism. He travelled in Brittany with this painter, then under the influence of Sisley's technique. After a short stay together at Belle-Ile (1896), Matisse went on alone to Beuzec-Cap-Sizun, a small market-town in Finistère, whence he brought back the usual indispensable local souvenirs, an *Église* and a *Femme gardant un Cochon*. He had already painted in Brittany some very original landscapes, of ample composition and full bluish tonality. In these works, curiously reminiscent of Courbet and Delacroix, the painter employs the usual scale of tones. His breadth of vision and intensity of expression suggest that he is approaching a point of rapture (1895). The effusion of the Fauve hemorrhage would seem due to the indirect intervention of Wéry. Each of the two young painters, in the course of repeated discussions, had succeeded in convincing the other of the excellence and superiority of his reasons. On their return to Paris, Matisse's palette was composed of brilliant colours, Wéry's of bitumen, which obtained for him a considerable if brief popularity.'[4]

This was in 1896. When, towards 1897, Matisse's painting, hitherto sombre, 'took on the radiance of his later work, it was (Duthuit relates) from deep within himself that he drew his palette of bright blue, blue-green, emerald and madder'.[5] So even before 1900, as Marquet also confirms, Matisse was working in what later became known as the Fauve manner. In 1898 he had painted

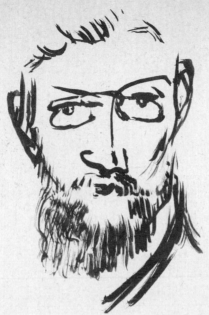

HENRI MATISSE *Self-portrait*

a large male nude in pure blue which even his friends found disconcerting. This seems to have been a spontaneous experiment, a product of his instinctive revolt. But just as this stage in his development he was guided towards the true source of discipline by Camille Pissarro, the most perceptive genius of the whole of this epoch. Pissarro may not have been the first to bring Cézanne to the notice of Matisse, but he it was who made clear his significance, to such effect that in 1899 Matisse, who could ill afford even the modest price (1300 francs) that the dealer Vollard asked for it, bought a painting by the master of Aix. This painting, *Three Bathers*, was to remain in his possession until 1936, when he presented it to the Museum of the City of Paris, with the remark in an accompanying letter that for thirty-seven years it had 'sustained me spiritually in the critical moments of my career as an artist; I have drawn from it my faith and my perseverence'.[6]

What had Matisse discovered in Cézanne at this turning-point in his career? Simply that colours in a painting must have a structure, or, to phrase it in another way, that structure is given

to a painting by the considered relationship of its constituent
colours. That may seem to differ in no way from Seurat's ideal of
structural harmony, but Matisse condemned Seurat for destroying
colour's integrity—splitting it up into dots took the life out of it.
Colours must be used in their 'plenitude' (Cézanne's word), and
the problem was to reveal the structure while maintaining the
purity of the colours, eschewing those adventitious aids due to an
admixture of black or grey. Cézanne was the only precursor who
had had the same ambition.

But Matisse did not become a mere imitator of Cézanne, and
this was due to the conviction, which he shared with many artists
of this time, that art must be dynamic rather than static (as
Seurat's art seemed to be), expressive of a 'nearly religious feeling
towards life' and not merely the record of a passing sensation (as
the art of the Impressionists had been). This attitude is made very
clear in the 'Notes d'un peintre' which Matisse published in
La Grande Revue, Paris, 25 December 1908—one of the funda-
mental documents in the history of modern art. In the ten years
that had passed since his painting of the *Blue Nude*, Matisse had
found himself and become sure of his direction. It is significant
that the first point he makes in this article is concerned with
expression. 'What I am after, above all, is expression. . . . I am
unable to distinguish between the feeling I have for life and my
way of expressing it. . . . Expression to my way of thinking does
not consist of the passion mirrored upon a human face or betrayed
by a violent gesture. The whole arrangement of my picture is
expressive. The place occupied by the figures or objects, the empty
spaces around them, the proportions, everything plays a part.
Composition is the art of arranging in a decorative manner the
various elements at the painter's disposal for the expression of
his feelings.'[7]

Nothing could be clearer, and as we shall see, the aims of the
German Expressionists, which were taking shape at the same time,
were, as far as verbal formulations go, identical. But Matisse went
on to make certain qualifications. The first was an insistence on
'solidity' as against the 'charm, lightness, crispness' of the

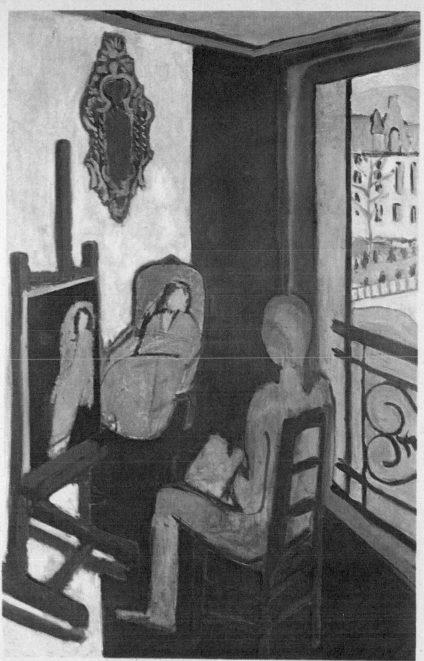

HENRI MATISSE. *The Painter and His Model. 1917*

Impressionists. Immediate or superficial colour sensations must be 'condensed', and it is this condensation of sensations which constitutes a picture. This is the first sign of the influence of Cézanne: the work of art is not 'immediate'—it is 'a work of my mind': it must have an *enduring* character and content, a character of *serenity*, and this is only arrived at by long contemplation of the problem of expression.

There are two ways of expressing things, Matisse then points out: 'One is to show them crudely, the other is to evoke them artistically.' Here is the crux which marks the possibility of a divergence between Matisse and some of his colleagues and more generally between French Expressionism and German Expressionism. Matisse had been looking at Egyptian and Greek art and at Oriental art, and had come to the important conclusion that 'in abandoning the literal representation of movement it is possible to reach toward *a higher ideal of beauty*.' The wild beast has been tamed! We search the rest of the article for a definition of this higher ideal, and find ourselves referred to the Greek virtues of serenity and harmony. 'The Greeks too are calm; a man hurling a discus will be shown in the moment in which he gathers his strength before the effort or else, if he is shown in the most violent and precarious position implied by his action, the sculptor will have abridged and condensed it so that balance is re-established, thereby suggesting a feeling of duration. Movement in itself is unstable and is not suited to something durable like a statue unless the artist has consciously realized the entire action of which he represents only a moment.'

It is significant that Matisse should have chosen a piece of sculpture to illustrate his meaning, for he had been experimenting with this medium himself since 1899, and had for a time come under the influence of Rodin. Indeed, along with the painting by Cézanne which he acquired from Vollard in 1899, he also acquired the original plaster bust of Henri Rochefort by Rodin, and to this work he also clung through years of poverty; from this too he drew his faith and his perseverance. His first considerable work in sculpture, *The Slave*, which he began in 1900 and did not finish

HENRI MATISSE *Vase and Pomegranates. 1947*

until 1903, is obviously influenced by Rodin's *Walking Man*. Matisse even went so far as to ask Rodin to take him as a pupil, but Rodin seems to have rebuffed him,[8] with the result that Matisse went to Bourdelle for instruction. Sculpture always played a significant if subordinate part in Matisse's career, from this early *Slave* of 1900 to the *Crucifix* he modelled for the chapel at Vence at the end of his life.

To return to the 'Notes' of 1908: In considering the 'artistic' way of expressing his feelings for life, Matisse distinguishes between order (clarity of form) and expression (purity of sensation). The sense of order he got from Cézanne, in whose pictures 'all is so well arranged . . . that no matter at what distance you stand, you will always be able to distinguish each figure clearly and you will always know which limb belongs to which body. If in the picture there is order and clarity it means that this same order and clarity existed in the mind of the painter and that the painter was conscious of their necessity.'

In the first place, therefore, a clear vision of the whole composition *in the mind* of the painter.

Then comes the choice of colours, based on observation, on feeling, and 'on the very nature of each experience'. This latter phrase implies that there is no *a priori* theory of colour to fit the subject (such as Seurat or Signac had tried to establish), but that the artist must each time try to find a colour that fits his sensations. Matisse's language is a little obscure at this point (and is not helped by the translation which ignores the distinction between 'tone' and 'hue'), but Matisse means that a balance has to be struck among all the constituent hues of the picture, to such a degree that 'a moment comes when every part has found its definite relationship and from then on it will be impossible for me to add a stroke to any picture without having to paint it all over again'.

After an expression of his abiding humanism ('what interests me most is neither still life nor landscape but the human figure') Matisse makes a confession that has led to much misunderstanding, but which must be reproduced again because it indicates,

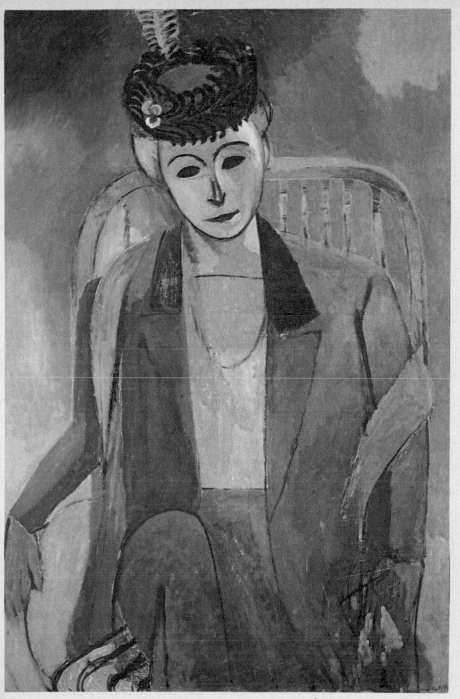

HENRI MATISSE *Portrait of Madame Matisse. 1913*

more decisively than any other expression of his point of view, the distance that was to separate him from not only most of his fellow-Fauves, but from the Expressionists of Germany and elsewhere:

> 'What I dream of is an art of balance, of purity and serenity devoid of troubling or depressing subject matter, an art which might be for every mental worker, be he business man or writer, like an appeasing influence, like a mental soother, something like a good armchair in which to rest from physical fatigue.'

An ingenuous statement, not altogether borne out by the works on which Matisse was busy at the time, e.g. *The Two Negresses* of 1908 (bronze) or the *Jeannette* (also bronze) of 1910–11, or the *Nymph and Satyr* of 1909 (Museum of Western Art, Moscow) or the *Goldfish* of 1909–10 (Copenhagen, Statens Museum). But this is also the period of the *Dances* of 1909 (Chrysler Collection) and 1910 (Museum of Western Art, Moscow), and by 1911 Matisse had fully accepted the implications of his creed. Exactly forty years later, however, for the catalogue of an exhibition of drawings held at the Philadelphia Museum of Art, Matisse made another statement which makes clear that he never lost his expressive intention: 'There is an inherent truth which must be disengaged from the outward appearance of the object to be represented. This is the only truth that matters. . . . These drawings are so little the result of chance, that in each one it can be seen how, as the truth of the character is expressed, the same light bathes them all, and that the plastic quality of their different parts—face, background, transparent quality of the spectacles, as well as the feeling of material weight—all impossible to put into words, but easy to do by dividing a piece of paper into spaces by a simple line of almost even breadth—all these things remain the same . . . its essential truth makes the drawing . . . *L'exactitude n'est pas la vérité*.'[9]

Exactitude is not truth is the thesis of the whole of the modern period in art, but as a thesis it was first clearly formulated by Matisse and the Fauves. Gauguin and the synthetists had formulated a different thesis which we call symbolism: the work

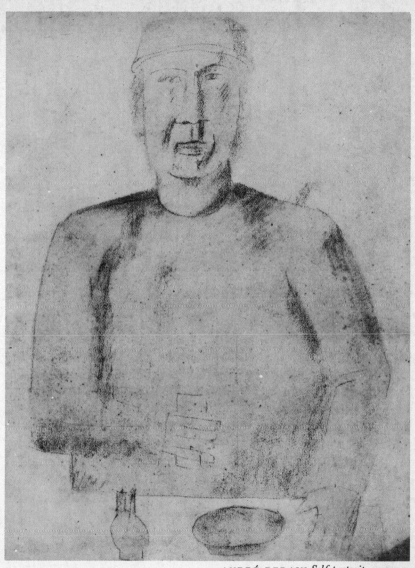

ANDRÉ DERAIN *Self-portrait.* C. *1912*

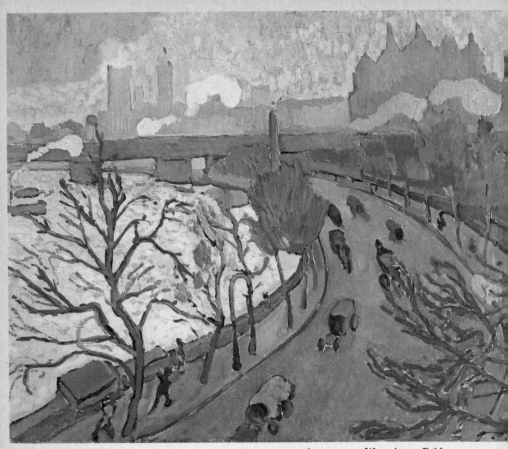

ANDRÉ DERAIN *Westminster Bridge. 1907*

of art is not expressive but representative, a correlative *for* feeling
and not an expression *of* feeling. Much as he admired Gauguin,
Matisse shared Pissarro's distrust of symbolism in general, and
with the possible exception of early works like *Luxe, calme et
volupté* (1904–5), *Bonheur de vivre* (1905–6), and *La Danse* (1909–10),
where both composition and colour are subordinated to *the idea*,
was never properly speaking a symbolist. It is necessary to empha-
size this because his use of colour is often described as 'symbolic',
simply because it is not 'exact' or naturalistic. But however much
they may be modified in the interest of harmony or serenity,
Matisse's colours remain essentially expressive, derived from the
function which colour has in the real existence of the object
depicted. The modifications or transpositions which the colours

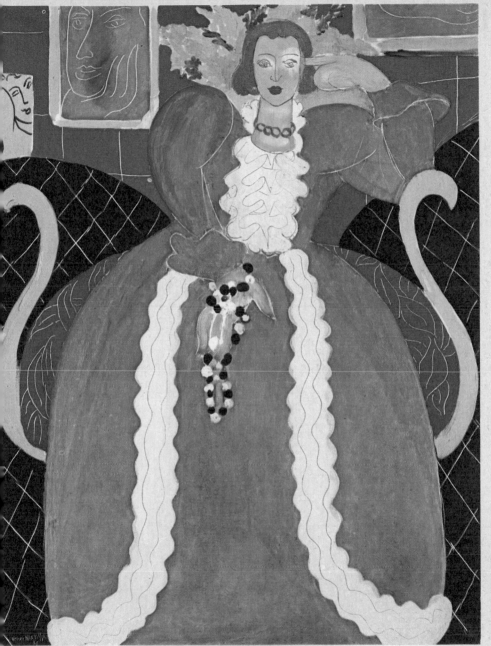

HENRI MATISSE *Lady in Blue.* 1937

undergo in the process of painting are based on selective observation, not on intellectual choice. 'To paint an autumn landscape I will not try to remember what colours suit this season, I will be inspired only by the sensation that the season gives me; the icy clearness of the sour blue sky will express the season just as well as the tonalities of the leaves. My sensation itself may vary, the autumn may be soft and warm like a protracted summer or quite cool with a cold sky and lemon yellow trees that give a chilly impression and announce winter.'[10]

The Fauves were never a coherent group, and Matisse was a leader by example rather than by precept. Of the artists who were to be associated with him, only Albert Marquet and Henri Manguin (1874–1943) had been fellow-students at Gustave Moreau's studio, though other Fauve artists, such as Charles Camoin (b. 1879) and Jules Flandrin (1871–1947), followed him there later. From 1902 all these younger artists exhibited alongside Matisse at Berthe Weill's gallery and later at the Salon des Indépendants. Others who then joined the group, not formally, but by association and sympathy, were Jean Puy (b. 1876), Raoul Dufy (1877–1953), Kees van Dongen (b. 1877), and Othon Friesz (1879–1949). But more important was the earlier adhesion, again sympathetic rather than formal, of André Derain (1880–1954) and Maurice de Vlaminck (1876–1958). Matisse met Derain as early as 1899, in the studio of Eugène Carrière where he had also met Jean Puy, and Derain introduced him to Vlaminck at a van Gogh exhibition in 1901. Derain and Vlaminck had already arrived independently at a style that Matisse found agreeable—'the painting of Derain and Vlaminck', he later recalled, 'did not surprise me, for it was close to the studies I myself was doing. But I was moved to see that these very young men had certain convictions similar to my own.'[11]

Finally, but not until 1907 and not to stay long with the group, came Georges Braque (b. 1882); but other artists too, Metzinger and Le Fauconnier, were also exhibiting with the Fauves at the Salon d'Automne or the Indépendants; and outside all groups were two painters who were as 'fauve' as any of the period—

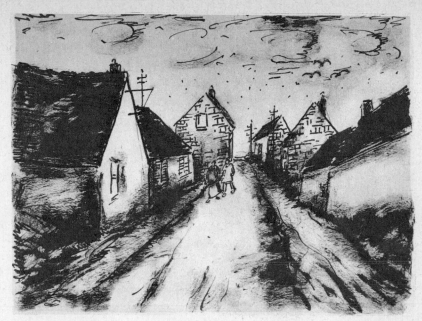

MAURICE DE VLAMINCK *Village Street*

Georges Rouault and Pablo Picasso (b. 1881). Rouault has already been mentioned as a fellow-student of Matisse at Moreau's; from his student days he was to pursue a lonely path, but he could not escape the influences that were abroad. Of all modern French painters he was the most expressionistic—in the sense that will be shortly made clear when we come to deal with the German Expressionists. But Picasso, too, in his *Self-portrait* of 1906 (Philadelphia Museum of Art) or the *Two Nudes* of the same year, was escaping from his youthful and sentimental mannerism and feeling his way towards a style at once more 'solid' and more powerful. But it would be a mistake to see in the turmoil of this decade any decisive tendency towards a unity of style. In fact, apart from personal mannerisms due to the individual artist's temperament, the whole scene was torn apart by two contrary forces, for which the names of Cézanne and van Gogh may stand as symbols. The divergence of Matisse from Vlaminck or Friesz, for example, apart from any question of personal staying-power, is to be seen as a triumph of the Cézanne influence in the one case, of the van

Gogh influence in the other. But what then shall we say of the diverging paths of Matisse and Picasso, both of which have a common starting-point in Cézanne? One might suppose that Cézanne was rich enough to contain all contraries, but the truth is too complicated for chronological analysis. All these names, Matisse, Rouault, Vlaminck, Derain, Picasso, refer to human beings in themselves intricately complex, each with a sensibility exposed to an infinite number of sensations, and the movement proceeds, not like an army on the march with one or two commanding officers, but as the gradual establishment of a series of strong-points each occupied by a solitary genius.

Nevertheless, the historian, however despairing in the presence of a phenomenon so intangible as art, must point to similarities and identities which indicate that the individual is not so unique as he may assume, and that however isolated the position he takes up, he is nevertheless exposed to a seeding of invisible spores. I have pointed out already how many significant artists made their way to Paris in this first decade of the century. But some spiritual unrest had uprooted them, and this unrest infected many who nevertheless stayed in their provincial fastnesses. The history of art, I have suggested, must be written in the terms of art itself— that is to say, as a piecemeal transformation of visual forms; but this does not mean that we should under-estimate the social and intellectual forces that from the beginning of the Romantic movement had been transforming the civilization of the Western World. The visual arts, and all the arts, are in this respect deeply involved, both as cause and symptom, in the general process of history. The arts have an originative function in this process—they pre-figure and give plastic precision to inhibitions and aspirations that would otherwise remain repressed and voiceless. In this sense artists are socially integrated, and act as units dispersed through-out society rather than as members of one or more self-sufficient and independent groups.

The origins of the Expressionist movement in Germany illustrate this fact very forcibly. One is immediately struck by the fact that although groups of artists did converge to definite centres, notably

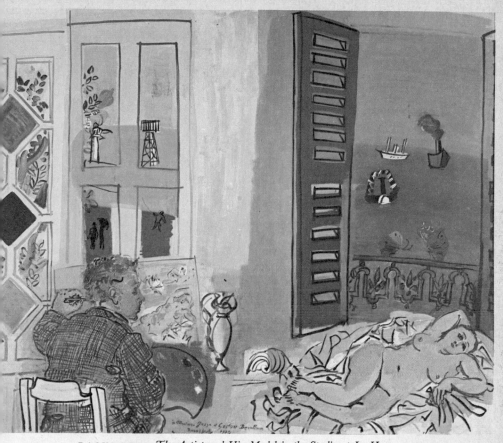

RAOUL DUFY *The Artist and His Model in the Studio at Le Havre. 1929*

Die Brücke in Dresden in 1905 and *Der Blaue Reiter* in Munich in 1911–12, some of the most influential members of these groups remained obstinately independent in their activities. Typical in this respect is an artist like Paula Modersohn-Becker (1876–1907), a sensitive nature absorbing romantic influences from Böcklin and Hans von Marées, blending these with a sensitive under-standing of Gauguin and van Gogh, maintaining an essentially feminine tenderness, but nevertheless arriving in her isolation at a style that is in no way inconsistent with that of the period, as more consciously formulated by groups like *Die Brücke*. Karl Hofer (1878–1955) is another independent German artist of the period whose work nevertheless conforms stylistically to the general character of Expressionism.

One should remember that artists in forming groups are more often actuated by practical rather than ideological motives. They find themselves in a world that is hostile to any kind of originality, in conditions where doors can only be opened or funds obtained by joint action. Such action is partly practical, partly propagandist. The practical side may include, as it did to some extent in the case of the *Brücke*, the sharing of a workshop and materials; and the propagandist side may include manifestoes, periodicals, and books that express a common purpose. But this community of purpose and practice is more likely to be evident in the early and difficult days of a young artist's life. With the coming of economic independence the individuality of each member of the group is sure to assert itself and its unity dissolves. The average life of such a group is not more than four or five years.

German Expressionism has certain elements which are common to French Fauvism, and these have a common source, not only in the *Jugendstil-Art Nouveau* mannerisms already mentioned, but also in the more personal characteristics of van Gogh and Gauguin. In so far as an exotic element enters into German Expressionism, and it is particularly evident in the work of Emil Nolde (1867–1956), and to a lesser extent in the work of Paula Modersohn-Becker, Otto Mueller (1874–1930), and Max Pechstein (1881–1955), it is almost certainly in each case derived from Gauguin, though we must again remember the direct influence of Oriental art. But this is not the distinctive element in German Expressionism or in van Gogh—what distinguishes the style from French Fauvism is a much wider and more basic prejudice—what Wilhelm Worringer was to call 'the transcendentalism of the Gothic world of expression'. Worringer's two treatises, *Abstraktion und Einfühlung* (1908) and *Formprobleme der Gothik* (1912), were to be decisive documents in the development of German Expressionism. The first book, as he himself justly claims, 'became an "Open Sesame" for the formulation of a whole range of questions important to the epoch'—'this doctorate thesis of a young and unknown student influenced many personal lives and the spiritual life of a whole era'.[12] Worringer had for the first time given a

KARL HOFER *Girl and Moon. 1923*

clear theoretical formulation of the psychological motives that distinguish Northern art from Classical and Oriental art, and the painters that were to constitute the Modern Expressionistic movement could henceforth advance with a confidence based on historical evidence; that is to say, on a tradition with roots in the soil and social evolution of the Transalpine peoples. This Northern tradition is in itself complex, but one fact is decisive—the classical acceptance of the organic world as a serene setting for human efforts, and art as an harmonious reflection of this world (the gay and soothing arm-chair ideal of art which Matisse was to adopt) is not sufficiently expressive for it; 'it needs rather that uncanny pathos which attaches to the animation of the inorganic'. Hence that tendency to restless abstraction which has always characterized the historical development of art in the North, and which has reappeared with redoubled intensity in our own harsh times; and hence those emotive distortions of natural forms which seek

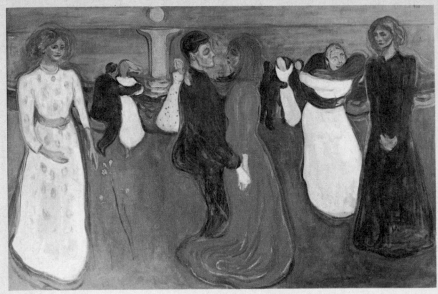

EDVARD MUNCH *The Dance of Life. 1899–1900*

to express the unease and terror which man may feel in the presence of a nature fundamentally hostile and inhuman. As rest and clear vision are denied him, his only recourse is to increase his restlessness and confusion to the pitch where they bring him stupefaction and release. 'The need in Northern man for activity, which is precluded from being translated into a clear knowledge of actuality and which is intensified for lack of this natural solution, finally disburdens itself in an unhealthy play of fantasy. Actuality, which the Gothic man could not transform into naturalness by means of clear-sighted knowledge, was overpowered by this intensified play of fantasy and transformed into a spectrally heightened and distorted actuality. Everything becomes weird and fantastic. Behind the visible appearance of a thing lurks its caricature, behind the lifelessness of a thing an uncanny, ghostly life, and so all actual things become grotesque. . . . Common to all is an urge to activity, which, being bound to no one object, loses itself as a result in infinity.'[13]

JAMES ENSOR *Girl with Doll. 1884*

There are phrases in this passage which describe all the varieties of Northern Expressionism of our own time. Edvard Munch and James Ensor (1860–1949), Ferdinand Hodler and Vincent van Gogh are all driven by this restless energy to depict 'a spectrally heightened and distorted actuality'. That is what Expressionism is, and it has absolutely no connexion with the calm refinement of Classical art (the 'objectified self-enjoyment' of Theodor Lipps's famous definition) nor with the mystical remoteness of Oriental art.

Implicit in this Northern attitude is, as Worringer has also pointed out,[14] a tendency to individualization and fragmentation. The 'personality' is not cultivated for its social values; instead the 'individual' becomes conscious of his isolation, his separateness, and he may intensify this consciousness to a state of self-denial or self-contempt (we see this clearly in the tragic life of van Gogh). But the more normal outcome of such individuation is the willing isolation of the artist, and his reliance for motive and inspiration on his own subjectivity or introspection.

If we take the precursors and founders of Expressionism in the order of birth, we find eight who were born between 1849 and 1870—Christian Rohlfs (1849), Ferdinand Hodler (1853), James Ensor (1860), Edvard Munch (1863), Alexei von Jawlensky (1864), Wassily Kandinsky (1866), Emil Nolde (1867), and Ernst Barlach (1870)—and all eight were for the most decisive years of their lives struggling in individual isolation, in hostile provincial environments. Rohlfs, who came first, developed slowly, impeded by illness and poverty, working in provincial schools, his style evolving from Naturalism to Impressionism, from Impressionism to Post-Impressionism; only after 1905–6, when he came under the influence of Nolde, did his style take on its full expressionistic vigour. He can, therefore, hardly be called a precursor of Expressionism, though he brought to it the experience of a nature matured in mystical solitude. Hodler was another lonely and mysticizing figure, condemned to isolation and suffering in one of the most unsympathetic environments possible for an artist—Calvinistic Geneva. Ensor lived for most of his long life in the still more

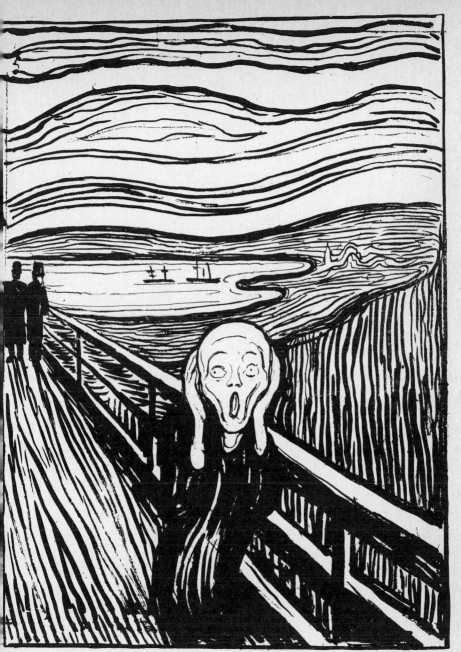

EDVARD MUNCH *The Cry. 1895*

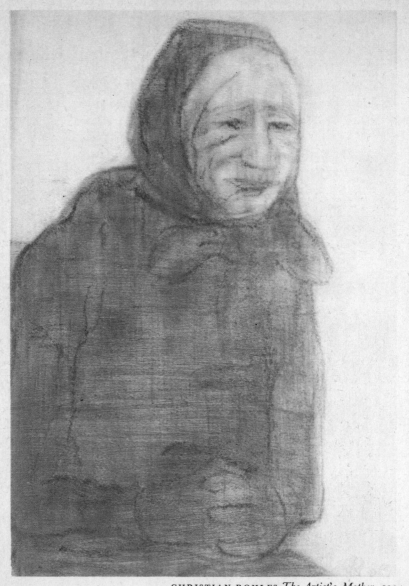

CHRISTIAN ROHLFS *The Artist's Mother. 1934*

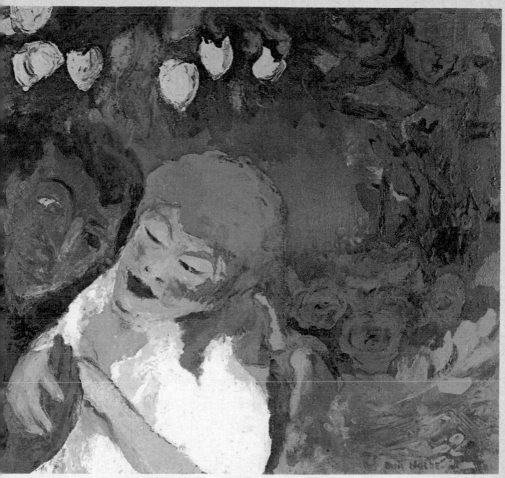

EMIL NOLDE *The Lemon Grove. 1933*

extreme isolation of Ostend, evolving his very individual type of mystical expressionism. Jawlensky and Kandinsky were both born in Russia (near Moscow). Though both had many contacts with younger artists during their lives, they were essentially solitary natures, Kandinsky metaphysical, Jawlensky mystical. Munch, the most dominant influence throughout the whole of Northern Europe, was the most isolated, the most introspective, and the most mordant of all these melancholy natures—he visited Paris occasionally and stayed for longer periods in Germany, but geographically and psychologically he was an 'outsider', his nearest parallels being spirits like Kierkegaard and Strindberg,

ERNST BARLACH *Rebellion (The Prophet Elias). 1922*

Ibsen and Nietzsche. Nolde was another 'outsider' of the same race and background as Kierkegaard, lonely, inhibited, morbidly religious. As for Barlach, like Rouault in France, a zeal at once humanistic and religious made him a prophetic figure, an artist depositing incongruous icons in our social wilderness. Nevertheless, his sculpture, his graphic work, and his dramas make him the most typical exponent among all these artists of the innate transcendentalism of this Northern world.

It is typical of artists of this type that they are very conscious of their mission and usually express themselves in literature as well as in their visual arts. Nolde's autobiographical writings and his letters;[15] Barlach's several dramas and his autobiography;[16] Kandinsky's more theoretical works and his poems; Munch's poems;[17] Hodler's writings and letters;[18] all these, like the letters of van Gogh, are works of art in their own rights, and not mere documents.[19]

Many other artists in Germany, Belgium, and Scandinavia had matured and were fully active during the first decade of the

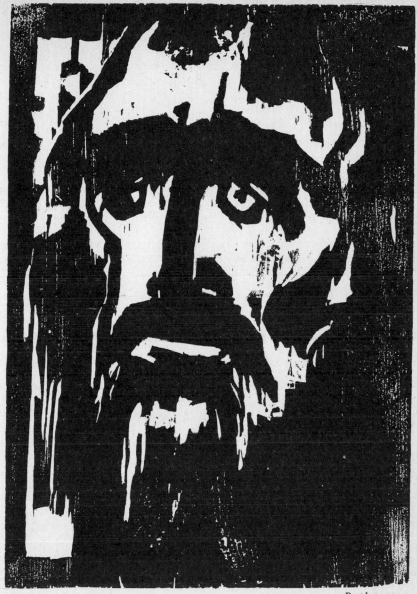

EMIL NOLDE *Prophet. 1912*

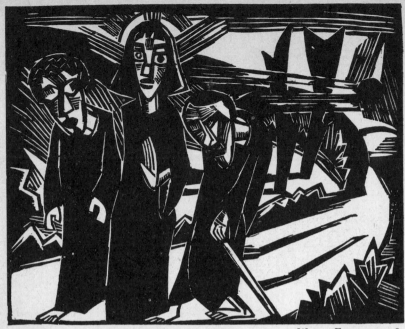

KARL SCHMIDT-ROTTLUFF *Way to Emmaus. 1918*

century. For the moment I shall only mention those who offer a fairly close chronological and stylistic parallel to the Fauvists, namely the group that was formed in Dresden in 1905 under the name of *Die Brücke* (The Bridge). The initiative in the formation of the group was taken by Ernst Ludwig Kirchner (1880–1938), originally a student of architecture in Dresden and Munich, but always drawn more and more to the graphic arts. His first experiments (woodcuts) were influenced by *Jugendstil*, but he too succumbed to the all-pervasive excitement of the decade—Neo-Impressionist painting, African and Oriental art, Gauguin and van Gogh. He communicated his enthusiasm to three of his fellow architectural students—first, in 1902, to Fritz Bleyl, then in 1904 to Erich Heckel (b. 1883), and in 1905 to Karl Schmidt-Rottluff (b. 1884). Other artists were soon to become associated with this quartet—Emil Nolde and Max Pechstein in 1906, Kees van Dongen in 1907, Otto Mueller in 1910. But some of these adherents were very temporary—Nolde remained for less than two years, van Dongen for even less time. The Swiss painter Cuno Amiet (b. 1868) and a Finnish painter called Axel

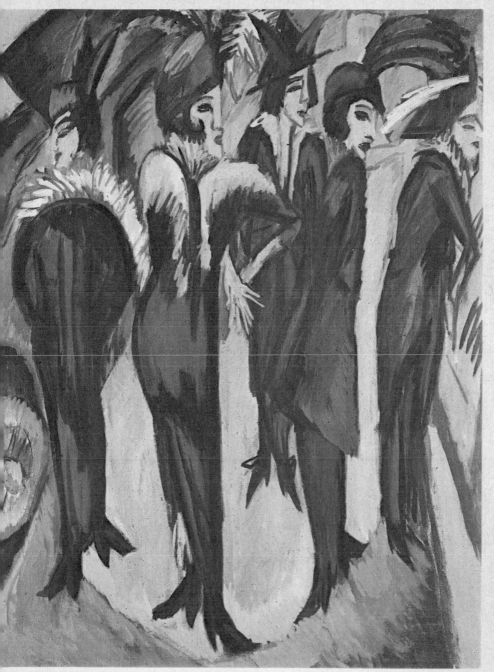

ERNST LUDWIG KIRCHNER *Five Women in the Street. 1913*

MAX PECHSTEIN *Portrait of Dr Paul Fechter. 1921*

Gallén-Kallela (1865–1931) were also for a time exhibitors with the group. But there is no doubt that Kirchner, Heckel, Schmidt-Rottluff and Pechstein were the main piers of the Bridge—they lived together and worked together, shared materials and money and jointly produced those bulletins, catalogues, posters, woodcuts and lithographs which give the group an unusually coherent historical documentation.

The *Brücke* was dissolved in 1913, by which time perhaps their individual differences were becoming too obvious for a common front; they were also beginning to find a market, and in a competitive economy this places a great strain on group unity. But by 1913 the Expressionistic ferment had spread throughout Germany; Munich in particular had become a centre of activity. Exhibitions multiplied and new influences penetrated from abroad. In Munich, Wassily Kandinsky was elaborating, in theory and practice, that other aspect of Northern sensibility, its 'impulse to self-alienation', that primal instinct, as Worringer

OTTO MUELLER *Gipsies with Sunflowers. 1927*

had called it in 1908, which 'seeks after pure abstraction as the only possibility of repose within the confusion and obscurity of the world-picture, and creates out of itself, with instinctive necessity, geometrical abstraction'. This was a reaction to the same world-picture that confronted the Expressionists, and in most cases the artists of the new tendency emerged from a preliminary stage of Expressionism. But the main piers of the Bridge were to remain standing. Neither Nolde nor Kirchner, Pechstein nor Schmidt-Rottluff, were ever diverted from their essentially humanistic ideals. In this respect (and in spite of stylistic differences to which I have already referred), they are to be associated with those Fauvists like Matisse, Derain, and Vlaminck who resisted the geometrical abstractions of Cubism. Fundamentally they do not differ in style from the Northern Expressionistic artists of the Middle Ages, as Worringer pointed out in *Form in Gothic*. The illuminated manuscripts and sculptures, the ivories and glass-paintings of the eleventh, twelfth, and thirteenth centuries express the same pathos with similar convulsive distortions, with the same relentless realism. The ideological differences—for in the twentieth century a private introspective mysticism has replaced the collective images of Christian mysticism—only serve to obscure the identity of the visual modes of expression. The works of a modern Expressionist like Barlach, still animated by the religious spirit of the Middle Ages, serve as a poignant demonstration of this fact.

ERICH HECKEL *Rising Sun. 1914*

CHAPTER THREE

Cubism

We found that Fauvism had little justification as a meaningful label in history or in theory. Cubism is also an ambiguous term, derisive in origin and of limited application. Nevertheless the Cubist movement, which may be said to have begun in 1907 and to have ended with the outbreak of war in 1914, had a stylistic coherence lacking in Fauvism. Long after the artists concerned had abandoned the style, or transformed it, it persisted as an influence in the architecture and decorative arts of the new century. The consequences of one individual act of perception were and remain incalculable.

This individual act of perception is recorded in a painting by Picasso, now called *Les Demoiselles d'Avignon* (*p. 69*). It was begun in the spring of 1907, but after many preliminary studies; the date of its completion is in doubt, though Picasso has admitted that the two figures to the right of the composition, which hardly conform to the rest of it, were painted at a later date—how much later he could not, or would not, say.[1] The date of completion is somewhat important, because on it depends whether we can say that this painting was influenced by African sculpture or not. Picasso himself has said that he first saw African sculpture in the ethnographical section of the Palais du Trocadéro in the autumn of this same year 1907; that is to say, after having painted *Les Demoiselles*.[2] But the visual evidence, as Mr John Golding has clearly shown,[3] proves that the decisive experience took place

while he was actually working on the painting, which is in point of fact stylistically incoherent, and was never considered 'finished' by Picasso himself. The faces of the three 'demoiselles' on the left of the picture are undoubtedly influenced by Iberian sculpture.[4] Picasso had studied such sculpture in the Louvre, and had even had two pieces in his possession at the time he began to paint *Les Demoiselles*.[5] But the two figures on the right of the picture, one crouching, the other standing and drawing back a curtain, are directly influenced by African negro sculpture to which Picasso's attention had first been drawn by Matisse in 1906, but which he began to understand and appreciate during 1907, while painting *Les Demoiselles*. Picasso had discovered an art which was essentially conceptual (he himself called it 'raisonnable'), and Cubism emerges as a fusion of the conceptual or rational element in African art with Cézanne's principle of 'realization' of the *motif*.

There is no doubt, however, that the main influence revealed in *Les Demoiselles* is Cézanne's. Picasso, like most artistic prodigies, was a roving eclectic in the early phases of his development. Influences from many sources appear in his work—Romanesque art of his native Catalonia, Gothic art in general, sixteenth-century Spanish painting (particularly the work of El Greco), and finally the work of his immediate predecessors, such as Toulouse-Lautrec, and of the Fauves whom he met when he first settled in Paris. But these influences were comparatively sporadic and superficial: the influence of Cézanne was profound and permanent.

The paintings of Cézanne exhibited at the Salon d'Automne in 1904 and 1905, and again in the Salon of 1906, had given rise to widespread criticism and appreciation.[6] In 1907 a memorial exhibition, consisting of fifty-six paintings by the now revered Master of Aix, was held in Paris. Picasso may have seen all, and certainly saw some of these exhibitions; he may also have seen paintings by Cézanne at Vollard's gallery. If one compares the composition of *Les Demoiselles* with the numerous *Baigneuses* of Cézanne, the derivation of the group is obvious: there is the

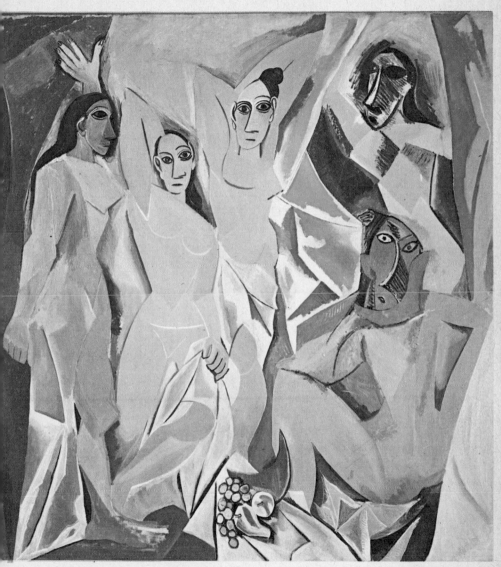

PABLO PICASSO *Les Demoiselles d'Avignon. 1907*

essential difference that Cézanne's pyramidal structure is replaced by vertical parallels, but the pose of some of the individual figures is identical.[7] In the completed painting, however, certain innovations appear for which there is no parallel in Cézanne's *Baigneuses*, notably the geometricization of the sharply outlined figures, and of the folds of the draperies against which the demoiselles disport themselves.

Questions of derivation and resemblance are not in themselves important; it is the new style that emerges from their complete fusion that was to be decisive for the whole future of Western art. But before the fusion could be complete, there was to be a strengthening of the African influence. *The Woman in Yellow (Le Corsage Jaune)* of 1907 in the Pulitzer Collection, the *Dancer* of the same year in the Chrysler Collection; *Friendship* (spring, 1908), in the Museum of Modern Western Art, Moscow, and the *Head* of summer, 1908 (also in the Chrysler Collection); these are all direct transpositions of the 'rationality' of African negro sculpture into pictorial compositions; in one or two cases it is even possible to indicate the provenance of the type of African sculpture that must have served as a model.[8]

Les Demoiselles contained elements of geometricization which merge into the same stylistic elements in Cubism, but it was not yet a Cubist picture. The two years from the spring of 1907, when he began to paint *Les Demoiselles*, to the summer of 1909, when he spent some time at Horta de Ebro in Spain, was a period of intense revision for Picasso. And not for Picasso alone. In the autumn of 1907 David Henry Kahnweiler, who had opened a gallery which was henceforth to be the focus for the new developments, introduced him to a young painter from Le Havre, Georges Braque (b. 1882). The next year (1908) a group of painters and poets sometimes called *Groupe du Bateau-Lavoir* (after the tenement in which Picasso had been living since 1904, nicknamed 'the floating laundry') began to take shape in Montmartre. In addition to Braque and Picasso, it included Max Jacob, Marie Laurencin (1885–1956), Guillaume Apollinaire, André Salmon, Maurice Raynal, Juan Gris (1887–1927), and Gertrude and Leo Stein.

PABLO PICASSO *Woman's Head. 1909*

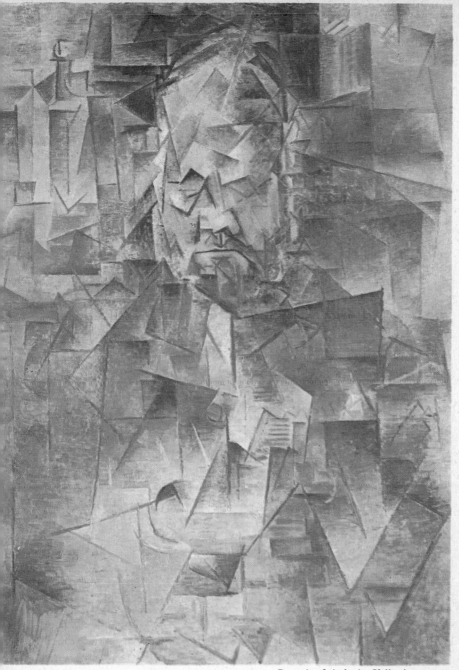

PABLO PICASSO *Portrait of Ambroise Vollard. 1909–10*

ABLO PICASSO *Seated Woman with Fan. 1908*

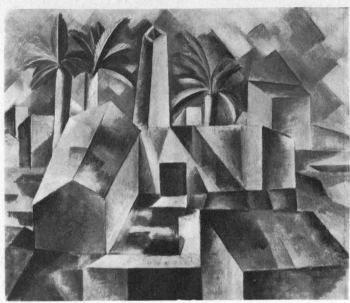

PABLO PICASSO *Factory at Horta de Ebro. 1909*

In the same year Apollinaire introduced Fernand Léger (1881–1955) to the group, though it was not until 1910 that Léger came into close personal contact with Picasso and Braque. During 1909 there were several new recruits—Robert Delaunay (1885–1941), Albert Gleizes (1881–1953), Auguste Herbin (b. 1882), Henri Le Fauconnier (1881–1946), André Lhote (b. 1885), Jean Metzinger (1883–1956), Francis Picabia (1878–1953), and the sculptor Alexander Archipenko (b. 1887).

The individual contributions made to the formation of the Cubist style by the members of this group are difficult to disentangle, but it would be a mistake to look on Picasso as a dominating influence. Certain landscapes painted by Braque in L'Estaque in the summer of 1908 anticipate very closely the landscapes which Picasso painted at Horta de Ebro in the summer of 1909 (compare Braque's *Houses at l'Estaque*, 1908, with Picasso's *Factory at Horta*, 1909). Braque throughout his career has maintained a stylistic integrity which is the one virtue that Picasso

GEORGES BRAQUE *Houses at L'Estaque. 1908*

could not claim, and this integrity dates from the formative stage of Cubism. Nevertheless, when Picasso returned from Horta in the summer of 1909 and held an exhibition at Ambroise Vollard's gallery of the pictures he had painted during the summer, it was at once apparent that Cubism had acquired a new meaning. What had been, in *Les Demoiselles*, a mannerism, became in the portrait of *Fernande* (Museum of Modern Art, New York) a style.

This style is usually distinguished from the earlier phases of Cubism as 'analytical', but this term suggests an intellectual or methodical approach to painting which has been repudiated by both Picasso and Braque, who have always insisted on the essentially intuitive or sensational nature of their creative activity. There is, of course, a very complete and consistent geometrical 'structurization' of the subject, such as, in a less obvious way, Cézanne had practised. But again (see page 18) this had been arrived at by way of 'modulation'; that is to say, by a sensitive co-ordination of the constituent planes; the difference being that Braque and

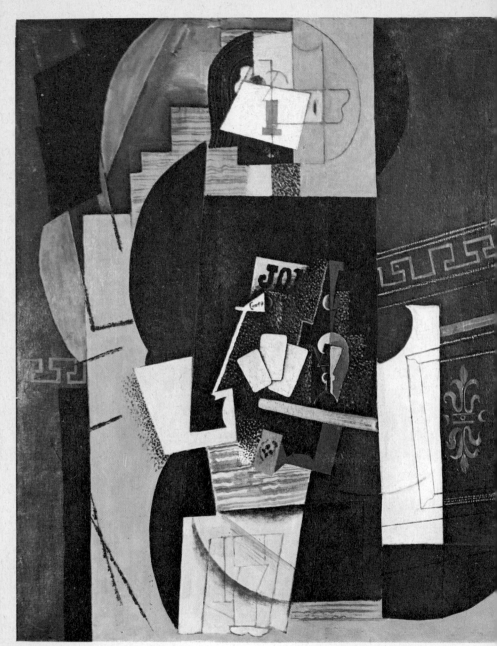

PABLO PICASSO *The Card Player. 1913–14*

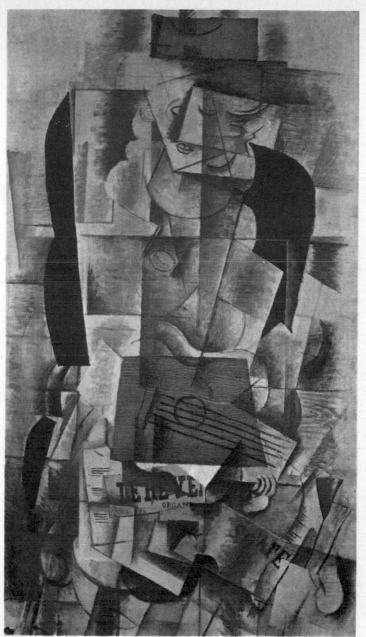

GEORGES BRAQUE *Young Girl with Guitar. 1913*

Picasso now abandoned the attempt to resolve this problem in terms of colour and relied essentially on light and shade. Picasso himself has defined Cubism as 'an art dealing primarily with forms, and when a form is realized, it is there to live its own life'. The aim is not to *analyse* a given subject: in the same statement Picasso disowned any idea of research, which he saw rather as 'the principal fault of modern art'. Cubism, he said, has kept itself within the limits and limitations of painting as always practised—only the subjects painted might be different, 'as we have introduced into painting objects and forms that were formerly ignored'. But 'mathematics, trigonometry, chemistry, psychoanalysis, music and whatnot, have been related to Cubism to give it an easier interpretation. All this has been pure literature, not to say nonsense, which brought bad results, blinding people with theories'.[9]

The exclusion of colour gave a sculptural effect to the magnificent series of portraits and still-lifes that Picasso and Braque painted during the next two or three years, but it is a fragmented sculpture, as if reflected in a mirror-glass mosaic. When, as he did from time to time, Picasso practised sculpture (there is a *Woman's Head* of bronze dating from 1909 in the Museum of Modern Art, New York), the fragmented effect is produced by angular distortions of the modelled surface. The analysis in this case (as no less obviously in the paintings of the period) has no 'scientific' justification (in anatomy or in representation—the portraits, for example, do not resemble their subjects in their characteristic appearance). The form produced is there to live its own life, which is a life communicated by the subject but re-created in the object.

If 'analytic' is a misleading term for the Cubist paintings of Picasso and Braque between 1910 and 1912, 'synthetic', which is by implication a contrary term, is even less appropriate for the next phase of their work, which continues until the outbreak of the war. There is actually no possibility of making an aesthetic distinction between these two phases of an evolving style; elements that were to become dominant in the paintings of 1913–14 (parts

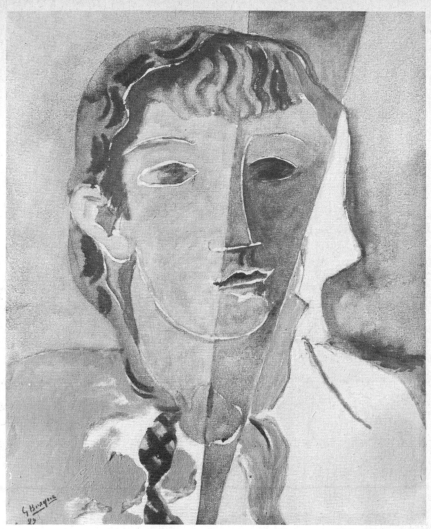

GEORGES BRAQUE *Girl's Head. 1929*

of musical instruments, fragments of typography, textures of wood, etc.) are present in embryo in the paintings of 1910–12. Picasso's *The Girl with the Mandoline* of 1910 is still identifiable as a portrait of Fanny Tellier; but the *Accordionist* of 1911 is already anonymous and *Ma Jolie* of 1911–12, without any violent transition, introduces the typography that was to become such a dominant feature of the collages of 1913–14. One may by way of analogy

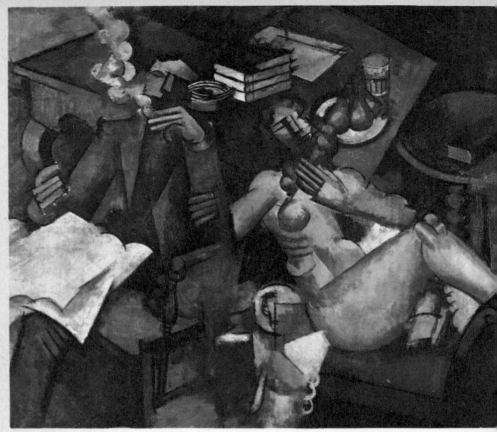

ROGER DE LA FRESNAYE *Conjugal Life. 1913*

speak of a 'rococo' Cubism in contrast with an earlier 'classic'
Cubism; but the style is the man himself, the visual elements
which he selects to create a vital organization of form.

Nevertheless, the gradual introduction of elements other than
paint produced a further variation of Picasso's style which was to
lead him far from Cubism; but before we deal with this develop-
ment we must trace the immediate diffusion of the movement
itself. Braque's development continued parallel with Picasso's
until the outbreak of the war, in which he served and was
wounded. After the war he resumed where he had left off, but
only, as it were, to consolidate the position he had reached in
1914. The geometrical idiom was gradually modified, to be replaced
by freer and more cursive forms, a private iconography of im-
peccable taste—an art as serene and comforting as Matisse's.

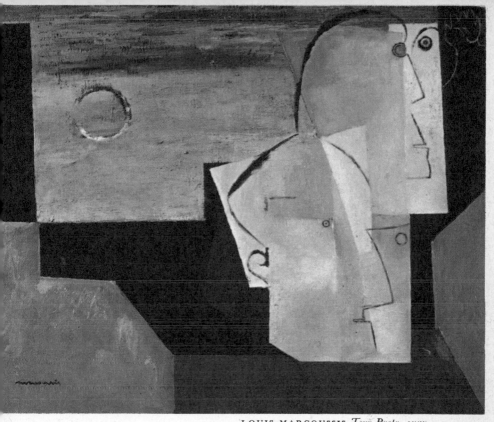

LOUIS MARCOUSSIS *Two Poets. 1929*

Braque became what is sometimes called 'a painter's painter', so that from the point of view of a painter of a younger generation, such as Patrick Heron, it is possible to maintain that he is 'the greatest living painter', and in so doing 'to remind a contemporary audience, fed to satiety on brilliant innovation, frenzied novelty and every variety of spontaneous expression, that, after all, permanence, grandeur, deliberation, lucidity and calm are paramount virtues of the art of painting'.[10] This is true, but our age has demanded other virtues: a new vision to express a new dimension of consciousness—not only harmony, but the truth which is, alas, fragmentary and unconsoling.

From 1909 onwards new recruits were joining the Cubist movement. Those of 1909 have already been mentioned; in 1910 came Roger de la Fresnaye (1885–1925), Louis Marcoussis

JUAN GRIS *Woman's Head. 1922*

(1883–1941) and the three Duchamp brothers (to be distinguished as Jacques Villon (b. 1875), Duchamp-Villon (1876–1918), and Marcel Duchamp (b. 1887). By this time a secession became inevitable—a new group, the *Groupe de Puteaux*, gathered round Jacques Villon and included Gleizes, La Fresnaye, Léger, Metzinger, Picabia, and Frank Kupka (1871–1957). In 1912 Piet Mondrian (1872–1944), who had come to Paris from Holland in 1910, and Diego Rivera (1886–1957), who came from Mexico about this time, made contact with this group. But the more the self-styled Cubists increased in numbers, the more evident it became that the movement included, not only distinct individualities, but even stylistic contradictions. This was made quite clear by the publication of a book in 1912, *Du Cubisme*, by Gleizes and Metzinger, that revealed a tendency to which the founders of the movement, Picasso and Braque, could never subscribe. This tendency, which may be implicit in the mechanistic bias of our

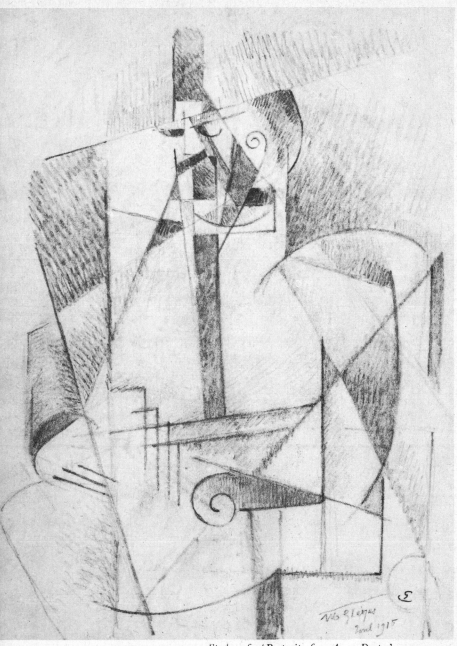

ALBERT GLEIZES *Study 5 for 'Portrait of an Army Doctor'. 1915*

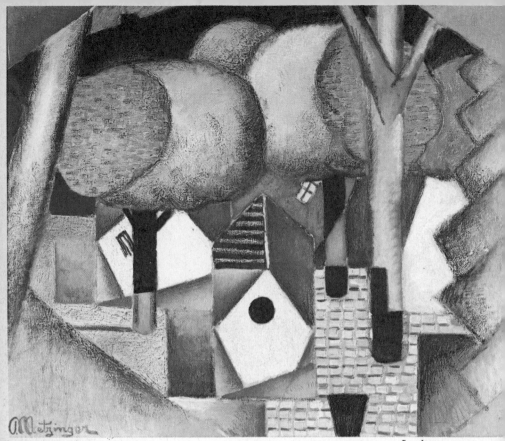

JEAN METZINGER *Landscape. 1912*

modern civilization, is an expression, perhaps unconscious, of the will to substitute for the principle of *composition after nature,* the principle of *autonomous structure*.[11] We shall see presently how in subsequent years this tendency developed into completely non-figurative types of art, but at the period we are considering such an outcome was not predictable. In *Les peintres cubistes,* which Guillaume Apollinaire wrote about 1911–12 and published in 1913, this 'scientific' tendency is rightly traced to Seurat, 'in whose works firmness of style is rivalled by the almost scientific clarity of conception'. It was Metzinger who carried forward this 'intellectual vision' and 'approached sublimity'. 'His art', wrote Apollinaire at this time, 'always more and more abstract, but

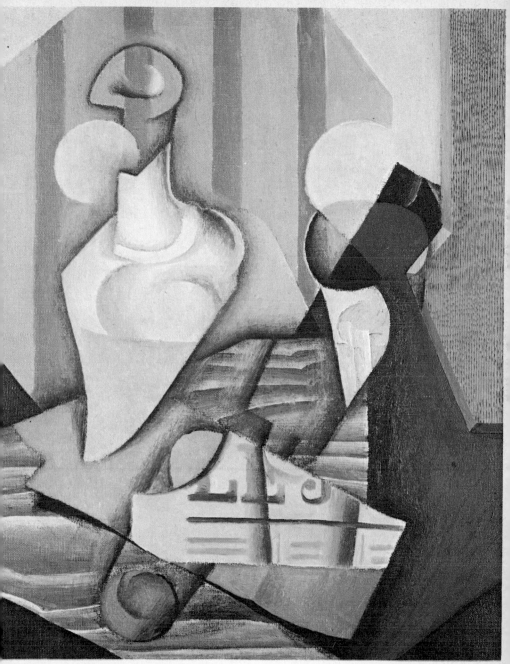

JUAN GRIS *Bottle and Glass. 1914*

always charming, raises and attempts to solve the most difficult and unforeseen problems of aesthetics. Each of his paintings contains a judgement of the universe, and his whole work is like the sky at night, when, cleared of clouds, it trembles with lovely lights. There is nothing unrealized in his works; poetry ennobles their slightest details.'[12]

As for Gleizes, who is inevitably associated with Metzinger, his goal was 'a sublime precision', and 'a capacity to individualize abstractions'. 'All the figures in the pictures of Albert Gleizes are not the same figure, all trees are not the tree, all rivers, river; but the spectator, if he aspires to generality, can readily generalize figure, tree or river, because the work of the painter has raised these objects to a superior degree of plasticity in which all the elements making up individual characters are represented with the same dramatic majesty.'

Gleizes and Metzinger, important as they were at this exploratory stage in the development of Cubism, did not have the eventual importance of a painter to whom Apollinaire gave a somewhat grudging recognition: Juan Gris. To Apollinaire Juan Gris seemed to be in danger of becoming too decorative (a shop-window dresser), 'too vigorous and too impoverished; it is a profoundly intellectual art, according to colour a merely symbolic significance'. This is a true observation, but it does not touch what was of most significance in Gris's art—his ability to combine the 'composition after nature' with the autonomous structure of the picture space. Gris did this by first planning the structure of his painting, and then imposing the subject on this framework; and for this reason the style he evolved has been called 'synthetic' Cubism. It was a procedure that profoundly influenced the development of non-figurative art in the post-war years—though Gris's own development in the years immediately preceding his death in 1927 at the early age of forty was to be disappointing and Apollinaire's word 'impoverished' becomes much more apt. He is an example, with such painters as Gleizes and Lhote, of the ease with which a new style becomes a new form of academicism.

It is one more illustration of the illogicality of the historical development of art that a relatively minor painter such as Gris should have had a more obvious influence than one of the major figures of the modern movement, and one who sprang from the same aesthetic background—Fernand Léger (1881–1955). Léger had kept himself a little apart from the Bateau-Lavoir artists in Montmartre. From 1905 to 1906 he had been influenced by Matisse and the Fauves in general, but then he too discovered the significance of Cézanne, and more literally than any other painter at the time, seems to have taken to heart Cézanne's famous remark about interpreting nature by means of the cylinder, the sphere, and the cone.[13] His first large painting in this style, the *Nudes in the Forest* of 1910 now in Kröller-Müller Museum at Otterloo (Holland), is a dense assemblage of such geometrical forms. By 1911, when he painted *The Smokers* now in the Solomon Guggenheim Museum, New York, he had found a freer and more personal idiom, well described in his own words:

FERNAND LÉGER *Cyclists. 1944*

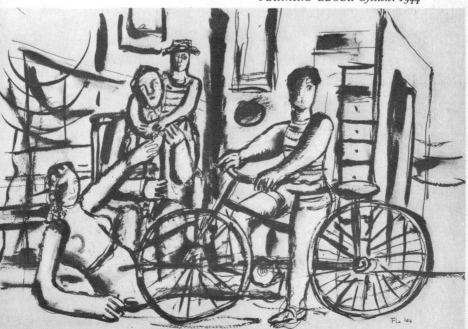

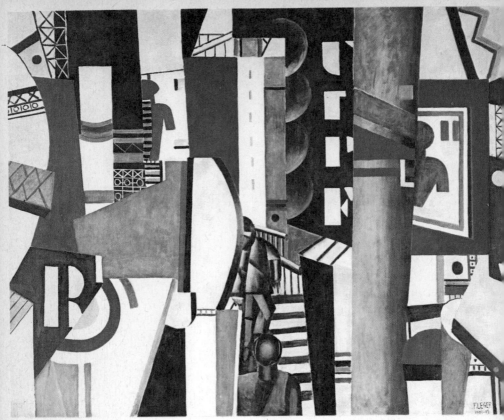

FERNAND LÉGER *City. 1919*

'To be free *and yet not to lose touch with reality*, that is the drama of that epic figure who is variously called inventor, artist or poet. Days and nights, dark or brightly lit, seated at some garish bar; renewed visions of forms and objects bathed in artificial light. Trees cease to be trees, a shadow cuts across the hand placed on the counter, an eye deformed by the light, the changing silhouettes of the passers-by. The life of fragments: a red finger-nail, an eye, a mouth. The elastic effects produced by complementary colours which transform objects into some other reality. He fills himself with all this, drinks in the whole of this vital instantaneity which cuts through him in every direction. He is a sponge: sensation of being a sponge, transparency, acuteness, new realism.'[14]

There is a directness or logicality in the development of Léger's painting between 1911 and 1918 which is lacking in the other

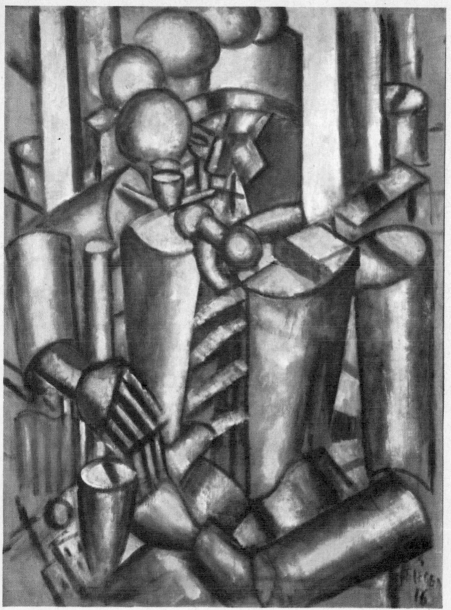

FERNAND LÉGER *Soldier with Pipe. 1916*

Cubists of the period. He may have hesitated at first, but once he had found his idiom he developed it consistently. He always proceeded from a visual experience, and though he often attained an extreme of abstraction in which it is difficult to identify the original *motif*, nevertheless he remains in contact with his original visual experience, and with a generalized notion of real space and vital forms. He might have developed towards a pure formal art but for the war, in which he served as a sapper. 'During those four years', he once confessed, 'I was abruptly thrust into a reality which was both blinding and new. When I left Paris my style was thoroughly abstract: period of pictorial liberation. Suddenly, and without any break, I found myself on a level with the whole of the French people; my new companions in the Engineer Corps were miners, navvies, workers in metal and wood. Among them I discovered the French people. At the same time I was dazzled by the breech of a 75 millimetre gun which was standing uncovered in the sunlight: the magic of light on white metal. This was enough to make me forget the abstract art of 1912–13.'[15]

It was a visionary revelation. 'Once I had got my teeth into that sort of reality I never let go of objects again.' This may be true in the sense that the *motifs* of his paintings were henceforth to be connected with the life of the people, or with the mechanistic aspects of modern civilization; there are nevertheless paintings as late as 1920 (*La Tombola* in the Kahnweiler Collection; ill. Cooper, p. 89) as abstract as anything he painted in 1912–13; and even much later there are *nature mortes* in which the function of the visual image is merely formal or 'conceptual'. A bunch of keys, a playing-card or a leaf signify nothing beyond the flat area of pure colour they occupy in a painting which, in Apollinaire's words, 'contains its own explanation'.

In spite of his immense integrity (or perhaps because of it) Léger had few followers. Whereas there were to be a hundred imitators of Picasso in every European and American country, there are only one or two who adopt the personal idiom of Léger.[16] He exerted a more direct influence (apart from personal characteristics such as his simplicity and humanity) by his dynamic use of

FERNAND LÉGER *The Parrot. 1940*

pure colour, by which I mean that colour was released from its figurative function to become purely decorative. Léger was one of those great painters like Veronese or Tiepolo who have no inhibitions about the decorative application of their art. He always welcomed an opportunity to paint murals in which his amazing energy could find full scope in large rhythmic areas of pure colour.

This coloristic aspect of Cubism had also been the preoccupation of Robert Delaunay (1885–1941), who was responsible for another deviation from orthodox Cubism (by which I mean the 'analytical' Cubism of Picasso and Braque). This deviation Apollinaire christened Orphism and defined it as 'the art of painting new structures out of elements which have not been borrowed from the visual sphere, but have been created entirely by the artist himself, and been endowed by him with fullness of reality. The works of the orphic artist must simultaneously give a pure aesthetic pleasure, a structure which is self-evident, and a sublime meaning, that is, the subject. This is pure art.'[17] Apollinaire, writing about 1912,

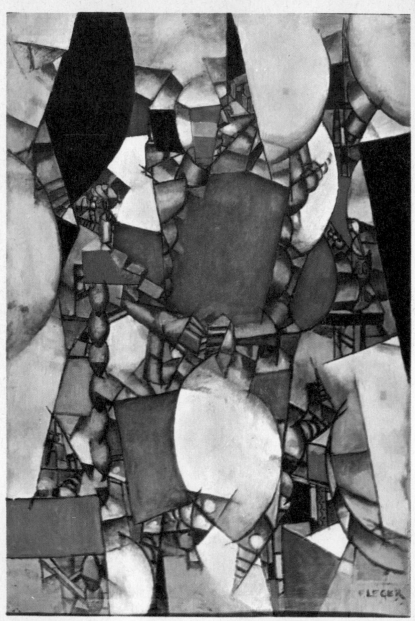

FERNAND LÉGER *Woman in Blue. 1912*

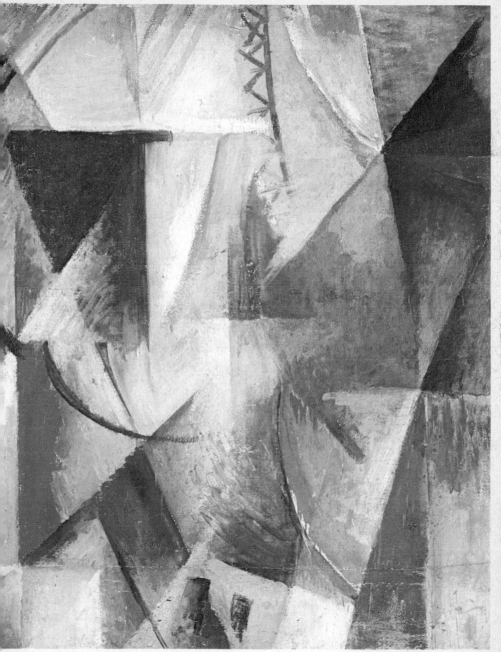

ROBERT DELAUNAY *Window. 1912–13*

associated Léger, Picabia and Marcel Duchamp with this 'important trend'. Later the Czech painter already mentioned, Frank (Frantisek) Kupka and two Americans, Patrick Henry Bruce (1880–1937) and Stanton Macdonald Wright (b. 1890), joined Delaunay, together with a Russian painter who became his wife, Sonia Terk. Delaunay, who was a Parisian by birth, had joined the Bateau-Lavoir group in 1909, after an early development which included the usual Fauve and Cézannian phases. Apollinaire described the kind of Cubism Delaunay evolved as 'instinctive', and certainly it was based on a passion which gave priority to colour—'colour alone is both form and subject', declared Delaunay. But equally it was based on the quasi-scientific experiments of the Impressionists, and in this respect Delaunay was trying to develop the researches of Seurat and Signac, and like these artists had studied the scientific treatises of Michel Eugène Chevreul to good effect. But also like Picasso and Braque, he was preoccupied with formal problems, and strove in particular to combine different aspects of figures and objects in the same painting. He himself gave the name of *Simultanéisme* to this kind of painting and was later to characterize it in these words: 'Nothing horizontal or vertical—light deforms everything, breaks everything up.' In this aspect of his work he came close to the Futurists, whose contemporary activities will be described in the next chapter. Delaunay's originality, and his importance in the history of modern art, is that he was gradually led to dispense with the *motif*, and to rely for his effects on a geometrical exploitation of the refrangibility of the spectrum itself. His paintings become what might be called fragmented rainbows, and by 1912 he had painted a completely 'non-objective' composition (*Le Disque*); that is to say, a composition not derived from a *motif* in nature, but composed as a geometrical pattern of colours. Already Kandinsky in Munich was experimenting with 'improvisations' that likewise were completely non-objective or non-figurative. The Orphism of Delaunay was at first more geometric, but the preoccupation of the two artists was essentially the same. The first exhibition of the new formed group (*Der Blaue Reiter*) in Munich in

ROBERT DELAUNAY
Sun Disks. 1912–13

December 1911 (see page 224) included work by Delaunay, and from that time onwards Delaunay and Kandinsky had maintained close touch by correspondence and had advanced, as it were, on a common front. Indeed, Delaunay's influence in Germany was far greater than it ever was in France; Franz Marc and Paul Klee must be included among those on whom he had a decisive effect.

Already by the end of 1910 the original insight which gave birth to the Cubist movement, and which was based primarily on a sense of geometrical structure derived from Cézanne, had submitted to several diversions. Picasso himself, in the series of portraits which he painted in this year 1910–11 (Vollard, Kahnweiler, Uhde, Eva or *Ma Jolie*) and Braque in his *Woman with Mandoline* (two versions of 1910) and *Seated Woman, Mandoline Player*, and *The Portuguese* of 1911, passed beyond a structure which *interpreted* the seen object to the creation of a structure which though *suggested by* the seen object existed by virtue of its own monumental coherence and power. Picasso's *Aficionado* (Kunstmuseum, Basle), painted in 1912, is 'abstracted' in the sense that the fragments or facets into which it is divided have a direct reference to the subject. One may discover not only elements derived from the features (nose, eyes) and clothing (hat) of the bullfight fan who was the point of departure, but also

fragments of typography (Nimes, where presumably the bullfight took place, and the word TORERO from a poster announcing the bullfight). That is to say, although the composition is derived from reality, there is no immediate perceptual image to be represented—rather a group of visual elements associated with a memory-image. These associated elements may indeed, as Picasso always insisted, be derived from visual experience; but the important distinction is that the painting becomes a free association of images (a construct of the visual *imagination*) and not the representation of a subject controlled by the laws of perspective. The whole conception of 'realization', as attempted by Cézanne, had been abandoned. The 'focus' is no longer concentric, fixing the object in a spatial continuum which recedes to a culminating point on our horizon. The focus is in the picture-space itself, and to the organization of this picture-space all visual elements contribute as colour and form, but not as the representation of an immediate perceptual image. There is only one 'percept': this is the composition itself: any elements from nature, that is to say, visual images derived from the subject, are broken down so that they may serve as structural elements. The solid rock is quarried (broken up into cubes); the stones are then used to build an independent structure.

This is the moment of liberation from which the whole future of the plastic arts in the Western World was to radiate in all its diversity. Once it is accepted that the plastic imagination has at its command, not the fixities of a perspectival point of view (with the consequent necessity of organizing visual images with objective coherence) but the free association of any visual elements (whether derived from nature or constructed *a priori*), then the way is open to an activity which has little correspondence with the plastic arts of the past. Of course, there are basic correspondences in so far as the plastic arts are *plastic*—that is to say, concerned with the manipulation of form and colour. In this sense, art has always been abstract and symbolic, appealing to human sensibility by its organization of visual and tactile sensations. But the vital difference consists in whether the artist in order to agitate the human

sensibility proceeds from perception to representation; or whether he proceeds from perception to imagination, breaking down the perceptual images in order to re-combine them in a non-representational (rational or conceptual) structure. This conceptual structure must still appeal to human sensibility, but the assumption is that it does this more directly, more intensely, and more profoundly in this new way than if burdened with an irrelevant representational function. On one side of this watershed in the history of art it may be argued that natural forms realized in conventional space reinforce the artist's appeal to human sensibility; on the other side it may be argued that since natural forms introduce a criterion of accurate presentation that is subject to an intellectual judgement, the spectator is likely to be affected more powerfully through images that can be freely organized to appeal directly to human sensibility.

An acceptance of this principle of the free association of images still leaves to the artist a wide choice, and the historical developments after 1912 are largely determined by the process of selection adopted by the particular artist or group of artists. Picasso and Braque extended their freedom of plastic association: that is to say, though their range of subjects was always arbitrarily limited, they would associate musical instruments with newspapers, wine-glasses with wall-papers, playing-cards with pipes, simply because these familiar objects lent themselves to the construction of an effective image. It is debatable whether such images have any deeper significance. Mr Barr suggests[18] that though 'the Cubists, traditionally, are supposed to have had little interest in subject matter whether objectively or symbolically, yet their preference for a rather repetitious range of subjects may be significant. Besides occasional vacation landscapes Picasso and his colleagues painted figures of poets, writers, musicians, pierrots, harlequins and women; or still-life compositions with ever-recurring guitars, violins, wine, brandy, ale and liqueur bottles, drinking glasses, pipes, cigarettes, dice, playing-cards, and words or word fragments referring to newspapers, music or drinks. These subjects, both people and things, consistently fall within the

range of the artistic and bohemian life and form an iconography of the studio and café. Whether they represent simply the artist's environment or whether they symbolize in a more positive though doubtless unconscious way his isolation from ordinary society is a debatable question.' But what we find in the development of Cubism from 1912 to 1914 is an increasing reliance, not so much on the *motif* or any visual images associated with the *motif*, but on *textures*. From imitating textures in paint Picasso and Braque proceed to use the original textures themselves by sticking pieces of newspaper, wall-paper, oilcloth, or fabric on to the canvas, linking these elements with areas of paint or outlines of charcoal. The technique was given a new name, *collage*, the normal French word for the process of mounting or pasting. For a year or two the technique retained its pictorial aim, but it led easily to a sculptural use of the same methods, and in 1914 Picasso constructed several three-dimensional still-lifes with bric-à-brac from the studios or café. These may be regarded as the direct precursors of constructions of a similar nature which were, a few years later, to constitute one of the main features of the Surrealist movement.

Cubist sculpture had a separate development, associated with the names of Brancusi, Duchamp-Villon, Gonzalez, Archipenko, Lipchitz, and Henri Laurens, but originally there was an intimate interchange of visual concepts and even of materials, and for this reason a brief reference to Cubist sculpture is justified in this history of modern painting. Some of the Cubist painters had experimented with sculpture—there is even a coloured plaster *Harlequin* (1917) by Juan Gris and a bronze *L'Italienne* (1912) by Roger de la Fresnaye. The first sculptor to use the Cubist idiom was Raymond Duchamp-Villon (b. 1876) in 1910; Archipenko began to show works at the Salon d'Automne of 1911; Brancusi followed in 1912 (at the Salon des Indépendants—*La Muse endormie*, now in the Musée d'Art Moderne, Paris); Lipchitz in 1913. Duchamp-Villon was undoubtedly the first to work out the implications of a Cubist sculpture, and to see immediately that it implied an identity or at least a confusion with the principles of architecture. As Apollinaire said: 'a structure becomes architecture,

HENRI LAURENS *The Guitarist. 1916* HENRI LAURENS *Little Boxer. 1920*

and not sculpture, when its elements no longer have their
justification in nature'. An abstract sculpture would, scale apart
(and why restrict sculpture in scale?) become a disinterested
architecture:

'The utilitarian end aimed at by most contemporary architects
is responsible for the great backwardness of architecture as com-
pared with the other arts. The architect, the engineer, should
have sublime aims: to build the highest tower, to prepare for time
and ivy the most beautiful of ruins, to throw across a harbour or
a river an arch more audacious than the rainbow, and finally to
compose to a lasting harmony, the most powerful ever imagined
by man.

'Duchamp-Villon had this titanic conception of architecture.
A sculptor and an architect, light is the only thing that counts for
him; but in all other arts, also, it is only light, the incorruptible
light, that counts.'[19]

But there is a distinction that can be made between disinterested
architecture and an abstract sculpture, and this is concerned not

so much with light as with the representation of movement: that is to say, endowing a static structure with a dynamic effect. This is exactly what Duchamp-Villon achieved in such pieces as *The Horse* (bronze, 1914; Museum of Modern Art, New York, and Musée National d'Art Moderne, Paris) and Alexander Archipenko in *Boxing Match* (synthetic stone, 1913; Peggy Guggenheim Collection, Venice). Duchamp-Villon died in 1918, but in his latest work, such as *Head of a Professor Gosset* (bronze, 1917), he had reached a degree of structural intensity which foreshadowed the forthcoming achievements of the Constructivist movement (see Chapter Four). Also to be mentioned in this connexion, if only because of his close association with Picasso, is the Spanish sculptor Julio Gonzalez (1876–1942) who came from Barcelona to Paris in 1900. At first a painter, from 1928 until his death he devoted himself to the development of sculpture in wrought iron.

Archipenko (b. 1887), who came from Moscow to Paris in 1908, first made contact with the Cubist group in 1910, and was much the most inventive of the pioneers of modern sculpture, a fact which is not often acknowledged. Already in 1912 he had introduced (on the same principle as the *collage*) different materials —wood, metal, and glass—into the same construction; and he was the first sculptor to realize the expressive value of the pierced hole as a contrast to the boss, or as a connecting link between opposite surfaces (the device that Henry Moore was subsequently to exploit to such good effect).

Henri Laurens (1885–1954) and Jacques Lipchitz (b. 1891) were somewhat later recruits to the Cubist movement, Laurens joining in 1911, Lipchitz not until 1913. But by the end of 1914 both artists had made decisive contributions to the development of Cubist sculpture, first translating the geometrical analysis of form into solid three-dimensional structures, and then exploiting the new freedom to evolve a disinterested architecture. In this respect again the Constructivists were anticipated, but characteristic works of the Cubist sculptors such as Laurens's *Woman with a Fan*, 1914, and Lipchitz's *Man with a Guitar* of 1915 (?) (cast stone, Museum of Modern Art, New York) are strict transpositions of

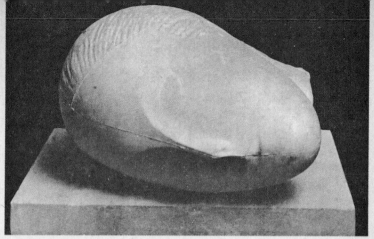

CONSTANTIN BRANCUSI *The Sleeping Muse. 1909–26*

the painting style of Picasso or Braque into three-dimensional structures. Laurens's *Head*, a wood construction of 1918 (Museum of Modern Art, New York) seems to be directly inspired by the similar wood constructions made by Picasso in 1914. Both Laurens and Lipchitz maintained the Cubist idiom far longer than the painters who had inspired it.

We come finally to a sculptor who, though sometimes associated with the Cubists (he exhibited with them at the Salon des Indépendants in 1912 and again in 1913), remained essentially an individualist: the Rumanian Constantin Brancusi (1876–1957). And not only an individualist, but a pragmatist, that is to say, one who was never motivated by theory, but discovered himself and his art in action. There are works of his which from their general appearance may be called Cubist (for example, *The Prodigal Son* of 1914, Arensberg Collection, Philadelphia Museum of Art). But if we revert to what I have called 'the moment of liberation' (see page 96), then one can see how decisively Brancusi rejected the Cubist revolution. He never broke down the unity of the perceptual image, to re-combine the fragments in a free construction. On the contrary, his whole effort was to preserve the integrity of the original visual experience, the innocency of a primordial consciousness, undisturbed by egoistic pretensions. From this point of view his art is diametrically opposed to that of Expressionism. Brancusi strove to eliminate the personal factor, to arrive at the essence of things, to strip from objects all accretions

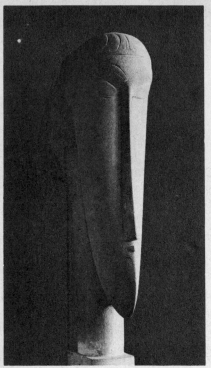

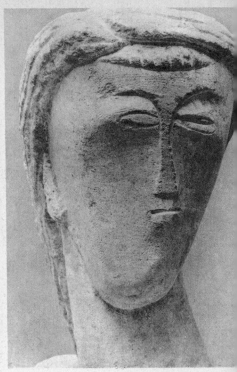

AMEDEO MODIGLIANI
Head of a Woman. 1910–13

CONSTANTIN BRAN
Young Girl's Head. 1

due to time and history. But this also implied an art diametrically opposed to Cubism, which, as we have seen, delighted in fragments of visual experience, in assortments of impressions. Beauty, said Brancusi, is absolute equity, and by this he meant, to use the phrase of Boileau and the eighteenth-century aestheticians, that nothing is beautiful but the true (*rien n'est beau que le vrai*).[20] In terms of sculpture, an art which in any case involves formal concentration,[21] this meant for Brancusi a reduction of the object to its organic essentials. The egg became, as it were, the formal archetype of organic life, and in carving a human head, or a bird, or a fish, Brancusi strove to find the irreducible organic form, the shape that signified the subject's mode of being, its essential reality. That in this enterprise he often arrived at forms which are

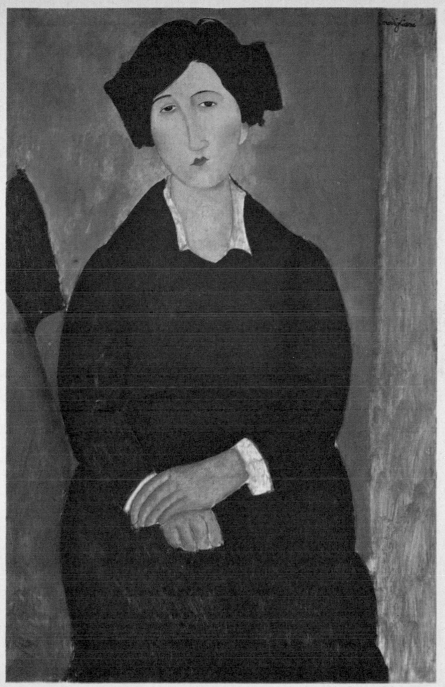

AMEDEO MODIGLIANI *The Italian Woman*

geometrical or even 'abstract' merely serves to relate Brancusi's aim to that of Cézanne—creations like the marble *Leda* (Art Institute of Chicago), the *Adolescent Torso* of maplewood (Arensberg Collection, Philadelphia Museum of Art), and the various versions of the *Mademoiselle Pogany* bust, are striking illustrations of an art that seeks to interpret nature by the cylinder, the sphere, and the cone. Indeed, it might be argued that Brancusi has shown a better understanding of Cézanne's intention than any of the Cubist painters—certainly a more consistent attempt to 'realize' the organic structure of natural objects.

It has sometimes been objected that Brancusi's method with its meticulous search for simplicity led in fact to a certain kind of sophistication—the kind of sophisticated elegance that we also find in the paintings of Amedeo Modigliani (1884–1920), an artist whom he befriended in 1909 and persuaded to turn for a time to sculpture. Modigliani had exhibited the previous year at the Salon des Indépendants, and was still torn between the contrary influences of Gauguin and Cézanne. But Brancusi (and therefore implicitly Cézanne) was to triumph. As Modigliani gradually found himself between 1915 and 1920, his style developed its characteristic mannerisms—elongated figures, curvilinear rhythms, ochre, or earthy coloration—but his debt to Brancusi remained evident to the untimely end.

A consideration of Brancusi and Modigliani has taken us beyond the stylistic range of Cubism. There are other artists who were associated with the Cubists—notably Picabia and Marcel Duchamp—who will be more appropriately considered in relation to subsequent developments (Dada and Surrealism). The end of the Cubist movement (though not the end of Cubism) came with the outbreak of war on 4 August 1914. Braque, Gleizes, Léger, Lhote, Villon, and Duchamp-Villon were immediately mobilized. Most of the others were gradually recruited. Picasso and Gris, as Spaniards, retained their freedom and continued their work in Paris. The group was never to be reconstituted, but in its brief existence it had liberated a creative energy that in the aftermath of war was to transform the art of the whole world.

CHAPTER FOUR

Futurism, Dada, Surrealism

The eight years between 1906 and 1914 have already been described as a period of intense fermentation. The ferment was never to subside in our time; there has been no coherent issue from the multiform experiments that preceded the First World War. Nevertheless, two general directions of development gradually became apparent, and no doubt these correspond to the main divisions of human temperament, which we call introvert and extrovert. Romanticism and Classicism are names we use for the same tendencies in the past, but when we are witnessing the actual process of history, and cannot yet generalize from particular experiences, all these categories become confused. We can see, from the typical example of Picasso, how difficult it is to attach the diverse manifestations of one genius to the logical limitations of one historical category. The artist, as Keats said of the poet, has a chameleon nature, apt to shock the virtuous philosopher. He has no identity—he is continually informing and filling some other body. That is to say, in practice the artist tends intuitively to identify himself with the purpose and achievement of every other artist, and only by an effort confines himself to a characteristic mode of expression. This may seem like an excuse for plagiarism, and much plagiarism there has been, in every epoch of art. But it is also the explanation of all historical

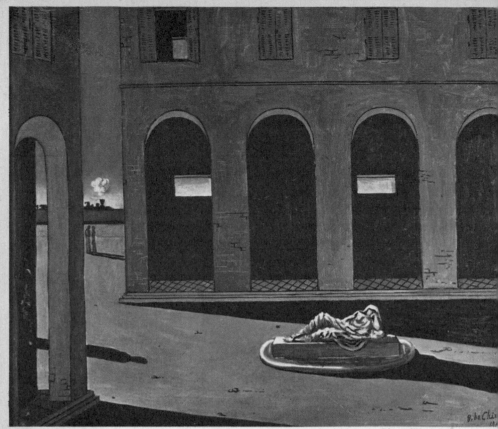

GIORGIO DE CHIRICO *Place d'Italie. 1912*

development in art, and an indication of the complexity, and even of the falsity, of all logical categories.

Though the constitution of the human personality will account for two general tendencies in the development of art, allowances must be made all the time for ambiguities and evasions. Lord Acton bade us 'seek no artistic unity in character', and art itself is an illustration of this aphorism. In our discussion of Cubism we have already distinguished two lines of development, one proceeding towards a fragmentation of perception and a reconstruction of form according to laws of the imagination; the other towards a 'realization' of the *motif*, a composition after nature. But even these two general tendencies are difficult to disentangle from one another, and each splits into subsidiary developments

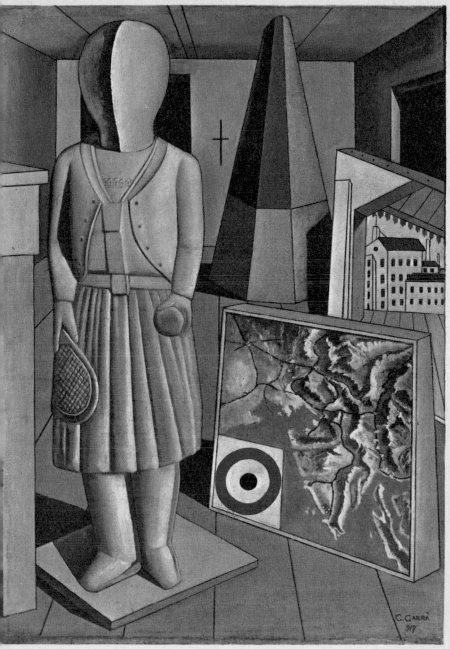

CARLO CARRÀ *The Metaphysical Muse. 1917*

which superficially have little resemblance to the parent movement. 'Realization of the *motif*,' for example, the Cézannian conception of realism, leads to Cubism, which is already a distortion of the *motif*, resulting in an independent structure; and this development was to suggest the invention of an entirely autonomous plastic reality—not a realization of a *motif*, but the creation of a *motif*. In this chapter and the next I shall deal with those movements in modern art which, taking advantage of the freedom offered by the fragmentation of the perceptual image, proceeded to evolve forms of art determined by either the imagination or the fancy.[1] It has been a characteristic of these movements that poets and literary propagandists have played a large part in their formation.

Futurism, the first movement of this character, was conceived and organized as a movement by the Italian poet, Filippo Tomasso Marinetti. During the course of the year 1909 he distributed throughout the world a manifesto which in brave rhetorical phrases proclaimed the end of the art of the past (*le Passéisme*) and the birth of an art of the future (*le Futurisme*). He gathered round him a group of poets and painters, the most important of which were Umberto Boccioni (1882–1916), Carlo Carrà (b. 1881), Luigi Russolo (1885–1947), Giacomo Balla (b. 1871), and Gino Severini (b. 1883). Boccioni composed a *Manifesto of Futuristic Painters* which was published on 11 February and publicly proclaimed on 3 March 1910 before a large audience at the Teatro Chiarella in Turin. This was followed on 11 April of the same year by a *Manifesto of the Technics of Futuristic Painting*. Further demonstrations and manifestoes appeared in quick succession.[2] In 1912 the group organized an exhibition of their work in Paris (later transferred to London and Berlin), and in 1914 Boccioni published a book which gave their ideals final expression[3]—final in form and fact, for the war that broke out in the same year dispersed the group. Boccioni, who had been its dynamic force, was accidentally killed in 1916 while convalescing from wounds. The group was never reconstituted. Severini turned for a time to Cubism, Carrà fell under the influence of the metaphysical

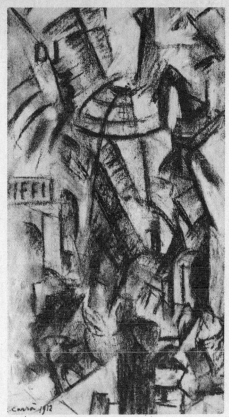

CARLO CARRÀ *Study in black and white for 'La Galleria'. 1912*

paintings of de Chirico (see page 121 below), Balla eventually reverted to academic realism, and Russolo, who was primarily a composer of Futurist music (sometimes known as 'bruitism'), apparently lost interest in painting.

The manifesto of 1910 is a logical document. It begins by declaring that a growing need for *truth* can no longer be satisfied by form and colour as they have been understood in the past: all things move and run, change rapidly, and this universal dynamism is what the artist should strive to represent. Space no longer exists, or only as an atmosphere within which bodies move and interpenetrate. Colour too is iridescent, scintillating; shadows are

luminous, flickering. And so these five painters were led to declare:

'1. That all forms of imitation should be held in contempt and that all forms of originality should be glorified.

'2. That we should rebel against the tyranny of the words harmony and good taste. With these expressions, which are too elastic, it would be an easy matter to demolish the works of Rembrandt, Goya, and Rodin.

'3. That art criticisms are either useless or detrimental.

'4. That a clean-sweep should be made of all stale and threadbare subject-matter in order to express the vortex of modern life—a life of steel, fever, pride and headlong speed.

'5. That the accusation "madmen", which has been employed to gag innovators, should be considered a noble and honourable title.

'6. That complementarism in painting is an absolute necessity like free verse in poetry and polyphony in music.

'7. That universal dynamism must be rendered in painting as a dynamic sensation.

'8. That sincerity and virginity, more than any other qualities, are necessary to the interpretation of nature.

'9. That motion and light destroy the materiality of bodies.'

The positive statements in this declaration are summarized in the fourth clause—the artist is required to express the vortex[4] of modern life—a life of steel, fever, pride, and headlong speed. Such an emphasis on the dynamic qualities of life began with the Impressionists, but the Impressionists never solved the problem of representing movement in the static forms of painting and sculpture. The Futurist solution was somewhat naïve: a galloping horse, they said, had not four feet but twenty, and their motion is triangular. They therefore painted horses, or dogs, or human beings, with multiple limbs in a serial or radial arrangement. Sound, too, could be represented as a succession of waves, colour as a prismatic rhythm. The different aspects of vision could be combined in one 'process of interpenetration—simultaneity-fusion'.

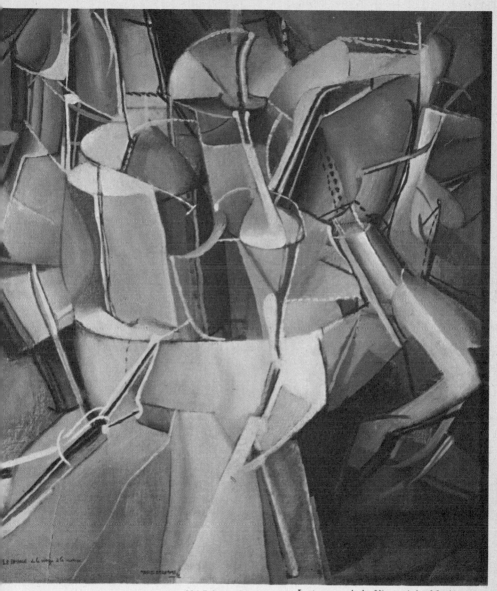

MARCEL DUCHAMP *Le passage de la Vierge à la Mariée. 1912*

In this aspect of their technique the Futurists anticipated the *simultanéisme* of Delaunay (see page 94).

The Futurist movement was short-lived, but its contribution to the modern movement as a whole was important and decisive. In so far as they attempted to represent motion, these pioneers were to be overtaken by the cinematograph; their paintings remain plastic symbols for motion rather than representations of motion. Their real importance derives from the fact that they developed a new sensibility for the typical objects of our age, notably the machine, and for the preoccupations of modern man, notably speed. Boccioni's figure, *Unique Forms of Continuity in Space* of 1913 (bronze casts in the Museum of Modern Art, New York, Galleria d'Arte Moderna, Milan, the Kunsthalle, Zürich, and the Winston Collection), has the dynamic vigour which we associated with Baroque sculpture, but while Baroque sculpture revolves within itself, Boccioni's piece seems to hurl itself into space, and anticipates the characteristic forms of the aeroplane. All the Futurists began by trying to represent physical or mechanical forces (e.g. Balla, *Automobile and Noise*, 1912; Carrà, *What the Streetcar told me*, ?1911; Russolo, *Force Lines of a Thunderbolt*, ?1911; Severini, *Dynamic Hieroglyph of the Bal Tabarin*, 1912). But the experiment was soon exhausted. Boccioni might have carried it through to a new synthesis of some kind, but the others were to relapse into realism or academicism. The reason is not far to seek: Futurism was fundamentally a symbolic art, an attempt to illustrate conceptual notions in plastic form. A living art, however, begins with feeling, proceeds to material, and only *incidentally* acquires symbolic significance.

The same criticism can, of course, be made of the Orphism of Delaunay and Picabia or the contemporary but independent Rayonism of Michel Larionov (b. 1881) in Russia. From 1910 to 1915 Picabia and Marcel Duchamp were painting in a manner which is difficult to distinguish from Futurism. Picabia's *Procession in Seville* of 1912 has a close parallel in Carrà's *The Funeral of Galli the Anarchist*, 1911, which was exhibited in Paris in that year. Duchamp's *Nude descending the Stairs* of 1912 (Philadelphia

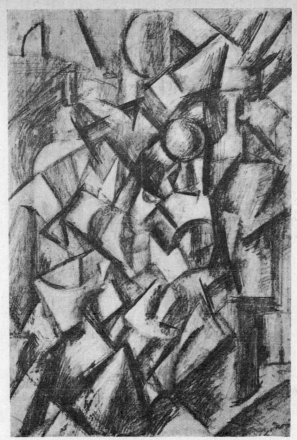

MARIO SIRONI *Composition. 1912*

Museum of Art) is paralleled by Balla's *Dog on a Leash* of the same year. Picabia's subsequent development belongs to the annals of Dada and Surrealism, as also to some extent does Duchamp's. But Duchamp, who has been one of the most enigmatic personalities of the modern movement (influential because enigmatic?) had a much clearer realization of the significance of Futurism than its originators. Already in 1913 Apollinaire had described this artist as 'detached from esthetic preoccupations', as 'preoccupied with energy'. Writing about his *Nude descending the Stairs*, the artist himself has explained that it is not properly speaking a painting—'it is an organization of kinetic elements, an expression of time and space through the abstract presentation of motion. A painting is, of necessity, a

juxtaposition of two or more colours on a surface. I purposely restricted the *Nude* to wood colouring so that the question of painting *per se* might not be raised. There are, I admit, many patterns by which this idea could be expressed. Art would be a poor muse if there were not. But remember, when we consider the motion of form through space in a given time, we enter the realm of geometry and mathematics, just as we do when we build a machine for that purpose. Now if I show the ascent of an airplane, I try to show what it does. I do not make a still-life picture of it. When the vision of the *Nude* flashed upon me, I knew that it would break for ever the enslaving chains of Naturalism.'[5]

Marcel Duchamp is here approaching to that conception of a plastic reality, of an object created with its own plastic identity and not as 'a painting of' another thing, which will be our concern in Chapter Six. His development after 1912, and more particularly after a visit which he paid to New York with Picabia in 1915, was increasingly towards constructions of glass, metal, and wood; but having arrived at this objective absolute Duchamp, like Rimbaud before him, retired into disdainful inaction. He had reached a point where the work of art is no longer to be considered as an aesthetic commodity, but as a free creation. But society had not kept pace: Apollinaire had prophesied that Marcel Duchamp was destined to 'reconcile art and the people'. But the people were not ready for reconciliation, and are not nearly ready yet.

The war had physically disrupted the groups that had formed in Paris, Munich, Milan, and elsewhere in Europe, but out of this very disruption and the spiritual chaos that ensued, the next artistic manifestation was to develop. During the course of the year 1915 a number of artists took refuge in the neutral city of Zürich— Tristan Tzara and Marcel Janko from Rumania, Hans Arp from France, Hugo Ball, Hans Richter and Richard Huelsenbeck from Germany. At casual meetings in cafés they conceived the idea of organizing an international cabaret entertainment. Hugo Ball was the organizer of the original celebration which took place on 5 February 1916 in a room hired from Jan Ephraim, a Dutch sailor, the proprietor of a public-house in the Spiegelgasse. A

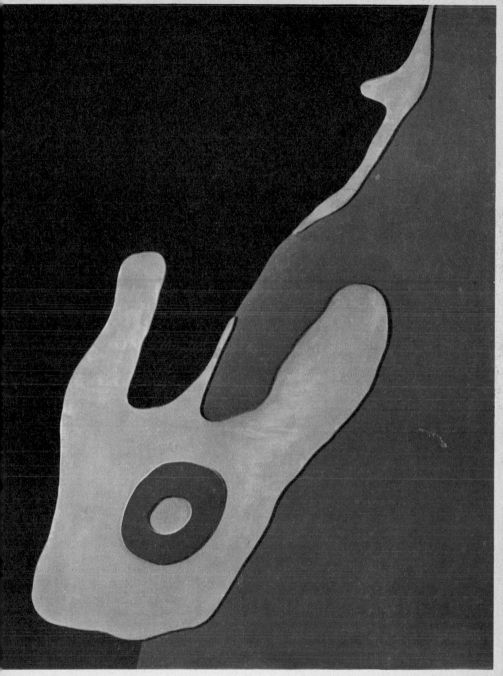

HANS ARP *Configuration. 1928*

variety of entertainments followed: French and Dutch songs, Russian music from a balalaika orchestra, negro music, poem recitals, and exhibitions of works of art. Ball and Huelsenbeck, who had arrived from Berlin early in February, searching a German-French dictionary for a suitable name for the *chanteuse* of their group, Madame le Roy, accidentally discovered the word *Dada*. It was adopted with enthusiasm as an appropriate name for all their activities. In June of this year a brochure entitled *Cabaret Voltaire* was published, edited by Hugo Ball, with a cover designed by Arp and contributions from Apollinaire, Marinetti, Picasso, Modigliani and Kandinsky, as well as the painters and poets already mentioned. In March of 1917 the 'Galerie Dada' was opened in the Bahnhofstrasse. In July the first number of a periodical entitled *Dada* appeared, edited by Tzara. The first Dada books followed—*La première aventure céleste de M. Antipyrine* by Tzara, illustrated by Janko, and *phantastische gebete* by Huelsenbeck illustrated by Arp. Viking Eggeling (1880–1925), a Swedish painter, came to Zurich in 1918 and tried with Hans Richter to 'mobilize' forms. First they made drawings, inspired by music, on stretchable rubber scrolls, but this failed, so they turned to the filming of scrolls. Their ways then separated, but Richter remained one of the leading spirits of the movement.

A paragraph in a history of Dada which Huelsenbeck published in Hanover[6] in 1920 summarizes the aims of the new group:

'The Cabaret Voltaire group were all artists in the sense that they were keenly sensitive to newly developed artistic possibilities. Ball and I had been extremely active in helping to spread expressionism in Germany; Ball was an intimate friend of Kandinsky in collaboration with whom he had attempted to found an expressionistic theatre in Munich. Arp in Paris had been in close contact with Picasso and Braque, the leaders of the Cubist movement, and was thoroughly convinced of the necessity of combatting naturalist conception in any form. Tristan Tzara, the romantic internationalist, whose propagandistic zeal we have to thank for the enormous growth of Dada, brought with him from Rumania an unlimited literary

facility. In that period, as we danced, sang, recited night after night in the Cabaret Voltaire, abstract art was for us tantamount to absolute honor. Naturalism was a psychological penetration of the motives of the bourgeois, in whom we saw our mortal enemy, and psychological penetration, despite all efforts at resistance, brings an identification with the various precepts of bourgeois morality. Archipenko, whom we honored as an unequalled model in the field of plastic art, maintained that art must be neither realistic nor idealistic, it must be true; and by this he meant above all that any imitation of nature, however concealed, is a lie. In this sense, Dada was to give the truth a new impetus. Dada was to be a rallying point for abstract energies and a lasting slingshot for the great international artistic movements.'

From the beginning Dada was consciously international—Tzara remained in close contact with Marinetti, and although the Dadaists regarded Futurism as too realistic and too programmatic, they borrowed from it, as Huelsenbeck admits, the concept of simultaneity (e.g. reciting different poems simultaneously and 'bruitism' or noise music (the precursor of *musique concrète*). But 'the Dadaists of the Cabaret Voltaire took over bruitism without suspecting its philosophy—basically they desired the opposite: calming of the soul, and endless lullaby, art, abstract art. The artists of the Cabaret Voltaire actually had no idea what they wanted—the wisps of "modern art" that at some time or other had clung to the minds of these individuals were gathered together and called "Dada".'[7]

Picabia had been to New York in 1913. In 1915, as already noted, he went there again, to join Marcel Duchamp, who had arrived in June of that year. They found a sympathetic patron in Walter Arensberg, and an impresario in Alfred Stieglitz, the artist-photographer, who had opened a gallery in Fifth Avenue as early as 1906, and had been the first to show not only American artists of the modern school like John Marin, Max Weber, and Man Ray but also Cézanne, the Douanier Rousseau, Toulouse-Lautrec, and Picasso. At the famous Armory Show, an immense

exhibition of eleven hundred works of the modern school held in New York in February 1913 (and subsequently transferred to Chicago and Boston), Duchamp's *Nude descending the Stairs* had created as much sensation as any other exhibit and when he arrived in New York two years later, his name was already well known. Stieglitz willingly allowed his gallery to become an outpost of the European movement, and undertook to publish a review which was called '291' after the number of the apartment-house in Fifth Avenue where the gallery was situated. Picabia remained in New York until the end of 1916, when he made his way back to Zürich via Barcelona, where he joined forces with Arthur Cravan, Gleizes, and Marie Laurencin, and on 25 January 1917 published the first number of a new periodical called '391' in memory of the Stieglitz periodical. After a brief return to America, where he rejoined Duchamp and published further numbers of '391', he went back to Switzerland, first to Lausanne, and then, in February 1918, rejoined the Zürich group which had meanwhile intensified its activities, publishing *Dada I* and *Dada II* in 1917 and a third number in 1918.[8]

Early in 1917 Huelsenbeck had returned to Berlin and found it easy to establish a German Dada movement in the despairful turmoil of the last year of the war. He was joined by George Grosz (b. 1893) and Raoul Hausmann. In Cologne, too, a movement took shape during 1918 under the leadership of a journalist called Baargeld and the painter Max Ernst (b. 1891), who had first met Arp in 1914. Another group was formed in Hanover with a publisher called Stegeman as a patron and Kurt Schwitters (1887–1948) as the leading artist. Other Dada groups were formed in Basle and Barcelona (as a result of Picabia's brief descent on that city). Meanwhile the Zürich group, now that the war was at an end, was beginning to disperse. Arp went to join the new group in Cologne. Tzara returned to Paris, where during the course of 1920 many manifestations and exhibitions took place. A Dada Festival was held at the Salle Gaveau and for the first time several names significant for the future appear—André Breton, Paul Eluard, Soupault, and Aragon. In this year also an International

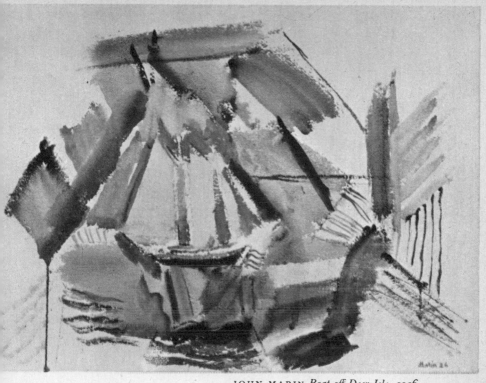

JOHN MARIN *Boat off Deer Isle. 1926*

Dada Fair was held in Berlin (June) which had been preceded (April) by an exhibition in Cologne, organized by Arp, Baargeld, and Ernst. This exhibition was closed by the police; Dada in Germany had from the beginning shown a revolutionary and politically nihilistic tendency; it had become a total social protest rather than an art movement.

But from the beginning Dada, inheriting the rhetorical propaganda of Marinetti, had claimed to be 'activist', and this in effect meant an attempt to shake off the dead-weight of all ancient traditions, social and artistic, rather than a positive attempt to create a new style in art. In the background was wide social unrest, war fever, war itself, and then the Russian Revolution. Anarchists rather than socialists, proto-fascists in some cases, the Dadaists adopted Bakunin's slogan: destruction is also creation! They were out to shock the bourgeoisie (whom they held responsible for the war) and they were ready to use any means within the

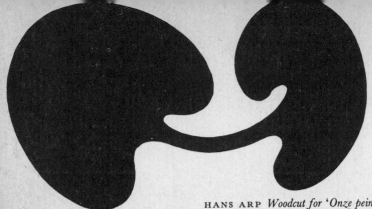

HANS ARP *Woodcut for 'Onze peintres vus par Arp'. 1949*

scope of a macabre imagination—to make pictures out of rubbish (Schwitters' *Merzbilder* [*p. 123*]) or to exalt scandalous objects like bottle-racks or urinals to the dignity of art-objects. Duchamp provided Mona Lisa with a moustache and Picabia painted absurd machines that had no function except to mock science and efficiency. Some of these gestures may now seem trivial, but that is to forget the task that had to be done—the breaking-up of all conventional notions of art in order to emancipate completely the visual imagination. Cubism had achieved much, but once it had rejected the laws of perspectival vision, it threatened to rest there and revert to a formal classicism more severe and rigid than the realism it had escaped. Dada was the final act of liberation, and apart from the response it elicited from Picasso and Braque, and even Léger, it provided 'a lasting slingshot' for a new and not less important generation of artists. Dada was to be largely forgotten in the inter-war period, but it had created an impetus and established a direction for the artistic development of Western art that was not to be exhausted in our time. The state of consciousness in Europe and America which evoked such manifestations as Futurism and Dadaism still prevails: we still search for images 'to express the vortex of modern life—a life of steel, fever, pride and headlong speed'.

Among the Italian painters who had signed the Dada manifesto in 1920 (published in the periodical *Bleu* at Mantua) was a Ferrarese painter, born of Italian parents in Greece in 1888. This artist, who significantly had gone to Munich for his training (1905–8) and had there come under the influence of Klinger's and Böcklin's mystical romanticism, was called Giorgio de

Chirico, and he was to play a decisive role in the next phase of modern art. De Chirico stayed in Milan and Florence from 1908 to 1910, and then went to Paris, where he met Picasso and Apollinaire. He returned to Italy at the outbreak of war and at Ferrara met Carlo Carrà, and with him established a 'scuola metafisica'—by which was meant a style of painting which might have owed something to the philosophy of Nietzsche, but which was essentially a new type of romantic landscape, based on Böcklin and Klinger, but using disconnected and disconcerting dream images rather than perceptual images. De Chirico's first landscapes in this style (they were generally dominated by architectural elements) were painted before he went to Paris; that is to say, in 1910. Then he began to use elements perhaps suggested by the 'constructions' of Picasso—geometrical instruments, fragments of maps, biscuits, etc., all painted with a *trompe l'oeil* exactitude and built up into grotesque figures somewhat after the manner of the fruit and vegetable monsters of the sixteenth century Milanese painter Giuseppe Arcimboldo. But such constructions are in no sense Cubist, and it may be doubted whether de Chirico ever sympathized with or even understood the aims of Cubism. He had no analytical intention and no logical aptitude: he used perspective, for example, not with a representational purpose, but for its emotional effect. The objects in his paintings are usually isolated, properties of an imaginary stage, and they are so disposed that they create a sense of expectancy, of drama. But there is no sense of deliberation in his compositions, and one must suppose that the images came into his inner vision with a trance-like spontaneity.[9] They depended on some mysterious faculty of evocation which in fact the artist suddenly lost, but not before he had produced a body of painting that still exercises a curious magical power.

De Chirico himself has given us the best verbal description of the poetry of his landscapes:

'Sometimes the horizon is defined by a wall behind which rises the noise of a disappearing train. The whole nostalgia of the infinite[10] is revealed to us behind the geometrical precision

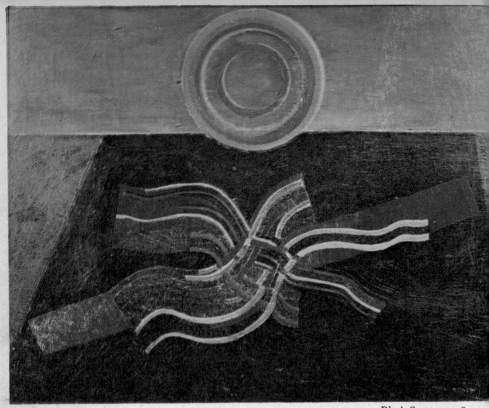

MAX ERNST *Black Sun. 1927–8*

of the square. We experience the most unforgettable movements when certain aspects of the world, whose existence we completely ignore, suddenly confront us with the revelation of mysteries lying all the time within our reach and which we cannot see because we are too short-sighted, and cannot feel because our senses are inadequately developed. Their dead voices speak to us from near-by, but they sound like voices from another planet.'[11]

For a few years (1915–20) Carlo Carrà and Giorgio Morandi (b. 1890) worked in sympathy with this poetic spirit, but both painters were always fundamentally classical in spirit, and when de Chirico returned to Paris (in 1924), left to themselves, they gradually abandoned the metaphysical style: they sought not the nostalgia of the infinite, but the serenity of the finite.

KURT SCHWITTERS *Merzbild Einunddreissig. 1920*

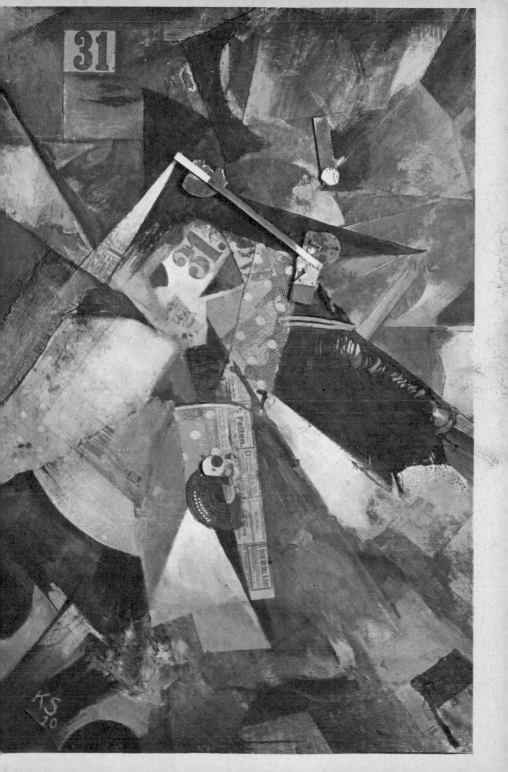

There is one other independent spirit whose presence in Paris was to contribute to the developments that took place at the end of the Dada period. Marc Chagall was born at Vitebsk in Russia in 1887. He received his training at the Imperial School of Fine Arts, St Petersburg, and first came to Paris in 1910, where he joined the circle of Apollinaire and Max Jacob and the painters Delaunay and La Fresnaye. In 1911 he was already exhibiting with the Indépendants—such paintings as *L'homme à la tête coupée*, *L'âne rouge*, *À ma fiancée*. Chagall has said that he came to Paris with some Russian soil still clinging to his shoes; certainly he brought with him a poetic vision which has its roots in Russian life and folk-lore, and this he has never lost. But already in 1911 he was showing the influence of the Cubists—indeed, he exhibited as a Cubist, alongside Gleizes and Metzinger. Paintings of this year, such as *Self-portrait with Seven Fingers* (*p. 126*) in the Stedelijk Museum, Amsterdam, or the great *Calvary* of 1912 in the Museum of Modern Art, New York, though they retain characteristic elements of Chagall's Russian iconography, are geometricized in the prevailing Cubist style. But Cubism, with Chagall, was never more than a superficial mannerism, and indeed he has confessed that he could not accept the violation of the sensuous texture belonging to the *motif*. Too much importance, he felt, was given to architectural form in Cubism; for himself, he preferred 'une figuration anti-logique', by which he meant an irrational arrangement of natural objects, the illogicality of dream imagery. La Fresnaye became his closest associate, but there was not much interchange of influences. Chagall, as he found his feet in the pre-war atmosphere of Paris, returned more and more to his own origins, and to what he has called the intimacy of simple life, to a childlike vision. But meanwhile his 'illogisme' was making a deep impression on the youngest generation of painters and poets, and when he returned to Paris in the winter of 1922–3—he had been absent in Russia during the war—his particular fantasy seemed to reinforce the quite different fantasy of de Chirico, and together they opened a path into the realms of the unconscious where few artists had hitherto ventured. But Chagall himself never entirely

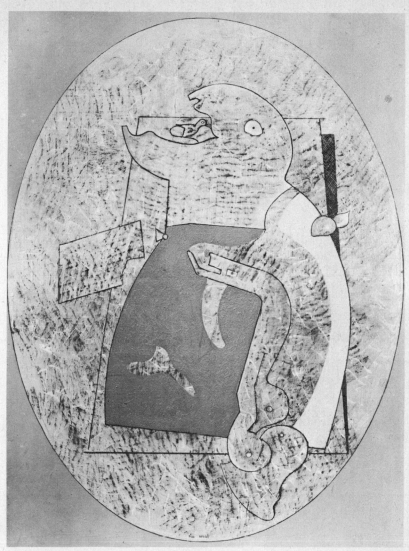

MAX ERNST *Figure. 1929*

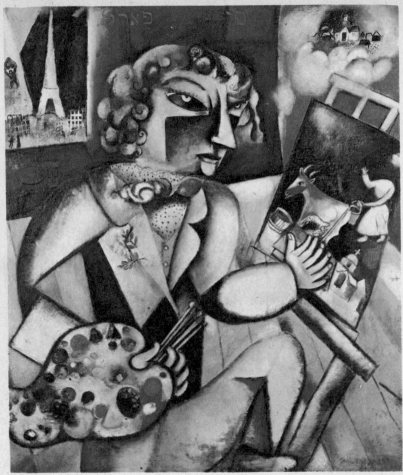

MARC CHAGALL *Self-portrait with Seven Fingers. 1912*

crossed this threshold: he has always kept one foot on the earth
that had nourished him. The Russian soil was never completely
shaken from his shoes.

In spite of his independence, Chagall has remained one of the
most influential artists of our time; and however much one allows
for purely artistic qualities, such as his barbaric richness of colour
(what he himself would call his 'primordial palette'), there is no

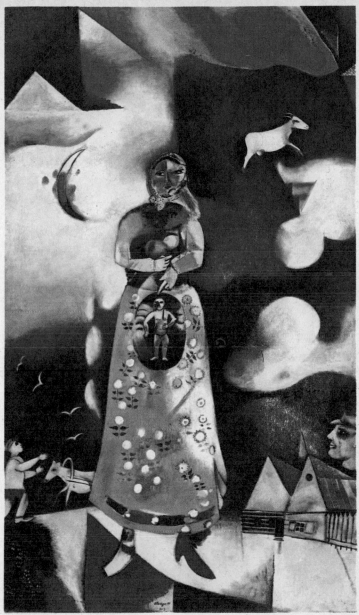

MARC CHAGALL *Maternity. 1913*

doubt that his essential appeal is to the emotions, which are worked on by means of a more or less nostalgic symbolism. Contrasting himself with the Impressionists and the Cubists he has said: 'I try to fill my canvas with ringing forms filled with passion that are to create an additional dimension such as cannot be attained with the pure geometry of Cubist lines or Impressionist dabs of colour.'[12] He cannot so easily disengage himself from the Surrealists, who were to find so much inspiration in his work, but he makes the attempt, accusing them of a literary approach to painting. The same accusation has often been made against his own painting, but he himself has identified painting and poetry:

'Everything may change in our demoralized world except the heart, man's love and his striving to know the divine. Painting, like all poetry, has a part in the divine; people feel this today just as much as they used to. What poverty surrounded my youth, what trials my father had with us nine children. And yet he was always full of love and in his way a poet. Through him I first sensed the existence of poetry on this earth. After that I felt it in the nights, when I looked into the dark sky. Then I learnt that there was also another world. This brought tears to my eyes, so deeply did it move me.'[13]

These are not, indeed, the sentiments of a Surrealist, in spite of the transcendental significance of the word. The word we again owe to Apollinaire: he used it to describe his own play, *Les mamelles de Tirésias* (*drama surréaliste en deux actes et un prologue*), which was first performed on 24 June 1917. When, in March 1919, André Breton and Philippe Soupault founded a review (*Littérature*), they adopted 'surréalisme' as a word to characterize a method of spontaneous writing with which they were experimenting. Breton was already familiar with the new doctrines of psychoanalysis, and he had come to the conclusion that the symbolic imagery released in dream and dream-analysis might be evoked for poetic effects. The origins of this new movement were therefore literary, but Breton was quick to see that the manifestations of Dada which began to reach Paris in this year

MARC CHAGALL *Self-portrait with Goat. 1922–3*

were of the greatest relevance to the experimental aims of his magazine. Tzara was invited to contribute and came to Paris; then followed those rowdy demonstrations in which the Dada movement expired. Its cult of absurdity became more and more extreme and by the end of 1922 it had ceased to exist as a coherent group. Breton rallied the remnants, at least those who appreciated his serious purpose, and in 1924, by which time he could count on the collaboration of artists like Arp and Max Ernst, as well as poets like Paul Eluard and Benjamin Péret, he issued his *First Surrealist Manifesto*.

Surrealism, as a movement, was to be as 'activist' and as incoherent in its manifestations as Dadaism, but it had the immense advantage of an intelligent and influential co-ordinator. Breton has always rejected the title of 'leader', and indeed the very concept of leadership is inconsistent with the essential libertarianism of the Surrealist doctrine. Nevertheless it was Breton who guided the modern movement from the Dada phase to the Surrealist phase. This is made very clear in several documents, above all in the pages of *Littérature* from its foundation in March 1919 onwards. It is true that this journal was edited jointly

by Louis Aragon, Breton, and Philippe Soupault, but during the controversies of 1920–2, which saw the decisive separation of Breton and Picabia from the rest of the Dadaists led by Tzara, Breton's well-expressed ideas and scientific spirit were to prove decisive. Breton began with manifestoes of sympathy with Dada, but before 1924 he had declared that he and his friends Soupault and Eluard had 'never regarded "Dada" as anything but a rough image of a state of mind that it by no means helped to create'.[14] Breton realized from this time onwards that an historical situation existed which called for something more constructive than the now futile antics of the Dada group. He conceived the idea of a congress of intellectuals which would 'distil and unify the essential principles of modernism'.[15]

The consequence has been well described by Georges Hugnet: 'It is easy to conceive that an undertaking of this sort would appear reactionary to Dada and to foresee how each individual Dadaist would interpret it. For Dada the adjective 'modern' was perjorative. Dada had always fought against the modern spirit. As for Breton, his intention was clear. Amid the mounting tide of obscurity, he wished to create light. He wished to investigate the manœuvres of Dada. Dada was at the end of its evolution. It had foundered like a ship in distress. A reorientation was necessary.'[16]

This reorientation Breton found in the doctrines of psycho-analysis. As a student of medicine he had been introduced to the work of Freud, and immediately realized its relevance to the manifestations of Dada. Apart from the significance which psychoanalysis attached to dreams and hallucinations, the therapeutic techniques of analysis suggested the use of word-association and induced day-dreams as possible methods of artistic creation. Breton himself has described how he was led to make the first experiments in this direction. One evening, as he was going to sleep, he heard distinctly articulated, 'as if it had knocked on the window-pane', the strange phrase: 'There's a man cut in two by the window,' and to reinforce the hearing of the phrase was a visual image of a man cut in two by a window. He then comments:

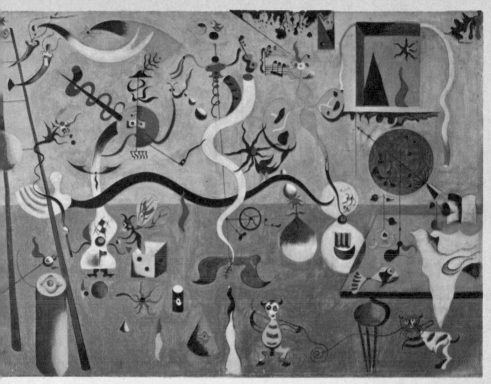

JOAN MIRÓ *Harlequinade. 1924–5*

'Preoccupied as I still was at that time with Freud and familiar with his methods of investigation which I had practised occasionally upon the sick during the War I resolved to obtain from myself what one seeks to obtain from patients, namely a monologue poured out as rapidly as possible, over which the subject's critical faculty has no control—the subject himself throwing reticence to the winds—and which as much as possible represents spoken thought. It seemed and still seems to me that the speed of thought is no greater than that of words, and hence does not exceed the flow of either tongue or pen. It was in such circumstances that, together with Philippe Soupault, whom I have told about my first ideas on the subject, I began to cover sheets of paper with writing, feeling a praiseworthy contempt for whatever the literary result might be. Ease of

achievement brought about the rest. By the end of the first day of the experiment we were able to read to one another about fifty pages obtained in this manner and to compare the results we had achieved. The likeness was on the whole striking. There were similar faults of construction, the same hesitant manner and also, in both cases, an illusion of extraordinary verve, much emotion, a considerable assortment of images of a quality such as we should never have been able to obtain in the normal way of writing, a very special sense of the picturesque, and, here and there, a few pieces of out and out buffoonery. The only differences which our two texts presented appeared to me to be due essentially to our respective temperaments. Soupault's being less static than mine, and, if he will allow me to make this slight criticism, to his having scattered about at the top of certain pages—doubtlessly in a spirit of mystification—various words under the guise of titles. I must give him credit, on the other hand, for having always forcibly opposed the least correction of any passage that did not seem to me to be quite the thing. In that he was most certainly right.'[17]

This passage shows that Surrealism was above all a question of *poetic* creation, and indeed painting and sculpture were to be conceived as essentially plastic transformations of poetry. In the manifesto Breton goes on to relate how he and Soupault continued and extended such experiments, and how 'in homage to Guillaume Apollinaire', they decided to give the name *Surréalisme* to the new mode of expression which came out of them. He then proceeds in dictionary style to define, 'once and for all time', the word:

'Surrealism, n. Pure psychic automatism, by which it is intended to express, whether verbally or in writing, or in any other way, the real process of thought. Thought's dictation, free from any control by the reason, independent of any esthetic or moral preoccupation.

'ENCYCL. *Philos.* Surrealism rests on a belief in the superior reality of certain forms of association hitherto neglected, in the omnipotence of the dream, in the disinterested play of thought.

JOAN MIRÓ *The Hare. 1927*

It tends definitely to destroy all other psychic mechanisms and to substitute itself for them in the solution of the principal problems of life.'[18]

This definition is broad enough to include all the varied manifestations of Surrealism that appeared in the next twenty-five years (and that still appear, for artists like Max Ernst, Hans Arp, Joan Miró [b. 1893], and many others have never ceased in their work to conform to this original definition of Surrealism). Breton himself, however, was to distinguish two epochs of equal duration in the movement which he describes as follows: 'from its origins (1919, year of the publication of the *Champs Magnétiques*)[19] until today [i.e. 1936]: a purely *intuitive* epoch, and a *reasoning* epoch. The first can summarily be characterized by the belief expressed during this time in the all-powerfulness of thought, considered capable of freeing itself by means of its own resources. This belief witnesses to a prevailing view that I look upon today as being extremely mistaken, the view that *thought is supreme over matter*. The definition of surrealism that has passed into the dictionary, a definition taken from the *Manifesto* of 1924, takes account only of this entirely idealist disposition and . . . does so in terms that suggest that I deceived myself at the time in advocating the use of

an automatic thought not only removed from all control exercised
by the reason, but also disengaged from *"all esthetic or moral
preoccupations"*. It should at least have been said: *conscious* esthetic
or moral preoccupations. . . . No coherent political or social
attitude made its appearance until 1925, that is to say (and it is
important to stress this), until the outbreak of the Moroccan war,
which, re-arousing in us our particular hostility to the way armed
conflicts affect man, abruptly placed before us the necessity of
making a public protest. This protest, which under the title
La Révolution d'Abord et Toujours (October, 1925), joined the names
of the Surrealists proper to those of thirty other intellectuals, was
undoubtedly rather confused ideologically; it none the less marked
the breaking away from a whole way of thinking; it none the less
created a precedent that was to determine the whole future
direction of the movement.'[20]

This new way of thinking was no doubt determined by the
political atmosphere of the 'thirties'; it did not survive, in any
concrete or active sense, the rise of Stalinism. But nevertheless a
permanent dichotomy is present in artistic activity, and Breton
and the Surrealists in general were correct in recognizing its
existence. Breton expressed it in more general terms in a lecture
given in Brussels in 1934:

'In reality two problems exist: one is the problem of know-
ledge raised, at the beginning of the twentieth century, by the
relations between the conscious and the unconscious. We
Surrealists seemed chosen for this problem: we were the first
to apply to its solution a special method, which still appears to
us among the most suitable and capable of perfection: we see
no reason to renounce it. The other problem which presents
itself to us is that of the social action to be adopted—action
which, according to us, has its proper method in dialectical
materialism, action which we cannot forego in as much as we
hold that the liberation of mankind is the first condition for
the liberation of the spirit, and that this liberation of mankind
can only be expected from the proletarian revolution.'[21]

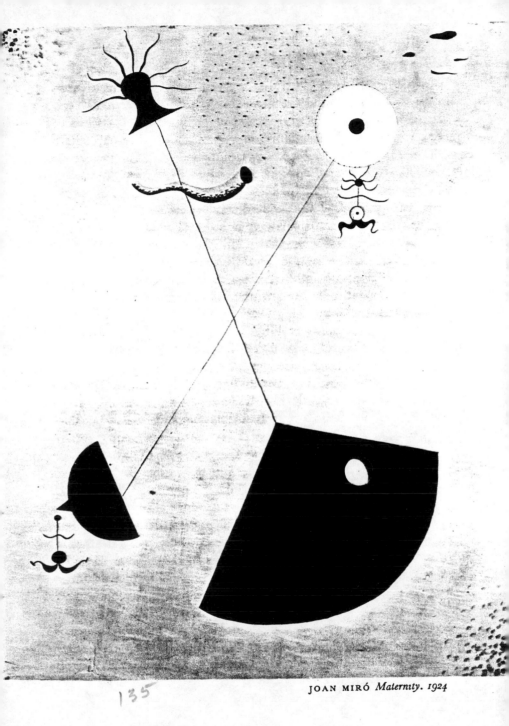

135

JOAN MIRÓ *Maternity.* 1924

In 1929 Breton published the 'Second Manifesto of Surrealism' in the final issue of the magazine *La Révolution Surréaliste*, which had been founded in December 1924, with Pierre Naville and Benjamin Péret as editors. Breton had taken over the editorship from the fourth number, and in the fifth number (October 1925) announced the formal adherence of the movement to Communism. Between the end of 1925 and the beginning of 1930, when a new periodical *La Surréalisme au Service de la Révolution* appeared, a considerable rearrangement of forces took place. In so far as these were poetic or literary manifestations, they are not primarily our concern in this book; in so far as they were political it was always the intention of Breton to align the plastic arts with the literature and politics of the movement. The first number of *La Surréalisme au Service de la Révolution* contained declarations of solidarity with Breton's point of view by Maxime Alexandre, Aragon, Joë Bosquet, Luis Bunuel, Réne Char, Crevel, Dali, Eluard, Ernst, Marcel Fourrier, Camille Goemans, Georges Malkine, Paul Nogué, Benjamin Péret, Francis Ponge, Marco Ristitch, Georges Sadoul, Yves Tanguy, André Thirion, Tzara, and Albert Valentin. Among these names only Salvador Dali (b. 1904),. Ernst, and Yves Tanguy (1900–55) were important as visual artists, though Bunuel was the producer of two films, *Le chien andalou* (1929) and *L'age d'or* (1931), which are Surrealist manifestations of the most typical kind. Though not temperamentally inclined to the political front adopted by Breton, Arp and Miró willingly exhibited with the Surrealists, and new recruits appeared every year—René Magritte (1930), André Masson (1931), Giacometti, Valentine Hugo, Victor Brauner (1933), and groups of Surrealist painters were formed in other countries—the United States, Belgium (Brussels), Czechoslovakia (Prague), Yugoslavia (Belgrade), Denmark, Japan, and even London. Surrealism from the beginning inherited the international character of Dada.

In spite of Breton's precise definitions, and in spite of its various collective manifestoes and programmes, Surrealism, like the previous phases of the modern movement so far reviewed, was a

fluctuating group of individualists. Indeed, two distinct and contradictory tendencies were always apparent: one more specifically Dadaist in derivation and nihilistic in purpose, opposed to all traditional concepts of 'fine art', all purely aesthetic categories; the other, in spite of its originality, still essentially dominated by aesthetic criteria. Some of the artists alternated between both tendencies.

If the first tendency is considered as a continuation, with no abrupt change, of the Dada movement, then the connecting link is Marcel Duchamp, of whom Breton wrote in 1922: 'It is by rallying around this name, a veritable oasis for those who are still *seeking*, that we might most acutely carry on the struggle to liberate the modern consciousness from that terrible fixation mania which we never cease to denounce.' And further: 'the thing that constitutes the strength of Marcel Duchamp, the thing to which he owes his escape alive from several perilous situations, is above all his *disdain for the thesis*, which will always astonish less favoured men'.[22] Both the tendencies mentioned may be said to represent a thesis, for or against a certain conception of the work of art. Duchamp refused to have any preconception at all, and for this reason he could sign and exhibit a manufactured article—even that act of selection could constitute the truth of a personal situation. That act of perception is as much as Duchamp would ever care to affirm, for the situation itself is always a matter of chance.

Duchamp had quickly emancipated himself from the theses of Cubism and Futurism; but Futurism left its traces. 'It is fitting, as a sequel to *Futurism*, to take into account a period of transition, relatively independent and *mechanical* in character (Duchamp, Picabia) which came about as a result of a premeditated identification of man with the machine. . . . The masterpiece of this movement, which surpassed in every way all the explicit intentions of the period, was Duchamp's *La mariée mise à nu par ses célibataires, même.*' Thus Breton.[23] But the 'machinism' of Duchamp and Picabia was never motivated by an acceptance of a machine aesthetic (as later the work of the Constructivists); rather it was a revolt against the machine ethic, against the subordination of

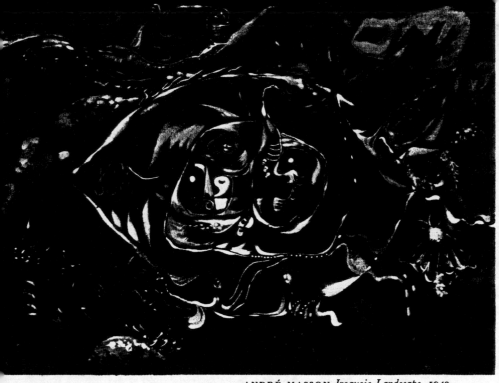

ANDRÉ MASSON *Iroquois Landscape. 1942*

human values to mechanistic values. Duchamp's and Picabia's machines are impious caricatures.

A 'disdain for the thesis' included a disdain of the aesthetic category as such: for to assert any value-judgement of the work of art constitutes a thesis from Duchamp's point of view. This anti-aestheticism was to characterize many of the future manifestations of the movement. The principle of the *collage* was extended to include any assembly of incongruous objects: Kurt Schwitters used the contents of his ash-can and waste-paper basket to make his sculpture and his pictures; Max Ernst made 'visible poems' from clippings taken from old newspapers and books illustrated with steel-engravings; he also invented the 'frottage'—that is to say, designs composed of 'rubbings' of various rough surfaces—in this technique he produced a *Histoire naturelle* (Paris, 1926) which consists of imaginary plants, animals, and other pseudo-organic forms. Even poets could indulge in this form of plastic creation— Breton himself made a number of arbitrary constructions out of

138

PAUL DELVAUX *The Hands. 1941*

waste material. But beauty would keep breaking in, and the most resolute disregard for the conventions of art often resulted in unconscious harmonies. It is obvious now, for example, that the *Merzbilder* of Schwitters are works of exquisite sensibility.

We find this involuntary aestheticism not only in the work of Max Ernst and Schwitters, but more obviously in that of Hans Arp. In 1916 he was making *collages* or constructions with such titles as *Squares arranged according to the law of chance, Objects arranged according to the law of chance.* One can only suppose that the law of chance is identical with the law of beauty, for from the beginning these works show a great degree of plastic sensibility. In an endeavour to explain the contradiction Breton has suggested[24] that there is an inherent connexion between chance, or what he prefers

to call *automatism*, and *rhythmic unity*. 'Recent psychological researches, we know, have drawn a comparison between the construction of a bird's nest and the beginning of a melody tending towards a certain characteristic conclusion. . . . I maintain that *Automatism* in writing and drawing . . . is the only mode of expression which gives entire satisfaction to both eye and ear by achieving a *rhythmic unity*, just as recognisable in a drawing or in an automatic text as in a melody or a bird's nest.'

Arp has continued throughout his career to make two-dimensional constructions, presumably still 'according to the law of chance', but he was gradually drawn towards the three-dimensional art of sculpture, in which he has created forms which seem to illustrate the essential modes of growth and organic function. Perhaps of all the Surrealist artists Arp most deserves the name of Surrealist, for his work reveals those essential modulations of matter due to secret action of natural forces: as water smooths a stone, or the wind moulds the snow-drift, as the pear swells to one kind of perfection and the crystal to another, so Arp has carved and modelled his faultless creations: art, as he has himself said, is a fruit born of man. Breton might add: born of man's unconscious.

The characteristic fruit of Surrealism, however, was not born to Arp, but rather to Max Ernst and to André Masson (b. 1896), to whom Breton attributes the invention of automatism.[25] But once the manifesto of Surrealism had been proclaimed in 1924, it became difficult to award priorities to all those artists who came forward with their personal contributions to a doctrine so all-embracing. Joan Miró emerged from his Spanish farm-yard in 1924; Yves Tanguy from Brittany in 1925; René Magritte (b. 1898) from Brussels about the same time; and finally, in Breton's words, 'Dali insinuated himself into the Surrealist movement in 1929.' Breton's acid account of Dali's contribution to the movement must be quoted in full: 'On the theoretical plane he proceeded thereafter by a series of borrowings and juxtapositions. The most striking example of this was the strange amalgam of two diverse elements to which he gave the name of "Paranoiac-critical activity"; on the one hand the lesson of Cosimo and Da Vinci

WILFREDO LAM *Cor de Pêche. 1946*

(to become absorbed in the contemplation of a blob of spittle or an old wall until there appeared before the eye a second revelation which painting was no less capable of revealing) and on the other various practices—on [*sic*] the order of *frottage*—already advocated by Max Ernst to "intensify the irritability of the mental faculties". In spite of an undeniable ingenuity in staging, Dali's work, hampered by an ultra-retrograde technique (return to Meissonier) and discredited by a cynical indifference to the means he used to put himself forward, has for a long time showed signs of panic, and has only been able to give the appearance of weathering the storm temporarily through a process of systematic vulgarization. It is sinking into *Academicism*—an *Academicism* which calls itself *Classicism* on its own authority alone—and since 1936 has had no interest whatsoever for *Surrealism*.'[26]

Since these words were written (1942) Salvador Dali's work has sunk lower still, cynically exploiting a sentimental and sensational religiosity (his *Last Supper*, loaned to the National Gallery of Art in Washington, is there stage-set for the superstitious). The theatricality, which was always a characteristic of his behaviour,

SALVADOR DALI *Premonition of Civil War. 1936*

is now at the service of those reactionary forces in Spain whose triumph has been the greatest affront to the humanism which, in spite of all its extravagance, has been the consistent concern of the Surrealist movement. Nevertheless, it must be admitted that Dali, largely due to the success of his exhibitionism, has become identified in the public mind with Surrealism, and indeed his 'paranoiac-critical activity' has been sufficiently ingenious, and sufficiently shocking, to excuse this mistaken identification. But it

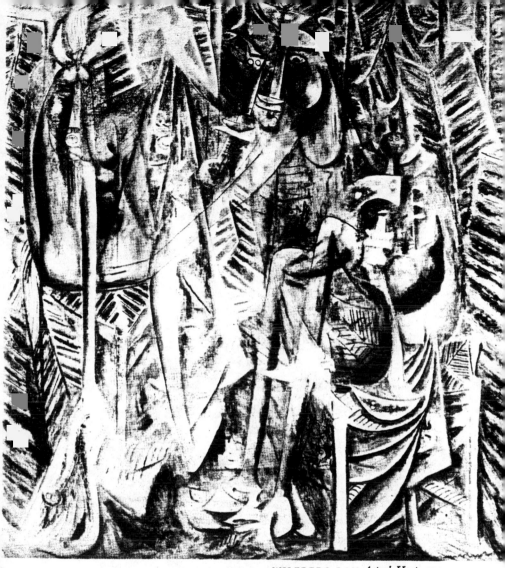

WILFREDO LAM *Astral Harp. 1944*

143

must already be clear that contradiction and ambiguity are inherent in the very concept of 'super-reality', and no one artist, and no group of artists, can represent a territory with such vague boundaries.

Within this vague concept one must include the work of many artists who were never formally associated with the group in Paris, and many who never gave more than a nominal adhesion. Victor Brauner (b. 1903), René Magritte (b. 1898), Paul Delvaux (b. 1898), Wolfgang Paalen (b. 1905), Wilfredo Lam (b. 1902), Kurt Seligmann (b. 1900), Matta Echaurren (b. 1912), Richard Oelze (b. 1900), Jindřich Styrsky (b. 1899), and Vilhelm Bjerke-Petersen (b. 1909) are all painters of widely separated origins who contributed to an emancipation of the visual imagination from the bonds of reason and convention. But this emancipation has been characteristic of the modern movement as a whole, and one has only to consider the work of artists like Picasso, Paul Klee, and Henry Moore to see that the Surrealist movement as such was a local and temporary concentration of forces whose wider manifestations were world-wide and enduring.[27] Much of the work of Picasso, to take his case only, conforms to Breton's definition of Surrealism, and was always annexed, if not conceded, as such. Again our historical categories break down, and Surrealism becomes but one term to characterize one aspect of the complex phenomena of the modern movement. That aspect is still in evidence, not only in the work of those artists like Max Ernst, Miró, Matta, Magritte, Delvaux and Lam, but also in the work of younger artists like Francis Bacon (b. 1909) and Heinz Trœkes (b. 1913) whose work is as 'paranoiacly critical' as any Surrealist could desire. The latest phase of contemporary art, 'action painting' (see page 258 below), also has its origins in Surrealism, and is distinguished by some degree of automatism. Surrealism was always, at the hands of Breton, an heroic effort to contain and define the demonic energies released from the unconscious by automatism and other 'paranoiac' processes. But those energies cannot be contained within a logical definition, and conformism was from the beginning out of the question. The charge that can

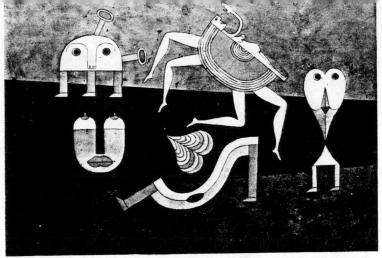

VICTOR BRAUNER *Hermetic Space. 1958*

be made against the Surrealists, and the subtle cause of their final failure to carry through their 'revolution', is that 'they have tried to *force* the unconscious, to conquer by violence secrets that might be revealed more readily to more artless minds. To advance on the path of true mysticism, Christian or not, they have lacked the power, and by this I mean faith, any faith whatsoever; they have lacked perseverance, devotion to something more inward than the self.' Nevertheless, as this same perceptive critic is willing to admit, 'Surrealism in the broad sense of the term represents the most recent romantic attempt to break with "things as they are" in order to replace them by others, in full activity, in process of birth, whose mobile contours are inscribed in filigree in the heart of existence. . . . Poets have long cultivated this tendency to suspect "reality", as their most precious faculty; now it becomes an absolute . . . the essence of the surrealist message consists in this call for the absolute freedom of the mind, in the affirmation that life and poetry are "elsewhere", and that they must be conquered dangerously, each separately, and each by means of the other, because ultimately they coincide and merge and negate this false world, bearing witness to the fact that the chips are not yet down, that everything can still be saved.'[28]

Marcel Raymond reminds us, in this passage and elsewhere in his intelligent book, that the consideration of Surrealism cannot

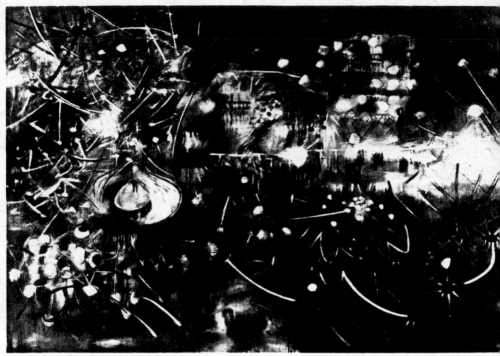

ROBERTO SEBASTIAN MATTA ECHAURREN *To Give Painless Light. 1955*

be confined to its manifestations in painting and sculpture: it was perhaps primarily a poetic movement, but from an historical point of view it was but a passing phase of that romantic movement which has been, and still is, the application of a total 'metaphysical sensibility', exploring without fear the confines of man's fate and destiny. Surrealism is an affirmation of this irreducible freedom. 'Only the word freedom still exalts me,' Breton has declared.[29] 'Among the many disgraces we inherit, we should do well to recognize that the *greatest freedom* of spirit is left to us. We ought not to misuse it. To reduce the imagination to slavery, even when it might lead to what one crudely calls happiness, is to evade whatever one finds, in the depths of the self, of supreme justice. Imagination alone tells me *what can be*, and that is enough to lift for a little the terrible interdict—enough also to allow me to abandon myself to this freedom without fear of self-deception.'[30]

146

Picasso, Kandinsky, Klee

These three artists, who have contributed more than any others to the development of modern art, cannot be assimilated to any particular phase of it. Movements were founded on their discoveries and inventions, but they themselves remained individualists, centres of creative energy influencing movements and even giving birth to them, but not themselves remaining attached to any one school. We have already seen how Picasso, in close association with Braque, initiated the Cubist movement. It cannot be claimed that he initiated the Surrealist movement, but as I have suggested, and as we shall see in more detail, his post-Cubist development cannot be dissociated from the typical manifestations of Surrealism: Picasso was always providing grist for their theoretical mills. As for Kandinsky, it cannot be claimed that he initiated non-figurative art, either in its expressionistic or geometric aspects, but he had the most intelligent prevision of the possibilities that awaited the new epoch, and more precisely than any other individual painter, indicated the likely lines of future development. As for Klee, it might perhaps be claimed that he possessed the supreme intelligence among all artists of the modern epoch, and both in theory and in practice established its aesthetic foundations.

'When you come right down to it, all you have is your self. Your self is a sun with a thousand rays in your belly. The rest is nothing.' Picasso said this in 1932 in a conversation with E. Tériade, while he was supervising the hanging of his pictures in a retrospective

exhibition held that year in Paris.[1] Picasso gave Matisse as an example of an artist to whom his aphorism would apply, but as he looked round the exhibition he must have had himself in mind, and it remains the best description of his talent. There is a single glowing centre of energy, and each of the rays that spread outwards from it represents a different aspect of his style. Apart from saying that the style is always the man himself, one cannot usefully distinguish these thousand rays one from another. They merge into one another as they approach the burning source, and it is only their more obvious aspects, which are farthest from this centre, that can be separated and named. We may distinguish these superficial characteristics as Cubist or Classical, Realist or Surrealist, but then we are faced with Classical drawings that are Surrealist in intention, or with Surrealist compositions of Classical serenity. Style and significance continually overlap and contradict each other.

Equally any attempt at a chronological classification is soon defeated, for no period is a closed period, confined to one style. It is true that there are short periods at the beginning of his career when the artist seems for a while to maintain some consistency of mood—the Blue period of 1901–4 and the Rose period of 1904–6 —so called from the predominant colour in the paintings of each period. But within even these periods there are considerable variations of style—*La belle Hollandaise* of 1905, for example, has a grey solidity which contrasts strongly with the effete delicacy of the *Mother and Child* of the same year. Cubism was a consistent passion with Picasso for about five years, but it was an exploratory passion and every canvas revealed new possibilities, new variations of the dominant idiom. Once all these possibilities had been explored, but not abandoned, Picasso suddenly in 1915 reverted to a most precise and subtle realism; but again with no set intention, for he alternated his classical portraits and groups with new variations of his Cubist style, his realistic still-lifes with geometrical abstractions derived from the same *motif*. One could conceivably arrange a thousand works of Picasso in an order beginning with the academic exercises of his youth and passing through the various modes of realism until one came to geometrical compositions like

The Table of 1919–20 (Smith College Museum of Art, North-ampton, Massachusetts), and there would be no abrupt change between any two contiguous paintings. But the significance of this fact would not be fully appreciated until it was realized that the stylistic transitional order corresponded in no way with the chronological sequence. Each ray had been emitted from the sun in the artistic belly at a different date in a different direction.

We must, however, make some attempt to record these kaleido-scopic changes. From 1914 onwards the following phases have been distinguished:[2]

1914: Further development of Cubism in a 'rococo' direction. Enrichment of colours, exploitation of materials and textures other than oil-paints.

1915–16: Bold linear Cubism, large compositions.

1915–21: Classical realism, mostly pencil drawings in the style of Ingres. (*Two Seated Women*, 1920, Walter P. Chrysler, Jr., Collection).

1918–25: Mannerism, distortions and elongations of the human form (The two versions of *Three Musicians* [*p. 154*], Museum of Modern Art; Philadelphia Museum of Art).

1920–24: These two styles merge into a neo-Classic style which is resumed at intervals throughout the rest of Picasso's career.

1924–28: Period of large Cubist still-life compositions.

1923–25: Development of a 'curvilinear cubism'.

1925: Beginning of Picasso's Surrealist phase (with the *Three Dancers* of 1925 [*p. 155*]). Barr avoids the word 'Surrealist' and substitutes epithets like 'convulsive', 'disquieting', and 'metamorphic', but Picasso's work from this year onwards illustrates the Surrealist thesis, and there can be no doubt that he had been im-pressed, not only by the theoretical writings of Breton and his colleagues, but also by the work of artists like Arp, Miró, and Tanguy.

1928–33: Sculptures beginning with metal constructions, but developing towards heads cast in bronze.

1929–31: Monumental archetypes, such as *Woman in an Armchair* (versions of 5 May and 13 May 1929) and the *Standing Bather* and *Seated Bather* of 1929 and the *Figure throwing a Stone* of 8 March 1931. But this style also continues throughout the rest of Picasso's career: cf. the *Girls with a Toy Boat* (1937) in the Peggy Guggenheim Collection, Venice; *The Rape of Europa* (1946); and the *Nude* of 1949 (cf. Boeck-Sabartés, Classified Catalogue No. 213).

1931–34: Period of renewed sculptural activity.

1932–34: Series of large canvases of women in a curvilinear style.

1937: (May–June) The painting of *Guernica*.

1938–40: Period of large, vigorous and sculpturesque compositions. *Night Fishing* (1939).

1940–44: The war period in Paris: return to flat, two-dimensional compositions; return to synthetic Cubism. Revival of sculptural activity.

1945: Post-liberation exuberance.

1946–48: Idyllic interlude at Antibes. *La joie de vivre* (1946); *Pastorale* (1946).

1948–54: Ceramics at Vallauris.

Such a chronological sequence has about as much value as a guide to a jungle; rather we should try to determine whether among these vacillating phases of Picasso's manifold activity we can discover any stylistic unities that have contributed to the general development of art in our time. That Picasso has been the most influential artist of the first half of the twentieth century is obvious, but not all influences are good influences, and indeed for an age to be dominated by the idiosyncrasies of a single personality is a sign of weakness. The example of Michelangelo in the past is a melancholy witness to this fact.

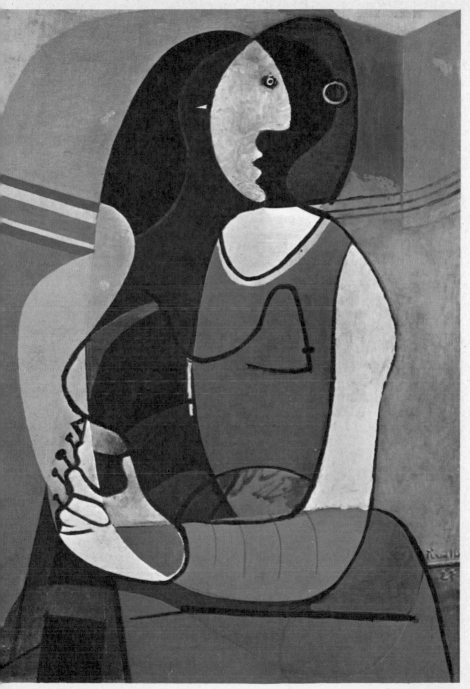

PABLO PICASSO *Seated Woman. 1927*

One obvious stylistic unity that can be separated from Picasso's prodigious output is the archaicizing neo-Classicism to which he has reverted at frequent intervals. In so far as this constitutes a certificate of academic competency ('after all, Picasso can draw!') this may have been more than paradoxical: it may have created an executive standard by which all contemporary experiments must be judged. An experimental period in the arts is harvest-time for the charlatan. Some of Picasso's mannerisms can be imitated very convincingly—he has himself made mistakes of identification. But only a Picasso could have drawn the illustrations he made for the Skira edition of Ovid's *Metamorphoses* (1931), or the series of etchings known as *The Sculptor's Studio* (1933).

From the point of view of his own personality, we can regard Picasso's periodic return to neo-Classicism as a return to order, as an occasional submission to a necessary discipline, or simply (and most probably) as a refreshing display of virtuosity. One has only to watch Picasso drawing (in one of the films that have shown him in action) to see how instinctive and effortless the activity is in his case. There is no deliberation, no anxiety: merely a hand that moves as naturally as a bird in flight. Such ease may be a product of early training, but it is also an innate gift; other artists have had a similar training but do not arrive at the same degree of skill. This style, therefore, is personal to the artist, but at the same time it is universal. As a linear idiom it does not differ from the drawings on Greek vases, the engravings on Etruscan mirrors, or even the prehistoric drawings on the walls of the Altamira caves. Only in so far as Picasso introduces manneristic distortions of the *motif* into them can his neo-Classical drawings be said to have any relevance to the modern movement.

Nevertheless, the same calligraphic instinct functions in drawings which are not neo-Classical: is, indeed, present in every line and brush-stroke of his work.

As for the main body of this work, it falls into two main groups which again merge into each other, but at their extremes can be distinguished, in the manner already indicated, as imaginative and fantastic. 'I don't work *after* nature, but *before* nature—and

PABLO PICASSO *Sculptor at Rest, Reclining Model and Sculpture, 1933*

with her' is another of Picasso's gnomic utterances.[3] *Before* nature might indicate an intuitive awareness of symbolic form; *with* nature (as distinct from *after* nature) the endowment of such symbolic forms with a natural vitality. That, at any rate, is the distinction I propose to make to characterize the two main post-Cubist divisions of Picasso's work.

Alfred Barr has already emphasized the significance of the large oil-painting of 1925, *Three Dancers*, still in the artist's possession, and has contrasted it with the two versions of the *Three Musicians* of 1921, and the neo-Classical *Three Graces* of 1924 (also still in the artist's possession). These three paintings are indeed the proto-types of the three categories into which Picasso's work may be divided. 'Instead of static, mildly cubist decoration', writes Mr Barr, 'the *Three Dancers* confronts us with a vision striking in its physical and emotional violence. Seen objectively as representations of nature, cubist paintings such as the *Three Musicians* of 1921 are grotesque enough—but their distortions are comparatively

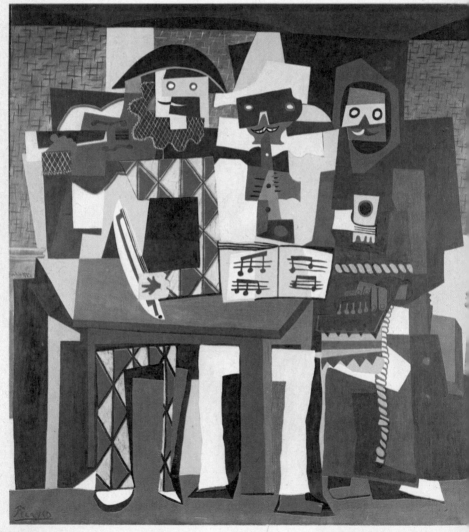

PABLO PICASSO *Three Musicians. 1921*

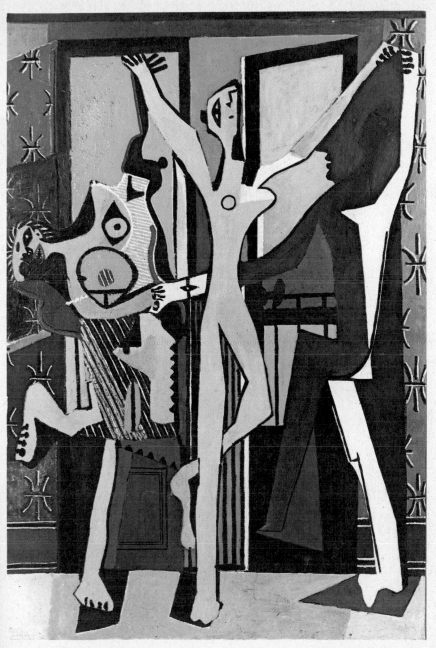

PABLO PICASSO *Three Dancers. 1925*

objective and formal whereas the frightful, grinning mask and convulsive action of the left-hand figure of the *Three Dancers* cannot be resolved into an exercise in esthetic relationships, magnificent as the canvas is from a purely formal point of view. The metamorphic *Three Dancers* is in fact a turning point in Picasso's art almost as radical as was the proto-cubist *Demoiselles d'Avignon*. The convulsive left-hand dancer foreshadows new periods in his art in which psychologically disturbing energies reinforce or, depending on one's point of view, adulterate his ever-changing achievements in the realm of form.'[4]

The compositional distinction between the *Three Musicians* (either version) and the *Three Dancers* is that the former is a calculated rearrangement (Kandinsky would say 'a constructive dispersal') of fragmented and geometricized images derived from the *motif*, whereas the latter is, to use Alfred Barr's term, a *metamorphosis* of the *motif* itself. But these terms are inadequate, and even misleading. Calculation, as we shall see when we come to discuss Kandinsky's early experiments, does not necessarily imply a conscious process of selection and adjustment: the arrangement of the elements within the picture-space remains intuitive. But these elements are derived from the *motif* by calculable or explicable stages. The cubic visages of the musicians are still frontal; their eyes are in the same plane, their limbs and musical instruments conform to a rational order, however dislocated. But in the *Three Dancers* the dislocation of the naturalistic elements—eyes, breasts, limbs—is no longer rational or calculable. Eyes are shifted to the side of the head, a breast is transformed into an eye, and for the first time the composite image (of side and frontal views of the face) appears. The 'order' of the *Three Musicians* no longer prevails; instead the elements of the painting display a convulsive energy which seems to burst out of the boundaries of the canvas.

The *Seated Woman* of 1926-7 (Museum of Modern Art, New York) and the related *Seated Woman* of 1927 [*p. 151*] (James Thrall Soby Collection) developed this new 'metamorphic' tendency to a more marked degree. Three simultaneous images of the woman seem to be combined, and the dislocation of eyes, mouth, and

breasts is arbitrary, though still 'with' nature in the sense that these features remain vital and not abstract. But Picasso quickly exploited this new tendency to further extremes, best typified by the bronze *Figure* of early 1928. In this year he made a series of drawings in which the human figure is subjected to extreme degrees of metamorphosis, the head becoming a pin-head, the limbs merging into flaccid breasts, eyes and mouth inserted in arbitrary positions. Mr Barr suggests that he may have taken hints from the metamorphic figure paintings of his friend, Joan Miró, or the early paintings of Yves Tanguy. Whether this is true or not, it does indicate that Picasso had passed beyond his Cubist

PABLO PICASSO *Four Children viewing a Monster.* c. *1933*

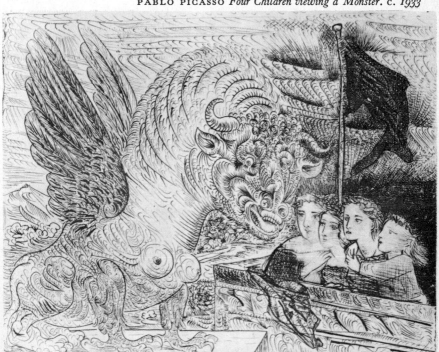

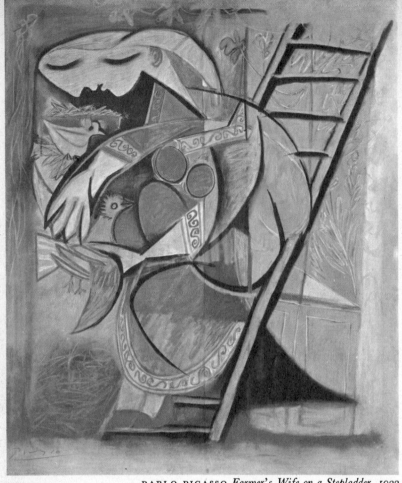

PABLO PICASSO *Farmer's Wife on a Stepladder. 1933*

and neo-Classical styles where the images are personal and had now entered a realm of fantasy where the images are archetypal or generic. The presentation of such images is still highly individual—line and colour are still the signature of the man himself. But the symbols are projected from that psychic depth which C. G. Jung has called the collective unconscious and their collectivity guarantees their validity. From this point of view the Surrealists were right to insist on the autonomous and anonymous content of this new kind of art.

From 1926 onwards Picasso did not cease to cultivate his unconscious—to watch objectively, as Jung has put it, the

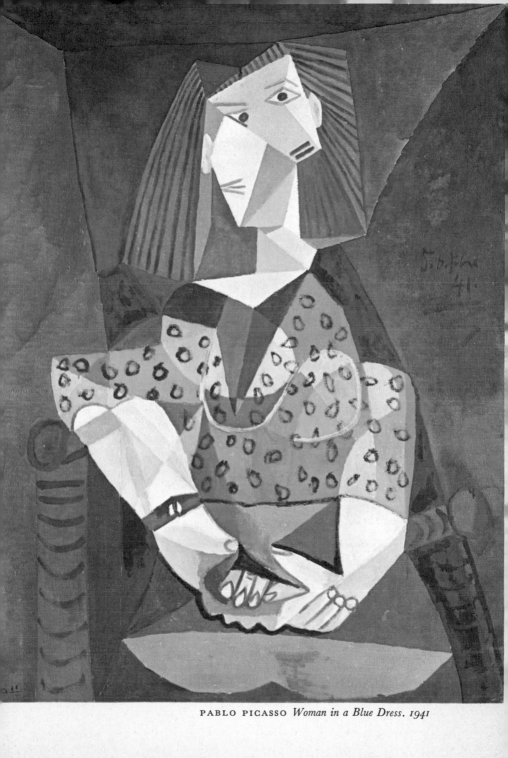

PABLO PICASSO *Woman in a Blue Dress*. 1941

development of any element of fantasy. It would not be appropriate to discuss on this occasion the psychological significance of the imagery proliferated by Picasso in this phase of his work. Picasso himself is not necessarily aware of its significance, though he is by no means ignorant of the role of symbolism in the history of art. But one may say quite briefly that the imagery is archetypal—that it is an iconography of sex and fertility, of birth and death, of love and violence, such as we find in all great epochs of art. To reveal the significance of the symbols is not a useful activity: they remain most potent in their secret integrity. They come from the unconscious and speak to the unconscious. We unrobe them at our peril.

This caution applies to a masterpiece like *Guernica* no less than to the minor works in this mode. *Guernica* is a proof, if one were needed, that Picasso is a socially conscious artist—painting, he has said, 'is an instrument of war for attack and defence against the enemy'. His statement on this subject, written for Simone Téry and first published in *Lettres françaises* (Paris), 24 March 1945, cannot be too often recalled: 'What do you think an artist is? An imbecile who has only his eyes if he's a painter, or ears if he's a musician, or a lyre at every level of his heart if he's a poet, or even if he's a boxer, just his muscles? On the contrary, he's at the same time a political being, constantly alive to heartrending, fiery or happy events, to which he responds in every way. How would it be possible to feel no interest in other people and by virtue of an ivory indifference to detach yourself from the life which they so copiously bring you? No, painting is not done to decorate apartments. It is an instrument of war for attack and defence against the enemy.' The enemy, as he has made clear on several occasions, is the man who exploits his fellow human beings from motives of self-interest and profit. More generally, one must fight everything that threatens the freedom of the imagination, and in this respect Picasso has always subscribed to the political programme of the Surrealists. But *Guernica* is, of course, more than a document of the Spanish Civil War. It was painted as an immediate reaction to the news of the destruction by German

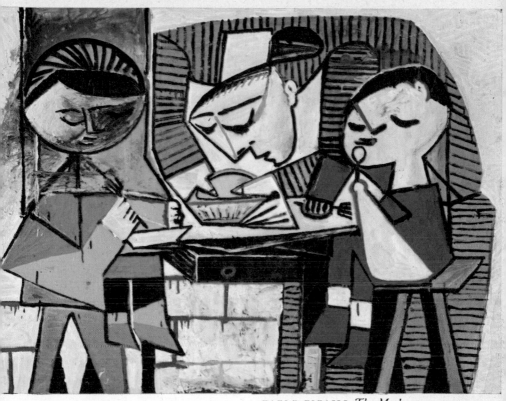

PABLO PICASSO *The Meal. 1953*

bombers of the Basque town of Guernica (28 April 1937). It
was painted with passion and with conviction (a fact more obvious
in the many preparatory drawings and studies); nevertheless, it is
not wholly unrelated to previous works of Picasso's, notably the
Minotauromachy etching of 1935. But this similarity may be ex-
plained by unconscious factors rather than as a deliberate use of
the same symbols (the bull, the horse, the figure holding up a light).
Either the same archetypal symbols emerge automatically from the
unconscious, or they are part of a necessary language of symbols.
But the symbols, as has often been pointed out, are not wholly free
from ambiguity[5]—does the bull represent the concept of violence,
or the dictator Franco and his military caste, and how can the

miserable disembowelled horse worthily represent suffering humanity? Picasso himself is reported to have said that 'the bull is not fascism, but it is brutality and darkness . . . the horse represents the people . . . the *Guernica* mural is symbolic . . . allegoric. That's the reason I use the bull, the horse, and so on. The mural is for the definite expression and solution of a problem and that is why I used symbolism.'[6] One must defer to the artist's interpretation of his own work, but it will be noted that he insists on the generic nature of the symbolism. At the time of its first exhibition I called these symbols used in *Guernica* 'commonplace', but added 'it is only when the widest commonplace is infused with the intensest passion that a great work of art, transcending all schools and categories, is born'.[7] *Guernica*, twenty years later, has not lost its monumental significance.

It is impossible within the scope of this volume to detail all the icons present in Picasso's symbolic discourse. At its most legible in works like *Guernica* or *Minotauromachy*, or the *War* and *Peace* allegories of 1952, symbolism is still present when he paints a *Girl with a Cock* (1938) or *La joie de vivre* (1946). Most of his portraits have symbolic elements in them, for he seeks the man behind the mask, or rather the unconscious forces that mould the mask. He paints one of his own children, but it is as symbolic as a child in a medieval painting of the Virgin and Child. But these smaller symbolic works merge imperceptibly into those paintings, equally numerous, that are innocent and gay, happy discoveries of some aspect of the infinite variety of nature, in landscape, fruit, flowers or the human body, and that together constitute the third category of Picasso's work. It is not only his incomparable innate talent that establishes Picasso's greatness, but also the all-inclusive range of his sensibility and vision, and an inexhaustible power of transformation, receiving all and giving all in endless and engrossing interchange.

Very few of his contemporaries have been able to resist the impact of such a creative force, and indeed why should they? In many cases the influence has led to imitation, but plagiary is not the most profound effect of a genius like Picasso. This is to be

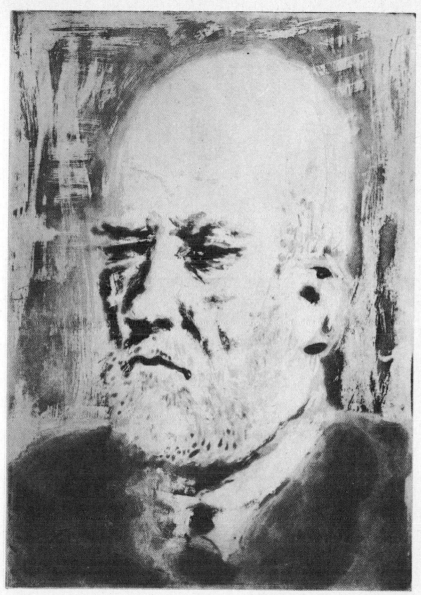

PABLO PICASSO *Portrait of Vollard I. c. 1937*

GEORGES BRAQUE *Mandolin, Glass, Pot and Fruit. 1927*

found in the inspiration of his method and the example of his courage. Sculptors like Jacques Lipchitz or Henry Moore may at first have been influenced in the superficial sense: they may have transformed the forms of Picasso's invention. But this apprenticeship released the doors of their own perceptions and intuitions, and once they had discovered the method, they could (indeed, by virtue of the reality of the process, had to) establish their own manner. It was the older painters, Picasso's own contemporaries such as Braque and Léger, who from their established strength could best resist his innovations. It is true that from about 1929 to 1931 Braque is conscious of Picasso's new trend, and introduces double-profiles and other organic distortions, but without conviction. He adopted the 'curvilinear cubism' of 1923–4, but with a decorative intention; and henceforth this artist, shading himself from the sun in Picasso's belly, cultivated his own perfect but restricted plot.

WASSILY KANDINSKY *Composition No. 2. 1910*

Wassily Kandinsky has already been mentioned in connexion with the origins of both Cubism and Expressionism (see pages 94 and 56), but only in retrospect does his contribution to the history of modern painting acquire its full significance. As a painter, as a creative genius, he may seem far more limited than Picasso; but he was more than a painter—he was a philosopher and even a visionary. After a period of experiment he made his decisions and pursued his precise aims. His work has a coherence comparable only to Léger's or Klee's; his influence has been far greater than is often acknowledged. It is more active today than it was in his lifetime.

Kandinsky was born on 4 December 1866, which is fifteen years before Picasso, and we should perhaps note for whatever significance it may have that his father's family came from Siberia, and that his father was actually born at Kjachta near the Chinese frontier. One of his great-grandmothers was an Asiatic

princess. His mother's family, however, came from Moscow, where Kandinsky himself was born.

Kandinsky's first intention was to be a musician—another significant fact, to be repeated in Klee's life. But at the age of twenty he went to Moscow University to study law and economics, and during this period made his first contact with the ancient art of Russia. He used to insist that the profound impression made on him by the medieval icons of Russia influenced the whole of his artistic development. Another early influence was the folk-art of Russia, with which he became familiar in the course of an ethnographic survey which he made in the northern provinces in 1889. In this same year he studied the old masters in Moscow and St Petersburg and made a first visit to Paris. He returned to the French capital again in 1892. In 1893 he took his degree in law at Moscow University.

In 1895, in his twenty-ninth year, he saw for the first time an exhibition of the French Impressionists, and that experience was decisive. He abandoned his legal career and the next year went to Munich to study painting. Three years later, in 1900, he received his diploma from the Royal Academy in Munich.

Some of his subsequent activities have already been recorded in connexion with the origins of Expressionism (see page 64). One should note as significant that he spent the autumn of 1902 in Paris, the winter of 1902–3 in Tunisia, and then settled in Rapallo (Italy) for more than a year. He next moved to Dresden, but was again in Paris early the following year (1906), and there (or rather at Sèvres near Paris) he remained for a year. In 1907 he went to Berlin for some months and finally in 1908 returned to Munich where he was to settle for the next six decisive years.

Kandinsky had packed a lot of experience into these twelve years of wandering apprenticeship, and by the time he reached Munich in 1908 his painting had already gone through several stylistic phases, from the academicism he learned at the Academy under Franz Stuck, through successive degrees of eclecticism (folk-art, impressionism, post-impressionism) until now, at the age of thirty-four, he felt that the time had come to consolidate his

WASSILY KANDINSKY *Composition. 1911*

experiences and to formulate his intuitions of the possibilities
of the art of painting, possibilities which had entered his mind
and vision that day, twelve years earlier, when he had first seen
a painting by Monet.

What else had he seen in those twelve years? Cézanne, of course,
and the Fauves—whatever there was to see in the Paris of 1902–6.
In that period he became a Fauve himself, but once back in
Munich he began to follow his own instincts and the result was a
complete emancipation from the influences that had hitherto
dominated him. In his book, which we will presently consider in
more detail, he refers to Matisse as 'the greatest of the young
Frenchmen', and to Picasso as 'another great young artist in
Paris', in whose work 'there is never any suspicion of conventional
beauty'. 'Matisse—colour. Picasso—form. Two great signposts
pointing towards a great end.'

When the war broke out in August 1914, Kandinsky fled from
Munich and made his way back to Moscow via Switzerland. He

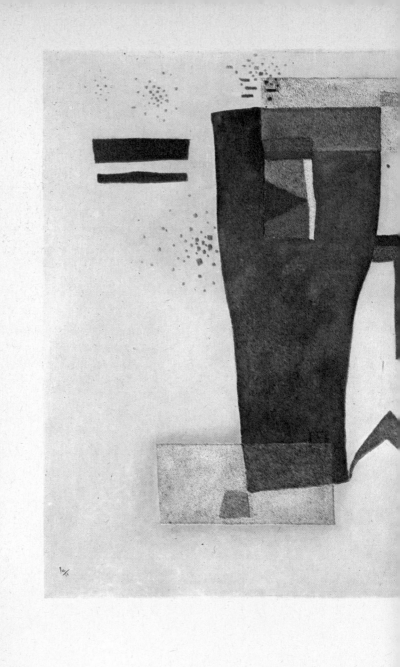

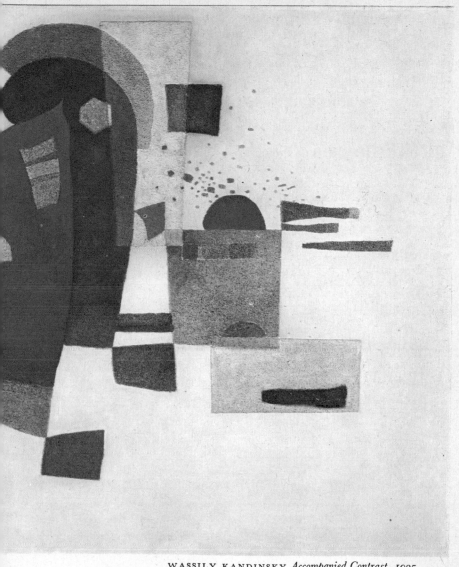

WASSILY KANDINSKY *Accompanied Contrast. 1935*

left behind him a collection of experimental work which by chance was preserved intact, and it is now in the Städtische Galerie of Munich. This material shows that Kandinsky for about two years after his return to Munich was still anchored to the *motif*, usually a landscape, and that his extremist variations were still organic in feeling. Then, according to Lorenz Eitner who has published an interesting study of this material,[8] there occurred a sudden break-through to non-objective painting, that is to say, to an art emancipated from the *motif*. 'The increasing abstraction in Kandinsky's landscapes and figure compositions does not lead to it directly, nor is it the gradual emancipation of colour from descriptive meaning that brings it about. Totally non-objective shapes are found first in studies of primarily graphic character rather than in colour compositions. The Münter Collection includes several such drawings in pen and ink or in pencil. Their criss-crossing lines, some spidery and sharp, some softly blurred, shoot across the paper singly or in tangles, like the traces of sudden energy discharges, suggestive only of motion or tension, not of body.'[9] This may sound like mere doodling, but the evidence shows that all these seemingly fortuitous strokes or blotches were painstakingly formulated, repeated, and perfected. It was a calculated informality.

Kandinsky's historic treatise, which has already been mentioned, was written during the year 1910 (though it was not published until January 1912) and is the first tentative justification of a non-objective art. I call it 'tentative' because Kandinsky did not at the time seem fully aware of the possible consequences of his theory, though he does state his conviction that mankind was moving towards a completely new epoch in the .history of art. Nevertheless, the originality and prophetic vision of this treatise should be fully appreciated. It was the first revelation of a new artistic faith.

To understand Kandinsky's theory of art it is essential to understand first his conception of the work of art. In an article which appeared in *Der Sturm* (Berlin) in 1913, he gives a definition which, if a little clumsy, is nevertheless clear:

'A work of art consists of two elements, the inner and the outer. The inner is the emotion in the soul of the artist; this emotion has the capacity to evoke a similar emotion in the observer.

'Being connected with the body, the soul is affected through the medium of the senses—the felt. Emotions are aroused and stirred by what is sensed. Thus the sensed is the bridge, i.e. the physical relation between the immaterial (which is the artist's emotion) and the material, which results in a work of art. And again, what is sensed is the bridge from the material (the artist and his work) to the immaterial (the emotion in the soul of the observer).

'The sequence is: emotion (in the artist)→the sensed→the art work→the sensed→emotion (in the observer).

'The two emotions will be like and equivalent to the extent that the work of art is successful. In this respect painting is in no way different from a song: each is communication. . . .

'The inner element, i.e. the emotion, must exist; otherwise the work of art is a sham. The inner element determines the form of the work of art.'[10]

This definition of 'the work of art' is probably based on a comparison, more or less unconscious, of painting and sculpture to music, which had been Kandinsky's own first art. *Concerning the Spiritual in Art* has many references to music, including the then modern composers Debussy and Schönberg ('almost alone in abandoning conventional beauty and in sanctioning *every* means of expression').

On the basis of such a definition of the work of art Kandinsky proceeds to argue that form and colour in themselves constitute the elements of a language adequate to express emotion; that just as musical sound acts directly on the soul, so do form and colour. The only necessity is to compose form and colour in a configuration that adequately expresses the inner emotion and adequately communicates it to the observer. It is not essential to give form and colour 'an appearance of materiality', that is to say, of natural

objects. Form itself is the expression of inner meaning, intense in the degree that it is presented in harmonic relations of colour. Beauty is the successful achievement of this correspondence between inner necessity and expressive significance. In his final summary Kandinsky does not hesitate to take up the musical analogy: great works of plastic art are symphonic compositions, in which the melodic element 'plays an infrequent and subordinate part'. The essential element is one of 'poise and the systematic arrangement of parts'.

Kandinsky ends his treatise with a distinction between three different sources of inspiration:

(1) A direct impression of outward nature. This I call an *Impression*.
(2) A largely unconscious, spontaneous expression of inner character, of non-material (i.e. spiritual) nature. This I call an *Improvisation*.
(3) An expression of a slowly formed inner feeling, worked over repeatedly and almost pedantically. This I call a *Composition*. In this reason, consciousness, purpose play an overwhelming part. But of the calculation nothing appears, only the feeling.

From the first of these sources flowed Kandinsky's own work up to 1910—his 'fauvist' paintings.

From the second of these sources flowed the expressionistic abstractions of 1910–21.

From the third of these sources flowed the constructive abstractions of 1921 and later.

The Improvisations of Kandinsky are the forerunners of the informal art of the present day (1945 and onwards); the Compositions are the forerunners of the Constructivist art whose intricate development I shall try to trace in the next chapter.

Kandinsky remained in Russia until 1921, preoccupied after the Revolution with the reorganization of the Academy of Fine Arts, the art schools and museums. When the cultural reaction came in 1921, he left for Berlin, arriving there at the end of the

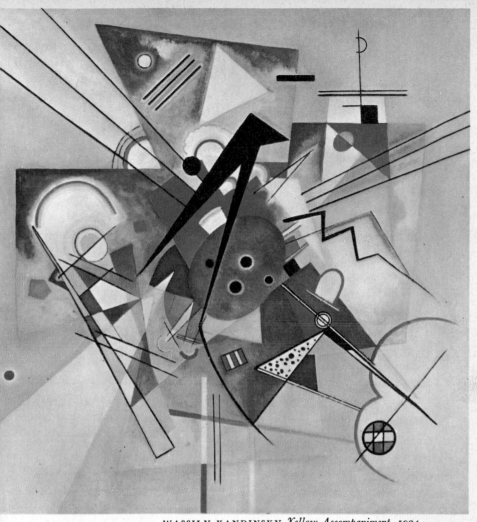

WASSILY KANDINSKY *Yellow Accompaniment. 1924*

year. Six months later he accepted an invitation from Walter
Gropius to join in the formation of a Bauhaus (school of design)
at Weimar, and out of his pedagogical experiences came his
second important treatise, *Point and Line to Plane*, written in 1925
and published in Munich the following year. In this book the
tendency merely announced at the end of *Concerning the Spiritual
in Art* is made quite clear. As Dr Carola Giedion-Welcker has
said, 'the book no longer stresses the gospel of a new inner universe
with the same almost religious fervour; it expounds, often with a

minute and quite scientific rigor, a new formal theory of the elements of drawing, the base of which, however, is always the same notion of an "irrational and mystical" spiritual unity. "Modern art can be born only where signs become symbols." Point and line are here detached from all explanatory and utilitarian purpose and transposed to the realm of the a-logical. They are advanced to the rank of autonomous, expressive essences, as colours had been earlier.'[11]

The later paintings (1925–44) serve to illustrate this final phase of his work, in which his symbolic language has become wholly concrete or objective, and at the same time transcendental. That is to say, there is no longer, and deliberately so, an organic continuity between the feeling and the symbol which 'stands for' it; there is rather a correspondence, a correlation. In liberating the symbol in this way, Kandinsky created an entirely new form of art, and in this respect was more revolutionary than Klee, whose symbols are an organic development of his feelings, flowers which have stems and roots in his individual psyche. To a certain degree sensibility itself became suspect to Kandinsky; at least, he insisted on the distinction that exists between the emotion in the artist to be expressed, which is personal, and the symbolic values of line, point and colour, which are impersonal. In painting, he might have said, one is using a universal language, as precise as mathematics, to express, to the best of one's technical abilities, feelings that must be freed from what is personal and imprecise. It is in this sense that works of art would in the future be 'concrete'.

In 1924 Kandinsky formed a group with Klee, Feininger, and Jawlensky, which was called *Die Blaue Vier* (the blue four), and exhibitions of their work were held in Dresden and Wiesbaden, but in general he exhibited alone. He had no considerable exhibition in Paris until 1929, but when the Bauhaus was closed by the Nazi government in 1932, after a few months in Berlin, he went to Paris to remain there for the rest of his life. There he became a French citizen and found sympathetic fellow-artists in Alberto Magnelli, Miró, Delaunay, Arp, and Antoine Pevsner, and his influence, too long confined to Eastern Europe, began to penetrate

LYONEL FEININGER *Mellingen. 1919*

far and wide. But an art so transcendental as Kandinsky's, so 'calculated' and objective, is not easily assimilated. Who are the disciples of Kandinsky? They are those artists, and they are now numberless, who believe that there exists a psychic or spiritual reality that can only be apprehended and communicated by means of a visual language, the elements of which are non-figurative plastic symbols.

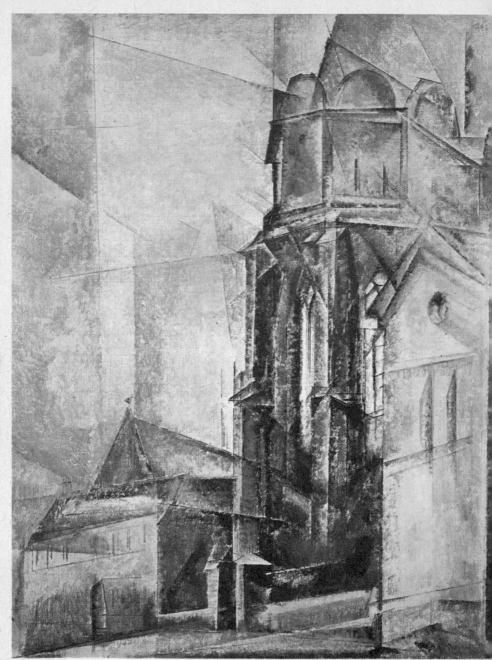

LYONEL FEININGER *East Choir of Halle Cathedral. 1931*

Paul Klee (1879–1940), the third of the great individualists of the modern epoch, was even more undeviating in his development than Kandinsky. Born in Switzerland (at Münchenbuchsee, near Berne), his talent was formed in the stillness of the countryside. This talent was at first manifested in music, and all his life Klee remained an accomplished violinist. But at the age of nineteen he went to Munich and after a short period of preliminary training under Erwin Knirr, followed Kandinsky's example and joined the class of Franz Stuck at the Academy. He does not seem to have met either Kandinsky or Jawlensky (who was also there) until much later (1911). In the autumn of 1901 he went to Italy, where he travelled widely for several months, and was instinctively attracted to Leonardo, Michelangelo, Pinturicchio (the frescoes in the Vatican), and Botticelli. But more significant, perhaps, was his perception that the frescoes of Hans von Marées in the Aquarium at Naples were 'very close to my heart'; and he was equally fascinated by the marine animals there.

Klee returned to Berne in May 1902, already conscious of his purpose and his limitations: 'I have to disappoint at first,' he

PAUL KLEE *Heads. 1913*

wrote at this time. 'I am expected to do things a clever fellow could easily make. But my consolation must be that I am much more handicapped by my sincerity than by any lack of talent or ability. I have a feeling that sooner or later I'll arrive at something valid, only I must begin, not with hypotheses, but with specific instances, no matter how minute. For me it is very necessary to begin with minutiae, but it is also a handicap. I want to be as though newborn, knowing absolutely nothing about Europe; ignoring facts and fashions, to be almost primitive. Then I want to do something very modest, to work out by myself a tiny formal *motif*, one that my pencil will be able to encompass without any technique. . . . So far as I can see, pictures will more than fill the whole of my lifetime . . . it is less a matter of will than of fate.'[12]

The whole character of Klee's work is foreshadowed in this modest statement, but one should realize that to be as if newborn is not a modest ambition: it is the essential mark of genius. Klee's self-awareness did not prevent him from absorbing certain influences, notably (according to Grohmann) Blake, Goya, and Corot. In 1905 he made his first journey to Paris, where once again it was the old masters, Leonardo, Rembrandt, and Goya, who impressed him most. It was not until his second visit to Paris, in 1912, that he made any effective contact with the work of contemporary French painters such as Braque and Picasso. But meanwhile two exhibitions of Van Gogh's work which he saw in 1908 came as a revelation to him; and in the same year or the next he became acquainted with the work of James Ensor, so close to his own visionary fantasy, and made his first approach to the work of Cézanne, who throughout many years was to be for Klee, in technical matters, *un point de repère*.

It was in 1911 that Klee made his most fruitful contacts with his contemporaries. In this year he met, not only Kandinsky and Jawlensky, but also Franz Marc, Heinrich Campendonk, Gabriele Münter (who was to preserve Kandinsky's work of this time), and Hans Arp. He immediately perceived that Kandinsky and Marc were working in the same direction, and when these two artists issued a publication, *Der Blaue Reiter*, and began to organize

PAUL KLEE *The Boat passes the Botanical Gardens. 1921*

exhibitions under this title, Klee joined them and took a modest part in their activities. It was at this time that the influence of Delaunay, which I have already mentioned (see page 94) began to play an important part in Klee's development. His translation of Delaunay's essay 'On Light' was published in the periodical *Der Sturm* in January 1913.

By this time Klee had found himself and his style, and in the thirty years that were to follow he drew and painted with unfailing zeal. In February 1911 he began to keep a catalogue of all he did; including the few retrospective entries which he made for the earlier years, this accounts for nearly 9,000 individual works, beginning with a preponderance of pen or pencil drawings, but gradually making way for drawings in colour or oil-paintings.

The consistency of Klee's development makes it unnecessary to follow it in detail in a general survey of modern painting, but there are three events in his life which perhaps had a decisive effect on his work. The first was a journey to Tunis in 1914, in the company of Macke and a Dr Jäggi from Berne. It lasted only seventeen days, but the experience of the light and colour, 'the concentrated essence of the Arabian Nights', penetrated deeply into Klee's consciousness. 'Colour has taken hold of me; no longer do I have to chase after it. I know that it has hold of me for ever. That is the significance of this blessed moment. Colour and I are one. I am a painter.'

The war broke out that year and Macke was one of its first victims—he was killed on 16 August, and Klee was profoundly shocked. At the beginning of 1915 he recorded in his diary these significant words: 'The more horrifying this world becomes (as it is these days) the more art becomes abstract; while a world at peace produces realistic art.' A year later, on 4 March 1916, Franz Marc was killed. This senseless sacrifice of the two artists nearest to him in feeling and vision haunted him to the end of his life: intimations of death are never far from his work.

The third event is of a different character. In November 1920, Walter Gropius invited Klee to join the Bauhaus. He went to Weimar in January 1921, and remained on the Bauhaus staff until April 1931—ten years of painting and teaching in an atmosphere that re-created, for the only time in our age, something of the creative atmosphere of the workshops of the Renaissance.[13]

This experience was important for Klee, and of inestimable value for posterity, not only because it compelled him to relate his work to a co-operate effort, but also because it compelled him to formulate, for his students, the principles of his art, which are the basic principles of all modern art. This theoretical work has been published in three volumes, the *Pädogogisches Skizzenbuch*, Munich, 1925 (English translation by Sibyl Moholy-Nagy: *Pedagogical Sketchbook*, New York and London, 1953); *Über die*

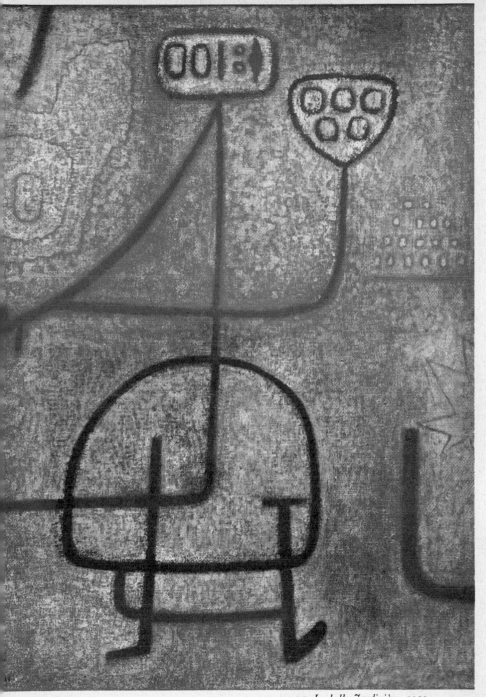

PAUL KLEE *La belle Jardinière. 1939*

moderne Kunst, Bern-Bümplitz, 1945 (English translation by Paul Findlay: *On Modern Art*, London, 1947); and *Das bildnerische Denken*, Basel/Stuttgart, 1956 (English translation by Ralph Manheim, London, 1959). An essay which he wrote in 1918 while still in the army (it was not published until 1920) summarizes his 'Creative Credo' (*Schöpferische Konfession*). The following aphorism from this essay will perhaps indicate its main line of thought: 'Art does not render the visible; rather, it makes visible'; and Klee then goes on to emphasize the subjective nature of the artist's inspiration, and to describe the way in which the graphic elements—dot, line, plane, and space—are set in action by an energy discharge within the artist's mind. Klee, like the Futurists, was always to emphasize the dynamic nature of art. 'Pictorial art springs from movement, is itself fixed movement, and is perceived through movements.' 'The creative impulse suddenly springs to life, like a flame, passes through the hand on to the canvas, where it spreads farther until, like the spark that closes an electric circuit, it returns to the source: the eye and the mind.'

These generalizations, however, had to be made more precise; simpler images had to be used for the purposes of instruction. The *Pedagogical Sketchbook* is mainly concerned with analyses of elementary forms and movements, and instructions for practical exercises in the constructive use of the basic elements of design. In the lecture 'On Modern Art' he makes his profoundest statement about the nature of the artistic process, and in particular explains the transformations (or deformations) which the visual image undergoes before it becomes a significant symbol. He makes very effective use of the simile of the tree:

'The artist has busied himself with this multiform world and has in some measure got his bearings in it, quietly, all by himself. He is so well orientated that he can put order into the flux of phenomena and experiences. This sense of direction in nature and life, this branching and spreading array, I shall compare with the root of the tree.

PAUL KLEE *The Great Dome. 1927*

'From the root the sap rises up into the artist, flows through him, flows to his eye.

'He is the trunk of the tree.

'Overwhelmed and activated by the force of the current, he conveys his vision into his work.

'In full view of the world, the crown of the tree unfolds and spreads in time and in space, and so with his work.

'Nobody will expect a tree to form its crown in exactly the same way as its root. Between above and below there cannot be exact mirror images of each other. It is obvious that different functions operating in different elements must produce vital divergences.

'But it is just the artist who at times is denied those departures from nature which his art demands. He has even been accused of incompetence and deliberate distortion.

PAUL KLEE *Battle scene from the fantastic comic opera 'Sinbad the Sailor'. 1923*

'And yet, standing at his appointed place, as the trunk of the tree, he does nothing other than gather and pass on what rises from the depths. He neither serves nor commands—he transmits.

'His position is humble. And the beauty at the crown is not his own; it has merely passed through him.'[14]

The rest of the lecture is a subtle comparison of these two realms, the crown and the root, nature and art, and an explanation of why the creation of a work of art must of necessity be accompanied by distortion of the natural form—only in that way can nature be reborn, and the symbols of art revitalized. The parts played by line, proportion, and colour in this process of transformation is then analysed, and Klee shows how they combine in a composition which is an image of creation itself—'Genesis eternal', a penetration by human consciousness to 'that secret place where primaeval power nurtures all evolution'.

Klee always showed the greatest respect for the science of the art of painting, and most of his pedagogical work is concerned with practical details. *Das bildnerische Denken*, his lectures at the Bauhaus and Weimar (a volume which, with its illustrations and diagrams, runs to more than five hundred pages), is the most complete presentation of the principles of design ever made by a modern artist—it constitutes the Principia Aesthetica of a new era of art, in which Klee occupies a position comparable to Newton's in the realm of physics. If Klee had done nothing but reach these principles, he would still have been the most significant figure in the modern movement; but he taught on the basis of his own creative achievement, and this is his unique distinction.

Klee realized, perhaps more clearly than any artist since Goethe, that all effort is vain if it is forced: that the essential formative process takes place below the level of consciousness. In this matter he agrees with the Surrealists, but he would never accept their view that a work of art could be projected automatically from the unconscious: the process of gestation is complex, involving observation, meditation, and finally a technical mastery of the pictorial elements. It is this insistence, at one and the same time,

on the subjective sources and the objective means of art that makes Klee, as I have said, the most significant artist of our epoch. 'Sometimes I dream', he confessed at the end of his lecture, 'of a work of really great breadth, ranging through the whole region of element, object, meaning and style', and added: 'This, I fear, will remain a dream, but it is a good thing even now to bear the possibility occasionally in mind.' Can any artist of our period be said to have produced such a work of really great breadth? Perhaps Picasso, in *Guernica*. Picasso was once asked what he thought of Klee, and replied: 'Pascal-Napoleon'—in which cryptic phrase, possibly intended as a physical description, he somehow conveyed a sense of Klee's command of a universal breadth and power, his aphoristic intensity and profound humanity. Each drawing of Klee is a *pensée*: 'Infinite movement, the point fitting everything, movement at rest, infinity without quantity, indivisible and infinite.'[15]

Klee's influence has not been superficial: it penetrates to the sources of inspiration and is still at work, like a ferment in the heart of our culture. If that culture survives the threat of atomic warfare, and if the new epoch of art initiated in the first half of the twentieth century is allowed to develop in creative freedom, then the work of Klee, visual and pedagogical, will inevitably be the main sap and impulsive force of its growth. But:

'Nothing can be rushed. Things must grow, they must grow upward, and if the time should ever come for the great work— then so much the better.

'We must go on searching.

'We have found parts, but not the whole!

'We still lack the ultimate strength for: there is no people to sustain us.

'But we are looking for a people. We began over there in the Bauhaus. We began there with a community to which each one of us gave what we had.

'More we cannot do.'[16]

<p style="text-align: center;">*　　*　　*</p>

CHAPTER SIX

The Origins and Development of an Art of Determined Relations: Constructivism

In this chapter and the next we shall consider two further developments of modern painting which have pursued a parallel course from the time of their origins to the present day. Again it is fundamentally a question of two kinds of sensibility, two distinct directions given to the creative energies of the artist. An artist such as Picasso, being like Shakespeare 'myriad-minded', may to some extent express himself in either mode, while rejecting the extremes of both. But other artists, not being so various, so ambivalent, tend to develop their style in strict accordance with a determinate personality. We have therefore two distinct movements, one reaching towards an ideal of clarity, formality, and precision; the other towards the opposite idea: obscurity, informality, and imprecision—or, since an ideal cannot be defined by such negative terms, let us say expressiveness, vitality, and flux.

I have already suggested that the analysis of these two distinct tendencies in the history of art which Wilhelm Worringer made in 1908, at the beginning of the modern movement, had a premonitory effect. It gave a painter like Kandinsky what one might call the courage of his instincts. Like every highly conscious artist at this time, he had been experimenting—experimenting with colours and forms to express what he called 'an inner necessity'. In the course of these experiments he hit upon the obvious fact that in order to be expressive of such inner necessity it was not

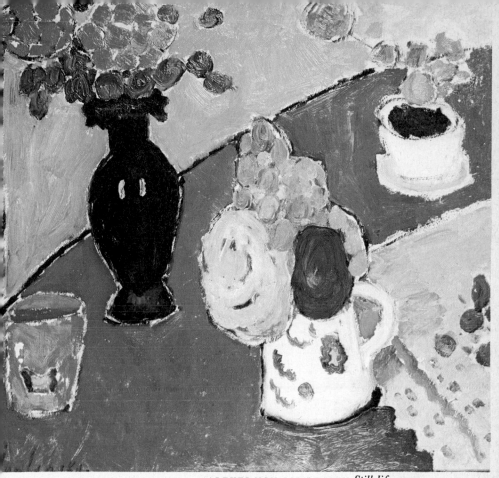

ALEXEI VON JAWLENSKY *Still-life. 1909*

necessary to be representational. He discovered that 'a round spot in painting can be more significant than a human figure'; that 'the impact of the acute angle of a triangle on a circle produces an effect no less powerful than the finger of God touching the finger of Adam in Michelangelo.'[1] But such expressive forms need not be geometrical—abstract forms are endlessly 'free', and inexhaustibly evocative. They constitute, so he thought then, a new power which would enable man to reach an essence and content of nature lying beneath the surface, and more meaningful than appearances.

In tracing the origins of this particular phase of modern painting one must again distinguish between the slow maturation of a

general spirit, a diffused and inarticulate need, and the sudden break-through to the appropriate expression of this need within an individual consciousness. The new tendency to abstraction is already observable in *Jugendstil*: in the distortion of plant-forms and even the human form for a decorative purpose; in the geometrical arrangement of typography; in the angularity of the new shapes in furniture; and in a linear emphasis in architecture —all these, together with a growing interest in Oriental art,[2] folk art, and African art, are manifestations of a spiritual discontent with the representational art of the academies. Cézanne himself may unconsciously have been influenced by the same prevailing spirit, and Cubism was its first explicit manifestation.

But Cubism, as its first practitioners insisted, was always an interpretation of objective reality, of a given *motif*. The art that Kandinsky was to initiate was by contrast essentially and deliberately non-objective, and though there may have been anticipations of such an art at an earlier date, Kandinsky's own experience was personal and even apocalyptic. He has described this experience in words that leave no doubt about this:

'I was returning, immersed in thought, from my sketching, when on opening the studio door, I was suddenly confronted by a picture of indescribable and incandescent loveliness. Bewildered, I stopped, staring at it. The painting lacked all subject, depicted no identifiable object and was entirely composed of bright colour-patches. Finally I approached closer and only then recognized it for what it really was—my own painting, standing on its side on the easel. . . . One thing became clear to me—that objectiveness, the depiction of objects, needed no place in my paintings, and was indeed harmful to them.'[3]

This apocalyptic experience took place in 1908, but it was two years before Kandinsky was confident enough *deliberately* to create a non-objective painting—a water-colour still in the possession of his widow.[4] Kandinsky was immediately aware of the dangers which lay ahead, and to which so much non-objective art was indeed to succumb—the danger of allowing painting to become 'mere geometric decoration, something like a necktie or a carpet'.

ALEXEI VON JAWLENSKY *Head. 1935*

He realized that a work of art must always be *expressive*—expressive, that is to say, of some profound emotion or spiritual experience. Could form and colour, free from all representational aim, be articulated into a language of symbolic discourse?

The appearance of Worringer's book had coincided with Kandinsky's apocalyptic experience, and direct discussions with Worringer followed—Worringer, indeed, became the intellectual patron of the modern movement in Munich at that time. The movement itself was seething with new ideas and influences, and in January 1909 Kandinsky felt that a new grouping was necessary. Together with his compatriots Jawlensky and Werefkin, and the

FRANZ MARC *Large Blue Horses. 1911*

Germans Alfred Kubin, Gabriele Münter, Alexander Kanoldt, and Adolf Erbslöh he formed a New Artists' Association. None of these artists shared Kandinsky's non-objective tendencies, but they formed a rallying point for the experimentalists. A first exhibition was held in December 1909, and a second one, which included several works by the French Cubist, Henri Le Fauconnier (1881–1946), in September 1910. In this second exhibition there were also a few Cubist paintings by Picasso and Braque. Kandinsky's own contributions were still 'improvisations' based on landscape and figures.

In January 1911, Franz Marc (1880–1916) joined the association and in Marc, Kandinsky found an artist who could understand his drift. They became close friends and decided to form a new group. Two other members of the Association joined them— Münter and Kubin—and they agreed to call their group *Der Blaue Reiter* (The Blue Rider, the title of a painting by Kandinsky of 1903). The subsequent history of this group is mainly significant for those developments of Expressionism which we shall describe in the next chapter. But during the course of its activities, which

included the publication of an important manifesto, an 'almanack' also called *Der Blaue Reiter*, the essential aims of non-objective painting first took shape, both in theory and in practice.

In order to understand the wide divergence that then began to manifest itself between two types of abstraction, it is essential to return to Kandinsky's theory of art, of which I gave some account in the last chapter. The distinction which Kandinsky made between three sources of inspiration—*direct im*pression, *spontaneous ex*pression, and *slowly formed ex*pression—implied a progressive emancipation of art from any *external* necessity (such as representing or copying 'nature') and the use of plastic forms as a system of symbolization whose function is to give outward expression to an *internal necessity*. Kandinsky insisted that such a symbolic language should be 'precise', by which he meant clearly articulated. His legal education and his musical sensibility predisposed him to the invention and elaboration of an exact system of notation. Coloured forms should be disposed on the canvas as clearly as notes in an orchestral score.

Kandinsky's first experiments in the invention of a non-verbal, visual mode of communication are still distinctly organic in feeling. Lines fluctuate and represent not only movement, but purpose and growth. Colours are associative not only in the sense that they express human emotions (joy or sadness, etc.) but also in that they signify emotive aspects of our external environment—yellow is earthy, blue is heavenly; yellow is brash and importunate, and upsets people, blue is pure and infinite, suggestive of external peace. The whole build-up, or orchestration, of form and colour is purposively expressive: there is a vague, undefined internal necessity and the artist then seeks intuitively for an arrangement of colours that will express this hitherto unarticulated feeling.

Kandinsky is quite clear on this point: the artist begins with the realization of his inner needs and he seeks to express these needs in visual symbols. There is no definition of the character of these symbols (apart from the fact that they must exploit the expressive potentialities of colour). There is only the knowledge

PIET MONDRIAN *Horizontal Tree. 1911*

that certain precise forms have precise effects—a triangle, for example, has 'its particular spiritual perfume'.

Such is the theoretical basis of Expressionism in general. But it was already obvious to Kandinsky, and implicit in his theory of art, that the artist might begin with colour and form, not in order to express an inner need, but rather to stimulate an emotional reaction. If colours have physical effects, if they can be combined to induce a wide range of moods and emotions; if shapes are also forces that penetrate our consciousness with physical effect (as sounds do), then why not use these possibilities in a deliberate and determined way to produce an aesthetic reaction (or even a spiritual reaction) in the spectator? In other words, the work of

art is a construction of concrete elements of form and colour which become expressive in the process of synthesis or arrangement: the form of the work of art is in itself the content, and whatever expressiveness there is in the work of art originates with the form.

Kandinsky himself, in theory if not in practice, was always to remain faithful to what he called 'the principle of internal necessity'. But largely on the basis of Kandinsky's practice other artists were to come forward with what might be called a principle of *external* necessity. The whole purpose of this alternative principle was to escape from the internal necessities of our individual existence and to create a pure art, free from human tragedy, impersonal and universal.

These two principles, corresponding as they do to an objective and a subjective theory of abstract art, have given rise to two quite separate movements, but since artists are but human, and not always given to a rationalization of their creative activities, there has been some confusion of aims and much inconsistency in achievements. In this brief survey we shall inevitably be drawn towards extremes that are positive, and we shall be in danger of neglecting artists of great talent who occupy an intermediate and more ambiguous position.

The painter who was to develop to its logical extreme the objective concept of abstraction was Piet Mondrian (or Mondriaan), born at Amersfoort in Holland in 1872. He began to paint at an early age and had the usual academic training. He passed from academic realism to Impressionism, and then to Fauvism, and in 1910–11 was attracted to Cubism. He went to Paris at the end of 1911 and stayed there until the outbreak of the war in 1914, absorbing and evaluating the new developments that were taking place in those momentous years. His Cubism was always analytical, and he seems never to have flirted with the synthetic Cubism of Gris. His final style of pure abstraction evolves gradually and consistently from his patient search for a reality behind the *motif*.

Back in Holland he associated himself with Theo van Doesburg (1883–1931) and Bart van der Leck (b. 1876), and in 1917 a journal was founded to develop and propagate their views on art. The journal was called *De Stijl*, and this became the name of the movement, though Mondrian himself always preferred *Nieuwe Beelding* (neo-Plasticism) as a more meaningful word. 'Néo-plasticisme' was the title of a theoretical exposition of his views which Léonce Rosenberg published as a pamphlet in 1920.[5] Mondrian undoubtedly benefited from his association with van Doesburg and van der Leck, but one has only to look at the paintings done in Paris between 1912 and 1914 to realise that the essential idiom of his style had been formulated before he met them. What is characteristic of Mondrian belonged to his temperament, and to the philosophy of life that went with it. Though he

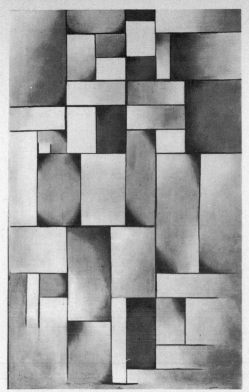

THEO VAN DOESBURG *Composition. 1918*

was much influenced by his great contemporaries, particularly Picasso and Braque in their Cubist phase, his development was organically consistent, and it is this consistency, combined with a passionate search for the plastic equivalent of a universal truth, that has made Mondrian one of the dominant forces of the modern movement.

Mondrian was not an intellectual in the usual sense of the word, and had no wide range of knowledge or experience. But he had the command of a philosophical vocabulary which he derived from a single source—the Dutch philosopher M. H. J. Schoenmaekers. It is true that before he met Schoenmaekers (which was at Laren in 1916, the year that he first met van der Leck and van Doesburg), Mondrian was already a member of the Theosophical Society—he had joined it in Amsterdam in 1909—but

Schoenmaekers was an original thinker and had elaborated a Neoplatonic system which he called 'positive mysticism' or 'plastic mathematics'. The connexion between these apparently disparate terms is explained as follows: 'Plastic mathematics mean true and methodical thinking from the point of view of the creator', and positive mysticism teaches the laws of creation thus: 'We now learn to translate reality in our imagination into constructions which can be controlled by reason, in order to recover these same constructions later in "given" natural reality, thus penetrating nature by means of plastic vision.'[6]

Dr Jaffé, whose monograph on *De Stijl* is essential for an understanding of the movement, makes it clear to what a considerable degree Schoenmaekers was responsible for Mondrian's philosophy and terminology. But:

'Schoenmaekers' philosophy was more than the mere source of Mondrian's terminology. It was—probably without van Doesburg's knowledge—one of the catalysing factors which helped to weld the various tendencies into one distinct form: "De Stijl". This supposition will have to be proved by texts, taken from the two works in which Schoenmaekers sets out his doctrines: *Het nieuwe wereldbeeld* (the new image of the world; published at Bussum in 1915) and *Beginselen der beeldende wiskunde* (principles of plastic mathematics; *ibid.*, 1916). But Mondrian was not necessarily influenced by these particular books, though they are mentioned as being part of a "De Stijl" library in *De Stijl*, II, p. 72. Both Mondrian and Schoenmaekers lived, at that time, in Laren, and we have verbal evidence, through the kindness of Mme Milius and of Messrs van der Leck, Slijper, and Wils, that Mondrian and Schoenmaekers saw each other frequently and had long and animated discussions.'[7]

A comparison of the texts made by Dr Jaffé makes it perfectly clear that Mondrian found a complete philosophical justification for the abstract tendency of his painting in the writings and conversation of this philosopher (who, incidentally, seems to have expressed himself with a rational clarity). According to Dr Schoenmaekers 'we want to penetrate nature in such a way that

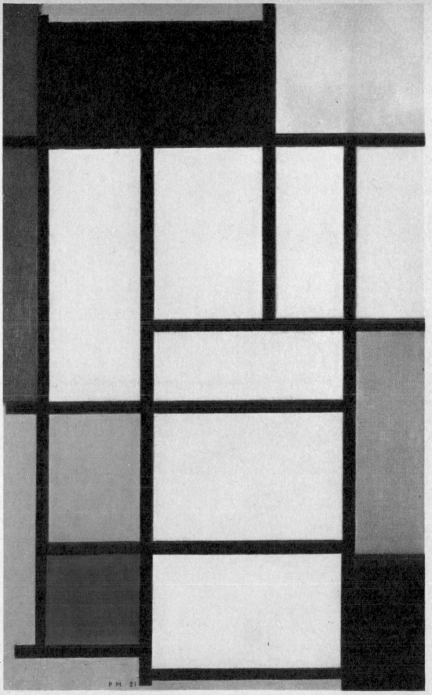

PIET MONDRIAN *Composition with Red, Yellow and Blue. 1921*

the inner construction of reality is revealed to us', and this, as Dr Jaffé remarks, 'is exactly the end that Mondrian saw before him when working in Paris'. Nature, says Schoenmaekers, 'as lively and capricious as it may be in its variations, fundamentally always functions with absolute regularity, that is to say, in plastic regularity', and Mondrian defines Neo-plasticism as a means by which the versatility of nature can be reduced to the plastic expression of definite relations. Art becomes an intuitive means, as exact as mathematics, for representing the fundamental characteristics of the cosmos.

There is much detail in the plastic mathematics of Schoenmaekers which can be directly transferred to a description of the plastic constructions of Mondrian, and though Mondrian had arrived at a similar position by an independent path (though calling at the same milestones—Calvinism, Hegel, and the publications of the Dutch Theosophical Society), there is no doubt that the contact with Schoenmaekers was decisive for Mondrian's subsequent development—it coincided, to quote Dr Jaffé once more, 'with the decisive years of his (Mondrian's) evolution; its importance has been stated by many contemporary witnesses, and it can.be traced through Schoenmaekers' and Mondrian's writings'.[8] But at the same time one must emphasize, not only that the plastic creations of Mondrian and other members of the *De Stijl* group such as the architect J. J. P. Oud (b. 1890) and the painter George Vantongerloo (b. 1886) had anticipated the philosopher's ideas, but also that this philosophy itself was 'in the air' at the time—there are many parallels between Schoenmaekers' ideas and Kandinsky's, for example, and van Doesburg, and probably others in the group, had read *Concerning the Spiritual in Art*. The distinctive element in Neo-plasticism was its desire for objectivity, its anti-individualistic tendency, and therefore one might say its anti-expressionistic tendency. This was an extreme to which the Oriental soul of Kandinsky was never to be driven. Even in his most precise and 'calculated' works (see page 173) there is still an element of sensibility which Mondrian would have found too sentimental.

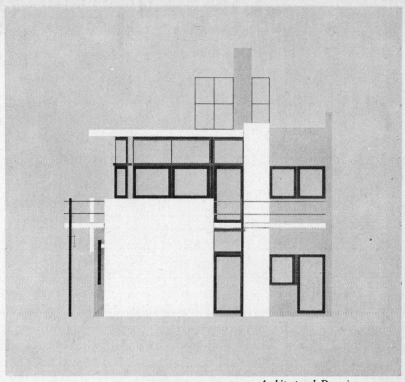

GERRIT RIETVELD *Architectural Drawing. 1923–4*

As a movement *De Stijl* was not confined to painting: architecture, furniture, the decorative arts, and typography played an equal part in a comprehensive attitude towards every aspect of life. Van Doesburg was the intellectual animator of the movement, and van Doesburg had a missionary zeal which aimed at establishing a new relationship between the artist and society. In this collective task the collaboration of the architect was essential. Of the architects who did collaborate the most important was Oud, who had become city architect of Rotterdam in 1918 (a year after he had joined the *De Stijl* group). Robert van't Hoff (b. 1887), who had studied architecture and visited the United States, joined the group in 1917 and brought with him a knowledge of the work of Frank Lloyd Wright. Gerrit Thomas Rietveld (b. 1888)

was a furniture designer and architect—a house he built at
Utrecht in 1924 was a deliberate attempt to apply *De Stijl*
principles to architecture. Other architects who collaborated
with *De Stijl* are Jan Wils (b. 1891) and Cornelis van Eesteren
(b. 1897). Van Doesburg indeed did not recognize any legitimate
distinction between architecture and design in general, and he
himself collaborated with Oud and Wils and other architects of
the group, and made many architectural 'projects'. His inclusive
claims to the direction of the activities of the group inevitably led
to trouble, but there can be no doubt, as Dr Jaffé says, that van
Doesburg *was De Stijl*, 'with all his incredible energy, creative
powers and resource. He really "drove" *De Stijl* from its very
beginning, and it is quite understandable that *De Stijl* as a
movement, as a concentration of people, did not survive him.'[9]

When one turns from the theories of *De Stijl*, impressive in their
force and consistency, to the achievements of this group in paint-
ing, one has, apart from the work of Mondrian, a sense of aridity.
There is, to begin with, a characteristic inherent in the anti-
individualism of their aims, a deliberate uniformity. Van der
Leck's forms may be more dispersed; Cesar Domela Nieuwenhuis
(b. 1900) may be bolder; Friedel Vordemberge-Gildewart (born
at Osnabrück in Germany, but invited by van Doesburg to join
De Stijl in 1924) may be more 'constructivist' in the sense to be
defined later in this chapter; but nevertheless one may be excused
for finding it difficult to distinguish any personal quality in the
work of these artists. We can appreciate the universal qualities
which are inherent in the Dutch tradition—clarity and austerity—
but these were expressed supremely by Mondrian, and one has
only to compare the achievement of Mondrian with the work of
the rest of the group to realize that he possessed some element of
genius which they lacked. 'I abhor all that is temperament,
inspiration, sacred fire, and all the attributes of genius that con-
ceal the untidiness of the mind,' van Doesburg once confessed.[10]
Mondrian might have said the same, but there is in his work, and
even in his writings, more than a spark of the sacred fire. His long
search for harmony and intensity, for precision and equilibrium,

in each individual work and in his whole creative achievement, was a passion that could not be denied. Mondrian was a humanist, and he believed that the new constructive art of which he was the forerunner would create among us 'a profoundly human and rich beauty', but a new beauty. 'Non-figurative art brings to an end the ancient culture of art; at present, therefore, one can review and judge more surely *the whole culture of art*. We are now at the turning point of this culture; *the culture of particular form is approaching its end. The culture of determined relations has begun.*'[11] A dry manner of expressing an inspired vision, perhaps, but one should remember, as Dr Georg Schmidt has so well said, that 'Mondrian's art . . . refutes Mondrian's theories. His pictures are far more than merely formal experiments—they are as great a spiritual achievement as any work of pure art. A Mondrian painting hung in a house and room designed entirely in the spirit of Mondrian, indeed, precisely in such a house and room, has a fundamentally different quality and higher stature than any object of material use. It is a most sublime expression of a spiritual idea or attitude, an embodiment of balance between discipline and freedom, an embodiment of elementary opposition in equilibrium; and these oppositions are no less spiritual than physical. The spiritual energy that Mondrian invested in his art will radiate, both spiritually and sensually, from each of his paintings for all time to come.'[12]

* * *

Kandinsky, as we have already noted, left Munich on the outbreak of war in 1914, and travelling via Switzerland, Italy, and the Balkans reached Moscow early in 1915. Apart from short trips to Sweden (1916) and Finland (1917), he remained in Russia until called to the Bauhaus in 1922. His sympathies were on the revolutionary side and in •1918 he became a professor at the reorganized Academy of Fine Arts in Moscow and a member of the Commissariat for Education. In 1919 he was made a director of the Museums of Pictorial Culture, and he presided over the reorganization of the picture galleries throughout the U.S.S.R. In 1920 he was appointed a professor at the University of Moscow

and in 1921 founded the Academy of Arts and Sciences and
became its vice-president. But the thermidorian reaction had
already set in, and at the end of this year he left Moscow, never
to return to Russia.

During these six years in Moscow a new and independent
movement of art was born, and there can be little doubt that
Kandinsky, who had the greatest experience and authority among
the artists then gathered in Moscow, was in some sense the pre-
siding genius. But once again we must suppose the precipitation,
in this city as in Paris, Munich, and elsewhere, of works of art
that expressed a diffuse longing for creative renewal. Kandinsky
himself had already spent several weeks in Russia almost every
year between 1896 and 1914, and in 1912 part of his book
Concerning the Spiritual in Art (the section on 'The Language of
Form and Colour') had been translated into Russian. This
publication was probably the catalyst that was needed, but one
should note that already in 1913, before Kandinsky's return to
Moscow, Kasimir Malevich (1878–1935) had founded a new
movement which he called Suprematism. Malevich (like van
Doesburg) had clear insight and a logical mind, and he went
straight to the point which other artists (including Mondrian)
reached by cautious evolution. Basing himself no doubt on current
aesthetic theories,[13] he asserted that the reality in art was the
sensational effect of colour itself. As an illustration he exhibited
(already in 1913) a picture of a black square on a white ground,
and claimed that the feeling this contract evoked was the basis
of all art. 'The representation of an object, in itself (the objectivity
as the aim of the representation), is something that has nothing
to do with art, although the use of representation in a work of art
does not rule out the possibility of its being of a high artistic
order. For the suprematist, therefore, the proper means is the one
that provides the fullest expression of pure feeling and ignores the
habitually accepted object. The object in itself is meaningless to
him; and the ideas of the conscious mind are worthless. Feeling is
the decisive factor . . . and thus art arrives at non-objective
representation—at suprematism.'

LASZLO MOHOLY-NAGY *Woodcut. 1924*

These sentences come from an account of Suprematism which was published by the Bauhaus in 1927,[14] but they faithfully repre sent the position taken up by Malevich in 1913, at a time when Mondrian was still tethered to the object. In the course of the next year or two Malevich found several recruits to his movement, notably Vladimir Tatlin (b. 1885) and Alexander Rodchenko (b. 1891). The developments that took place in Moscow between 1913 and 1917 remain somewhat obscure—they represented but one other aspect of the general European ferment. From the beginning, however, there were in existence at least three incompatible points of view: the purist point of view represented by Malevich, a constructivist or functional point of view represented by Tatlin and Rodchenko, and Kandinsky's more individualistic point of view. These different points of view were to be accentuated as the Revolution progressed, but the Revolution itself had brought back to their native country certain exiled artists who were to play a decisive part in these further developments, notably two brothers, Antoine Pevsner (1886–1962) and Naum Gabo (b. 1890—he adopted the name Gabo in 1915 to distinguish himself from his brother).

Pevsner had decided to become an artist at the age of fifteen, and had then spent two years as a student at the Kiev Academy of Arts, followed by one year at the St Petersburg Academy. Inevitably he was drawn to Paris and arrived there in 1911, in time to see and be overwhelmed by the first Cubist exhibition in the Salon des Indépendants. He returned to Russia for a year, but was back in Paris the following year, 1913, and then came into close association, not only with his compatriot Archipenko, then making his first experiments in Cubist sculpture, but also with the *Section d'or* group of painters, which included Gleizes and Metzinger, the first theorists of the movement, who had published *Du Cubisme* the previous year. It is also on record that Pevsner saw Boccioni's 1913 exhibition of 'architectonic constructions',[15] perhaps a decisive experience.

Meanwhile his brother Naum had chosen a medical career, and in 1909 was sent to Munich University. There his interests turned first to the physical sciences; later he studied civil engineering. But he was also becoming interested in the arts, attended Heinrich Wölfflin's lectures on art history, and visited the Cubist exhibition of 1910. In this year, too, he first met Kandinsky and read his recently published book, *Concerning the Spiritual in Art*. In 1913 and again in 1914 he visited his brother in Paris, met Archipenko, saw the works of the *Section d'or* group, and became acquainted with the theories of Gleizes and Metzinger. On his return to Munich he modelled his first piece of sculpture—a naturalistic head of a negro.

On the outbreak of war in August 1914 Gabo took refuge in Denmark, and then made his way to Oslo. There he was joined by his brother and there for two years they digested all their diverse experiences and together evolved the art they were to call Constructivism. One may suppose that Antoine contributed his knowledge of artistic techniques, Naum his scientific approach to materials and form. During his training as a physicist Naum had learned how to make three-dimensional constructions to illustrate mathematical formulas, and in this manner a fusion of artistic insight and scientific method came about.

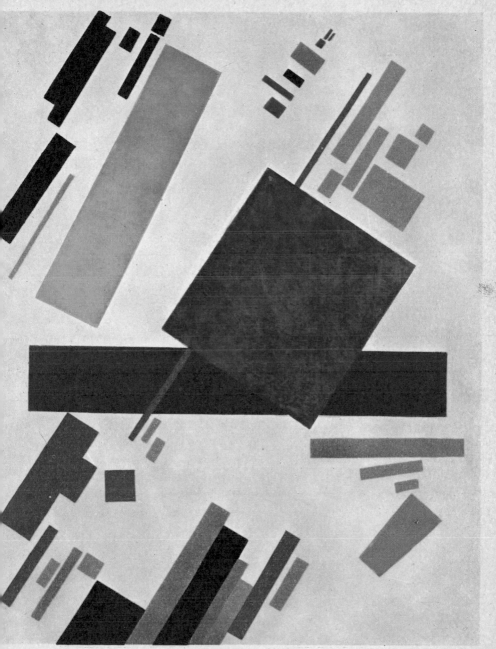

KASIMIR MALEVICH *Suprematist Composition.* 1915

When, therefore, the two brothers returned to Moscow in 1917 they came with already formed conceptions of the future of art. But the works of art which they brought from Norway—Gabo's *Bust* of 1916 and the *Head of a Woman* of the same year (the latter now in the Museum of Modern Art, New York), though influenced by Cubism, and more particularly by Archipenko's use of materials like glass and metal—were not in any sense *abstract*. Indeed, Gabo claims that he has never called himself an abstract artist, and is opposed to the use of the word abstraction in art.[16] When, therefore, Gabo and Pevsner came into direct contact with Malevich's suprematism, a divergence was evident which had to be resolved. Gabo has vividly described the discussions that then went on between all the artists now assembled in Moscow, 'each bringing something to the clarification of another's work. Our activities went on incessantly in both theoretical and concrete experiments at the workshops of the schools and in the artists' studios. Regular open discussions were held in the school auditorium . . . this in the midst of a whirlwind of war and civil war, utter physical privation and political strife.'[17]

Pevsner and Gabo eventually accepted the non-objective point of view of Malevich, but sought for a more dynamic and spatial conception of art: Suprematism, with its insistence on basic forms and pure colour, was too limited. But they rejected much more decisively the functionalist, or productivist, point of view of Tatlin and his group. 'The conflict in our ideologies,' Gabo relates, 'between Tatlin's group . . . and our group only accelerated the open break and forced us to make a public declaration. Tatlin's group called for the abolition of art as an outlived aestheticism, belonging to the culture of capitalistic society, and they were calling on those artists who were doing constructions in space to drop this "occupation" and start doing things useful to the human being in his material surroundings—to make chairs and tables, to build ovens, houses, etc. We were opposed to these materialistic and political ideas on art and in particular, against this kind of Nihilism, revived by them from the 80's of the last century.'[18]

NAUM GABO *Op. 3. 1950*

Gabo and Pevsner then issued a manifesto. It is dated 5 August 1920, and its most important pronouncement, as Gabo has said, was that art has its absolute, independent value and a function to perform in society, whether capitalistic, socialistic, or communistic. 'Art will always be alive as one of the indispensable expressions of human experience and as an important means of communication. The other important pronouncement in the manifesto was the assertion that space and time constitute the backbone of the constructive arts.'[19]

It is necessary to dwell a little on these discussions because though they took place in Moscow between 1917 and 1922, they are still live issues, and the future development of art still depends on their resolution. By 1922 the differences between the two

groups in Moscow were obviously irreconcilable, but the victory was not to be with either party. Suprematists, Constructivists, Productivists—all alike had been merely tolerated by the Russian government because for the moment more urgent problems occupied its attention. When finally it became aware of the issues, neither the Government itself nor the soldiers and peasants and industrial workers they represented cared for any of these fine points of aesthetics. They wanted an art they could understand, an anecdotic art, indeed an academic art; and since all forces had to be organized in defence of the Soviet, they wanted a propagandist art, an art in the service of the Revolution. That the artists themselves conceived their art to be essentially revolutionary and therefore appropriate for the new society that was coming into being was irrelevant. Who were these artists? Not workers, in any proletarian sense; but rather survivals of Western bourgeois decadence, probably anarchists, in any case a noisy and subversive minority. The game was up and the artists knew it. In 1922 Gabo left for Berlin to supervise an exhibition of Russian art sent there by the Government. He never returned to Moscow, and a year later Pevsner joined him in Berlin. Kandinsky left the same year, to join Gropius in Weimar. Of those who remained in Moscow, either like Tatlin they became industrial designers or like Malevich they retired into obscurity and poverty. The fate of most of them is unknown.

Gabo stayed in Berlin for ten years, then spent three years in Paris. In 1935 he settled in London and remained in England ten years. In 1946 he left England for the United States and eventually became an American citizen. Pevsner, who had had a decisive meeting with Marcel Duchamp in Berlin in 1922 or 1923, then turned from painting to constructivist sculpture, and in October 1923 returned to Paris, where he has remained ever since, becoming a French citizen in 1930.

In so far as Constructivism is conceived as a development of traditional sculpture, it might seem to lie outside the scope of this volume; but though both Gabo and Pevsner often speak of themselves as sculptors and are so regarded by critics and the

ANTOINE PEVSNER *Design in Enamel. 1923*

public, in fact what they have aimed at and achieved is a form of art that supersedes all previous categories of art. Pevsner has written:

'The gigantic constructions of the modern world, the prodigious discoveries of science have changed the face of the world, while artists were announcing new conceptions and forms. A revolution is imposed on the arts and on the emotions—it will discover a new world as yet scarcely explored. Thus we have arrived, Gabo

and I, on the road to new research of which the guiding idea is the attempt at a synthesis of the plastic arts: painting, sculpture and architecture. . . . It is not fanciful to think that the epoch which will succeed ours will be once more, in the history of humanity, a period of great collective works; that it will witness the execution of imposing constructions in vast urban spaces.'[20]

Such a 'synthesis of all the plastic arts', in which the traditional Renaissance categories disappear in a new architectonic complex of constructive activities, has also been the ideal of the great architects of our period, Walter Gropius (b. 1883), Mies van der Rohe (b. 1886), and Le Corbusier (Charles Edouard Jeanneret, b. 1887). The Bauhaus was founded by Gropius with just such an ideal of a synthesis of the plastic arts; and this too was the ideal of van Doesburg and other members of *De Stijl*. The Bauhaus united for ten productive years artists of every category in this common endeavour. In the first proclamation issued at Weimar in 1919 it was argued that all the arts must be unified round *the building*. 'Architects, painters and sculptors must recognize anew the composite character of a building as an entity. Only then will their work be imbued with the architectonic spirit which it has lost as "salon art". *Architects, sculptors, painters: we must all turn to the crafts.* . . . Let us create a *new guild of craftsmen*, without the class distinctions which raise an arrogant barrier between craftsman and artist. Together let us conceive and create the new building of the future, which will embrace architecture *and* sculpture *and* painting in one unity and which will rise one day toward heaven from the hands of a million workers like the crystal symbol of a new faith.'[21]

This brave ambition was defeated by the machinations of philistine politicians, but the Bauhaus itself became the symbol of all that is creative and constructive in an age of economic and political confusion, and remains such a symbol. During the four-teen years of its existence it not only gave a professional status and means of livelihood to such 'creative' artists as Klee, Feininger and Oskar Schlemmer (1888–1943), but also through the teaching of Johannes Itten (b. 1888) and Josef Albers (b. 1888) established

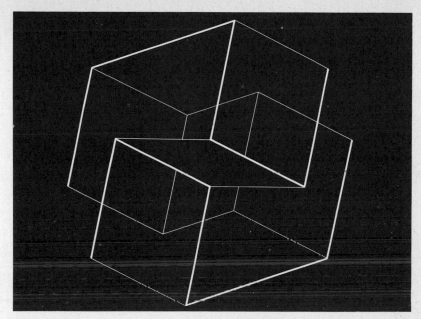

for the first time a course in basic design that could serve as a training for the machine art of an industrial civilization. A fundamental parallelism was for the first time drawn between the principles of abstract art and design for mass production.

While Gropius was creating the Bauhaus in Weimar, Lasar (El) Lissitzky (1890–1941) was establishing similar principles in Russia, first at Vitebsk and then in Moscow. In 1921 he was sent to Berlin to make contact with Western artists and for a time was actively associated with Mies van der Rohe, Theo van Doesburg, Hans Richter and others. In 1923 Richter, in association with Werner Graeff, Doesburg and Mies, founded still another group known as 'G', to which Gabo, Lissitzky and several other artists and architects adhered. Laszlo Moholy-Nagy (1895–1946), a Hungarian who came to Berlin in 1920 already imbued with Constructivist ideals, joined this group. In 1923 Moholy-Nagy was appointed to the staff of the Bauhaus, and was eventually to carry the Bauhaus ideal to America—in 1938 he became

VICTOR PASMORE *Inland Sea. 1950*

director of a new Bauhaus in Chicago. Virtually all the leaders of the movement and many of its disciples (Gropius, Mies van der Rohe, Richter, Lyonel Feininger, Herbert Bayer, Marcel Breuer, Gyorgy Kepes) were eventually displaced from Europe and established themselves in America.

Paris remained obstinately attached to 'salon art', in spite of the efforts of Le Corbusier. The *Section d'or* school of Cubism, represented by Gleizes and Metzinger, had already before the war moved towards a 'pure' form of abstraction. Immediately after the war Le Corbusier and Amédée Ozenfant published a 'purist manifesto', *Après le Cubisme*.[22] This was an attack on the decorative tendencies of Cubism, on the cult of sensibility, and a call for an art as pure and 'rigorous' as the machine. *Purism* was chosen as a word to express the characteristics of the modern spirit. The work

BEN NICHOLSON *Still-life (off green). 1945–54*

of art of the future was not to be accidental, exceptional, impressionist, inorganic, picturesque, etc., but on the contrary general, static, expressing the constant factor in nature. Clarity, precision, fidelity to the 'concept'—these were to be the ideals of the new art. In 1920 a periodical entitled *L'esprit nouveau* was established to propagate these ideals, and there can be no doubt that between the years 1920 and 1925 the Purists had a decisive influence on the development of abstract art throughout Europe and America. But Purism did not desert the object: it was an ideal of style or technique, a purification of the *motif* as such. Nevertheless, a non-figurative school of painting did emerge in Paris, and in 1932 a group with many adherents was founded by Antoine Pevsner and Gabo with the title *Abstraction-Création*. It has continued to represent a strictly non-figurative ideal in abstract

art, but it is still essentially a group of painters and sculptors and has not tried to realize that synthesis of the plastic arts which was the ideal of the Bauhaus and *De Stijl*. At the most there has been some merging of the techniques of painting and sculpture—a merging that was first suggested by some of the 'constructions' in wood, paper, and other materials made by Picasso as early as 1912—an invention subsequently exploited with good effect by many artists. Most constructions of this kind are experimental, or decorative, or surrealistic accretions meant to shock us; but one has only to examine the evolution of a painter like Ben Nicholson (b. 1894) to see how such a constructive element has modified the concept of the painted picture. Nicholson began as a decorative painter of great charm, and then came under various 'purist' influences of which the most direct and powerful was that of Mondrian, though Arp also must be taken into account. He then evolved the 'relief' which is still representative of his work. This can be literally a relief—a geometrical division of the picture-area distinguished not by colour but by differences in level, usually cut down from the original surface of a board. A very subtle difference of level between the various divisions of the composition suffices to create the abstract pattern, though this may sometimes be elaborated by a circle or other detail drawn in pencil.

Are such reliefs painting or sculpture? The question is more difficult to answer when we pass to works by this artist which are not carved in relief, but wholly painted, for we then see that the disposition of the colours, their balance and interrelationship, has been influenced by an architectonic conception of painting—that is to say, the colours are disposed as if in relief. The spatial conception of the painting has been influenced by a sculptural conception of space.

This is not exactly the synthesis of the arts as conceived by van Doesburg, Le Corbusier or Gropius, but it is a secure step in this direction. Victor Pasmore is another English artist whose progress has been in this same limited but intensive direction; Pasmore, moreover, has recently worked on architectural projects which bring his work into line with the Bauhaus intentions of 1919–28.

The ideal of a synthesis of the plastic arts is not dead; but the experience gained at much cost of effort and disillusionment of spirit at Weimar, Dessau, Harvard, Chicago, and elsewhere shows that the vital conceptions of the artist cannot immediately transform societies still clinging to obsolete political and economic concepts. The artist creates his image, original and universal; it is dropped like a crystal into the amorphous ferment of life; and only slowly and perhaps imperceptibly can it communicate its order and clarity to the chaos around it.

After the Second World War the manifestations of abstract art in Paris continued to increase. An annual salon which was given the name of *Réalités Nouvelles* was established, and this organization revealed for the first time the growing strength of the movement in that city, where from 1933 onwards the presence of Kandinsky and of Alberto Magnelli (b. 1888, in Florence) had exercised a decisive influence. The artists who were associated with *Réalités Nouvelles* are too numerous to be mentioned, but they include Jean Piaubert (b. 1900), Serge Poliakoff (b. 1906, in Moscow), Victor de Vasarely (b. 1908, in Hungary), Jean Deyrolle (b. 1911), Natalia Dumitresco (b. 1915, in Rumania), Alexander Istrati (b. 1915, in Rumania) and Jean Dewasne (b. 1921). From 1949 onwards the Salon de Mai turned towards abstraction; among its regular exhibitors were Charles Lapicque (b. 1898), Geer van Velde (b. 1898), André Lanskoy (b. 1902, in Moscow), Léon Gischia (b. 1904), Maurice Estève (b. 1904), Jean Bazaine (b. 1904), Maria Elena Vieira da Silva (b. 1908, in Lisbon), Gustave Singier (b. 1909), Raoul Ubac (b. 1911), Alfred Manessier (b. 1911) and Jean Paul Riopelle (b. 1924, at Montreal). In general the artists of the Salon de Mai represented a variety of abstract styles, some of which tended to get far away from the formal severity of Kandinsky's and Magnelli's compositions; they began to merge with an expressionistic type of abstraction which had separate origins and different aims, and must be the subject of a further chapter.

* * *

CHAPTER SEVEN

The Origins and Development of an Art of
Internal Necessity: Abstract Expressionism

In 1912 Wilhelm Worringer published, again in Munich, a second book, *Formprobleme der Gotik*,[1] which was almost as significant for the modern Expressionist movement as his *Abstraktion und Einfuhlung* was for the modern Abstract movement. He gave the Germans what they had longed for—an aesthetic and historical justification for a type of art distinct from Classicism, independent of Paris and the Mediterranean tradition. That the Northern peoples had in the past evolved a distinct type of art had been evident ever since the Renaissance, and Gothic was the name given to it, at first contemptuously. It had not been difficult to find an explanation for this distinct style in climatic and economic factors, but Worringer now proceeded to give it the character of inevitability: the style was the man himself, Northern man. Standing over against the serene and joyous art of the Classical man is this other type of art, agitated and fearful, 'the trans-cendentalism of the Gothic world of expression'. Worringer assumes that the will to form at any period of human history is always an adequate expression of the relations of man to his surrounding world, and in the North this surrounding world in all its austerity, coldness, and darkness had always tended to induce feelings of insecurity and fear. He examines the origins and evolution of Northern European art and shows how it becomes, in its linear intensity, a graphic index to the prevailing sensibility. The Gothic soul, in all its pathos and restlessness, finds an outlet

GEORGES ROUAULT *Au Salon. 1906*

FRANZ MARC *Tigers. 1912*

in every form of art—not only in ornament and architecture, but even in the alliterative diction and repetitive refrains of Northern poetry. The general condition of Northern man, so that argument runs, is one of *metaphysical* anxiety, and since serenity and clarity, the distinctive characteristics of Classical art, are denied to him, his only recourse is to increase his restlessness and confusion to the pitch where they bring him stupefaction and release.[2]

Worringer's argument, as I have already suggested, would serve as a description not only of the artistic movements that were to develop in Munich from 1912 onwards, but generally of the development of Expressionism throughout Europe and America in our century. It would not be difficult to find the parallels in literature (in the prose style of Joyce's *Ulysses* and *Finnegans Wake*; in Bert Brecht's plays and in the verse forms of Ezra Pound, William Carlos Williams, and Boris Pasternak); and even contemporary architecture (in Frank Lloyd Wright, Le Corbusier, and Luigi Nervi) exhibits the same restless linear activity and refined construction.[3]

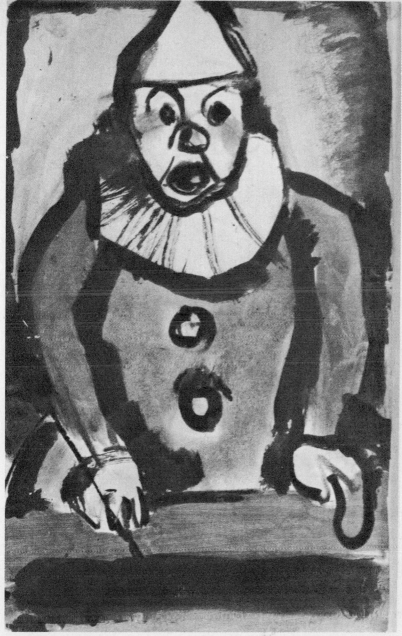

GEORGES ROUAULT *The Clown.* c. *1905*

This descriptive theory is wide enough to include some of the movements whose origins we have already traced in previous chapters. Certainly Futurism and Surrealism are manifestations of the same metaphysical anxiety, and since these manifestations have been world-wide, it is not possible to characterize them as Northern or Germanic. Indeed, what one might call the basic theory of Expressionism, which Kandinsky formulated, is a theory of universal application: it relates to human psychology in general and not to the characteristics of any particular race. The work of art, Kandinsky says, is the outward expression of an inner need; and though Worringer might insist that this inner need is generated only in a particular environment, one has merely to look for a moment at the modern world to realize that the frontiers of the Middle Ages no longer exist. Metaphysical anxiety is now a global condition of mankind.

What remains, to distinguish one people from another (or one man from another), is merely the degree to which they are (or he is) conscious of this anxiety. One might say that Constructivism is an unconscious sublimation of this state of mind: it is the modern parallel to Gothic linear ornament and transcendental architecture. The same tendency has its scholasticism in the philosophical writings of Wittgenstein and in the aesthetic theories of Mondrian. But Expressionism is a deliberate revelation of this anxiety, and it is as evident in Fauvism and Cubism, in Futurism and Surrealism, as it is in those movements which had their origin in Scandinavia and Germany and which constitute the Expressionist movement in its most precise historical meaning.[4]

Though the word Expressionism only came into use from 1911 onwards, it is usual to apply it retrospectively to the work of the *Brücke* artists before this date, and certainly one cannot now discuss the development of Expressionism without taking into account the work of the German artists discussed in Chapter Two. The *Brücke* collapsed in 1913, but meanwhile a new group was taking shape in Munich. Since 1892 contemporary art had been represented in the Bavarian capital by the *Secession*, which included the German Impressionists, notably Slevogt and Corinth.

AUGUST MACKE *Landscape with Cows and Camel. 1914*

When Kandinsky came to Munich in 1896 the *Secession* was just entering its *Jugendstil* phase. Already by 1901 Kandinsky had established an inner group, the Phalanx, and it was in this period that he painted a romantic picture to which he gave the title *Der Blaue Reiter*. The Phalanx lasted until 1904. Kandinsky did not break entirely with the *Brücke* (exhibiting with the group in 1907) and he continued to exhibit with the *Secession*. But by 1909, as we have seen, Kandinsky was reaching towards a totally new conception of art, which had nothing in common either with the established tradition represented by the *Secession*, or with the

aggressive realism of the *Brücke* group. A new grouping became necessary, and it first took the form of a break-away from the *Secession*. In the autumn of 1909 a number of artists resigned from that body and formed the New Artists' Association (*Neue Künstlervereinigung*). These dissident artists had little in common except their desire to experiment without restriction: they included Kandinsky and Jawlensky, Jawlensky's friend Marianne von Werefkin, Alfred Kubin (b. 1877), Alexander Kanoldt (1881–1947), Adolf Erbslöh (1881–1947), and Karl Hofer (1878–1955). Le Fauconnier was invited to participate in the second exhibition (1910), and, as already mentioned, this established an important link between the German Expressionists and the French Cubists. Rouault was also represented in this second exhibition, as well as Picasso and Braque. The whole enterprise, which was practical rather than ideological, became a concentration in Munich of all the new forces of European art. But its very catholicity was its weakness, and like all such organizations it inevitably developed what might be called jury-trouble. In the autumn of 1911 Kandinsky, by then in close association with Marc and Macke, decided to leave the Association, and the rejection by the jury of one of Kandinsky's own paintings was the signal to go. Kandinsky in company with Kubin, Marc, and Münter formally resigned. Marc immediately took the initiative and formed a new society which held an exhibition concurrently with the third exhibition of the New Artists' Association. Apart from Kandinsky, Marc and Macke, and invited foreigners, like Henri Rousseau and Robert Delaunay, the group included Albert Bloch, Heinrich Campendonk, Gabriele Münter, J. B. Niestlé, and Arnold Schönberg (the composer, but he also painted at this time).

The new group took its name from the painting by Kandinsky already mentioned, *Der Blaue Reiter* (the Blue Rider), for no very significant reason.[5] Kandinsky, who was already forty-five years old, seems to have been content to leave the direction of the new group to his enthusiastic disciple, who was then thirty-one. But Macke, who was younger still, was also a considerable influence

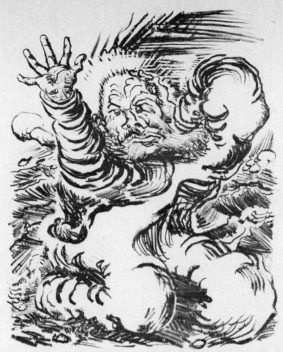

LUDWIG MEIDNER *Prophet. c 1918*

within the new group. It only remains to ask what these two younger artists could contribute to the new conception of art that was not already implicit in Kandinsky's work at this time, and which was already formulating in the book he was to publish a year later.

From a theoretical or aesthetic point of view the younger men could perhaps add nothing new, but in contradistinction to some of the artists of the *Brücke* group, who were developing towards a 'new realism bearing a socialistic flavour',[6] they were essentially romantic in their approach to art. They might have a theory about the symbolic value of colours, or an interest in primitive art, folk art or children's art, but Kandinsky too had always been interested in such subjects, and his universal mind was to preside over all the group's activities. Contributory influences came from the French artists: Rousseau, Delaunay, and Le Fauconnier added their romanticism to the inherent tendencies of Marc,

Macke, and Campendonk. When in 1912 Klee joined the group
he seemed to synthetize all the diverse elements represented by
the other artists, and one might say that Klee rather than
Kandinsky was the only Blue Rider to stay that particular course.
Marc and Macke were killed before they could complete their
development, and Campendonk was never to pass beyond the
appealing but essentially decorative ideal of folk art. There are
statements by Marc which suggest that he would have accom-
panied Kandinsky all the way to abstract Expressionism, but when
Marc says, for example, that he seeks to paint 'the inner spiritual
side of nature', the emphasis is on *nature*; whereas when Kandinsky
speaks of art as the expression of an internal necessity, he is
thinking of the spiritual aspects of *man*. It is, of course, possible to
argue that man and nature belong to the same order of reality,
and that what matters in art is not one or other aspect of this
reality, but only the degree to which the artist apprehends any
aspect of the totality. But the particular development of modern
painting which I am trying to trace in this chapter is concerned
with man's own spiritual condition, and nature is only significant
in so far as it is transformed to express this human condition. It is
this fact (or rather tendency) which makes the fundamental
difference between the *Blaue Reiter* group and the *Brücke* group.

In spite of this fundamental difference some of the *Brücke*
artists were invited to contribute works to the second *Blaue Reiter*
Exhibition, which was held in Munich in the spring of 1912. This
exhibition was restricted to graphic work and water-colour draw-
ings, media popular with the *Brücke* artists, who were represented
by some hundred and thirty items by Nolde, Pechstein, Kirchner,
Heckel, and Mueller. But this second exhibition no longer repre-
sented a coherent style of any kind—in addition to the German
artists there were the leading French Cubists, several Russians
(Gontcharova, Larionov, and Malevich), and a new Swiss group
(*Der moderne Bund*) which included Klee and Arp. The exhibition
was an almost complete index to all the modern styles—Fauvism,
Cubism, Futurism, Rayonism, and Suprematism, and of course Ex-
pressionism. Even more eclectic, for it also included reproductions

WILLI BAUMEISTER *Two Lanterns. 1955*

of Bavarian glass-paintings, Russian folk art, medieval art, Chinese and Japanese drawings and woodcuts, African masks, pre-Columbian sculpture and textiles, children's drawings, etc., was the *Blaue Reiter Almanac* which Marc and Kandinsky produced in this same spring of 1912. In a preface to the second edition of the *Almanac* Marc declared: 'We went with a divining-rod through the art of the past and present. We showed only that art which lives untouched by the constraint of convention. Our devoted love was extended to all artistic expression which is born out of itself, lives on its own merit, and does not walk with the crutches of custom. Wherever we have seen a crevice in the crust of convention, we have called attention to it, because we have hoped for a force underneath, which will someday come to light.'[7]

'A force underneath, which will someday come to light': *Blaue Reiter* was the first coherent attempt to show that what matters in art—what gives art its vitality and effect—is not some principle of composition or some ideal of perfection, but a direct expression of feeling, the form corresponding to the feeling, as spontaneous as a gesture, but as enduring as a rock. 'To create forms means to live. Are not the children who construct directly from the secrets of their emotions more creative than the imitators of Greek form? Are not the savage artists, who have their own form, strong as the form of thunder?'[8]

Such a theory of expression was wide enough to cover all the very various manifestations of art included in the *Blaue Reiter Almanac*, and in these vital two years, between the spring of 1912 and the outbreak of war in the autumn of 1914, a complete revision of the theoretical concept of art took place in Germany. It was fed, of course, from Europe generally, and an exhibition like the First German Autumn Salon which was held in Berlin in 1913, aimed to be universal, 'a survey of the creative art in all countries', and probably no other exhibition of such scope was to be held in Europe again until the Exhibition of Fifty Years of Modern Art at the Brussels Universal and International Exhibition of 1958, an exhibition of almost exactly the same size and scope. It speaks well for Herwarth Walden's prescience that practically every

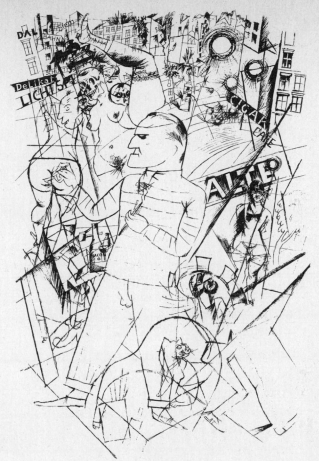

GEORGE GROSZ *Self-portrait for Charlie Chaplin. 1919*

artist of significance for the future was included in his 1913 *salon*: Chagall, Delaunay, Léger, Metzinger, Gleizes, Marcoussis, Picabia, Balla, Carrà, Severini, Boccioni, Russolo, Gontcharova, Larionov, Kokoschka, Mondrian, Klee, Feininger, Marsden Hartley, Jawlensky, Kubin, Marc, Campendonk, Kandinsky, Macke, Arp, Max Ernst, Willi Baumeister, and Archipenko. Even Rousseau was included as a 'precursor'.

The impact of this exhibition on the younger artists like Marc and Macke was a little bewildering, but the influences that predominated were Kandinsky's theories and Delaunay's 'colour

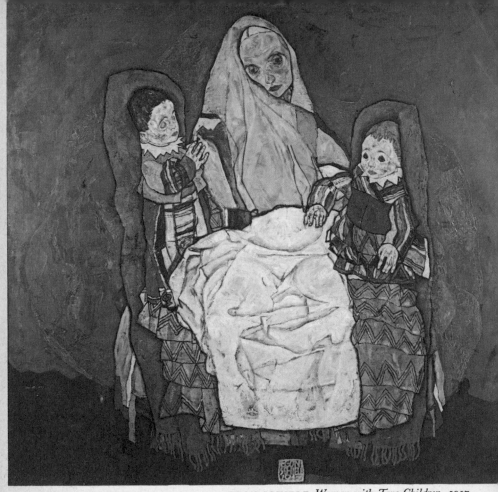

EGON SCHIELE *Woman with Two Children. 1917*

dynamism', and they led towards that type of art which we now call Abstract Expressionism. But the older Expressionists, particularly Christian Rohlfs and Emil Nolde, in their exploitation of the emotional and symbolic values of colour, were also pointing towards the possibility that colour might be given its independence —might in itself possess the requisite elements for the plastic representation of 'inner necessity', that is to say, of wordless insights, ineffable intuitions, essential feelings, all that constitutes 'the life of the spirit'. At the point of decision, which was being reached in Germany in the ominous shadow of universal war, the

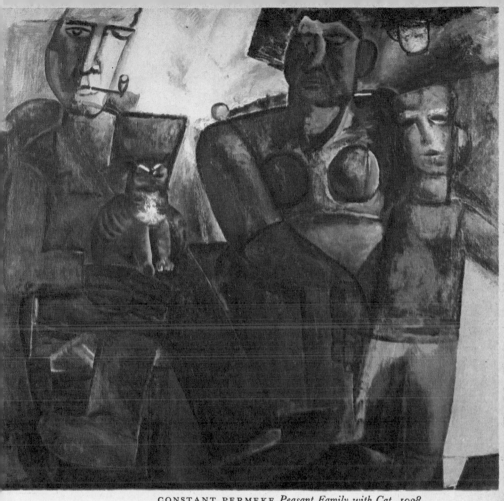

CONSTANT PERMEKE *Peasant Family with Cat. 1928*

choice seemed to be between two kinds of freedom: a freedom to transform the real object, the *motif*, until it corresponded to unexpressed feelings; or a freedom to create an entirely new *motif*-less object, which would also correspond with these same unexpressed feelings. Transformation or deformation of the real object was the way taken by the *Brücke* group, and was persisted in throughout and beyond the war by Schmidt-Rottluff, Kirchner, Heckel, Pechstein, Mueller, and Nolde: and to this tendency, though not necessarily sharing all their ideals, belong Egon Schiele, Oskar Kokoschka, Karl Hofer, Jawlensky, Kubin, Soutine, Rouault,

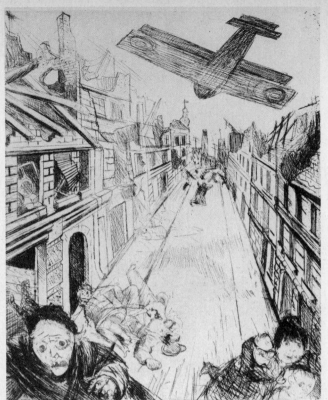

OTTO DIX *Lens Bombed. 1924*

Rohlfs, George Grosz, Max Beckmann, the Belgian Expressionists (James Ensor, Constant Permeke, Jan Sluyters, Gustave de Smet), and artists in many other countries, notably Mexico (Rufino Tamayo, b. 1899) and the United States (John Marin, 1870–1953; Ben Shahn, b. 1898; Abraham Rattner, b. 1895; Jack Levine, b. 1915).

Since the artist who pursues this way tends to keep to the human figure as a *motif*, and to make that *motif* more and more an index of elementary feelings, the art it led to was given the name of *Neue Sachlichkeit*, New Objectivity.[9] At some points—for example, in the work of Diego Rivera (b. 1886) and of Edouard Pignon (b. 1905), José Clemente Orozco (1883–1949), and Renato Guttuso (b. 1912)—this movement links up with the political ideal known as Socialist Realism.[10]

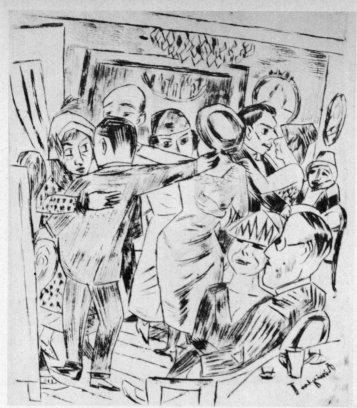

MAX BECKMANN *Königinen II. 1923*

The other way, more difficult, more doubtful, more adventurous, was taken by Kandinsky, and would, we may be sure, have been taken by Marc and Macke. Marc's painting of 1914, *Fighting Forms*, now in the Bayerische Staatsgemäldesammlungen, Munich, is already as abstract as any future form of Expressionism.

Kandinsky himself, as I have already explained, after his experience in Russia, was to pursue a separate path, though always close to Klee. But Klee and Kandinsky, in the course of their experimentation, had anticipated all the possibilities that lay ahead: every type of abstract Expressionism that was to be developed between 1914 and the present day, has somewhere its prototype in the immense *œuvre* of these two masters. They went to the limits of plastic consciousness, in so far as limits have been given to that consciousness in our age.

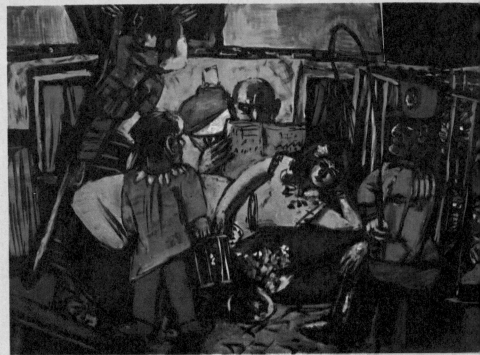

MAX BECKMANN *Circus Caravan. 1940*

Let us for a moment follow the first path, the path taken after the First Word War by the *Brücke* artists, and by such outstanding individualists as Nolde, Soutine, and Kokoschka. All the *Brücke* artists survived the war, and some of them, such as Max Pechstein and Otto Mueller, took part in an attempt to create an organization to deal with the urgent problems of reconstruction. This was called the *Novembergruppe*, and had a broad front which included architects, musicians, film directors, dramatists, as well as painters and sculptors. Dadaists like Viking Eggeling and Hans Richter returned from Zürich to participate; architects like Walter Gropius and Erich Mendelsohn were there; composers like Hindemith, Krenek, and Berg; and practically every kind of artist, whether Expressionist, Cubist, Futurist, or Realist, joined in the hope of 'planning and realizing . . . a far-reaching programme, to be carried out with the co-operation of trustworthy

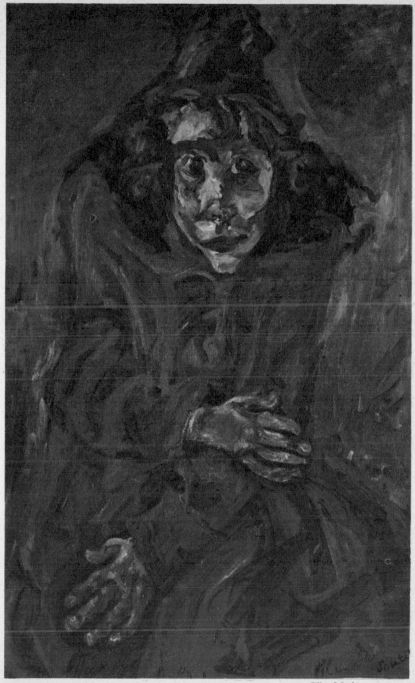

CHAIM SOUTINE *The Madwoman. 1920*

people in the various art centres', a programme which would bring about 'the closest mingling of art and the people'.[11] It was a revolutionary period, in politics as well as in art, and a political motive is evident in the declarations of purpose and expressions of sympathy of the German artists of this post-war period. A bitter and cynical social criticism was expressed in the work of two artists in particular—George Grosz (b. 1893) and Otto Dix (b. 1891), but other artists such as Ludwig Meidner (b. 1884) were no less positive in their social criticism.

Such a wide movement held no promise of coherence, and it was not long before the realists began to distinguish themselves from the superrealists—there could be no aesthetic unity between say Arp and Otto Dix, or between Max Ernst and Max Beckmann. It was a question of motivation: on the one hand were artists determined to use their powers of expression in the social (but not necessarily political) struggle: on the other hand, artists determined to use these same powers of expression to explore the nature of reality, or their own troubled souls. The first determination led to the New Objectivity (*die Neue Sachlichkeit*) whose typical representatives are Dix, Grosz, and Beckmann; the second to what might have been called the New Subjectivity, but which was never concentrated enough to have a single name, though Surrealism covers most of its aspects, especially if we give this term a general significance (and do not confine it to the movement initiated by Breton and Eluard). The New Objectivity, we might further observe, remained a Germanic movement, though it had a significant expansion in America, especially after the arrival there of Max Beckmann (in 1947), and has its representatives in every country. But we should distinguish between objectivity or 'verism', which is an aesthetic ideal, but nevertheless often the ideal of artists with socialist or humanist sympathies: and those naïve conceptions of 'realism' typical of the Communists and National Socialists, which constitute an academic illusionism of no artistic value. The failure of the politicians to appreciate the objectivity of artists like Grosz and Dix led all too inevitably to mutual disillusionment and a 'failure of nerve'.

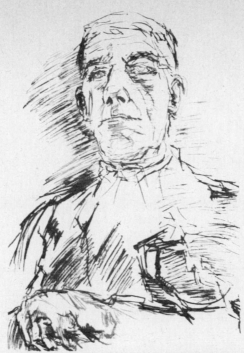

OSKAR KOKOSCHKA *Self-portrait at Seventy, 1956*

What is of more interest, in retrospect, is the obstinate retention, in the case of artists like Jawlensky, Nolde, Kokoschka, and Soutine of a figurative *motif* in apparently flagrant conflict with their symbolic intentions. Alexei von Jawlensky had been intimately associated with Kandinsky from the time they were students together in Munich in 1905, and no one can have been so closely and continuously subjected to his influence. And yet, however much he distorted the *motif*, however far he departed from a natural palette, Jawlensky never accepted the idea of an autonomous work of art, liberated from any dependence on the object. Some of Nolde's masks, and the paintings he made after his visit to the South Seas in 1913–14, carry distortion to limits that are nearly abstract. Colour takes on an independent function, as it does in Rembrandt's *Slaughtered Ox*: it transcends the object that has evolved it to become in itself an alchemical substance, a *materia prima* with its own mystery and power. But Nolde, too, was never to desert the *motif*.

The artist who perhaps more than any other carried this evocative intensity of colour to its sensuous limit was not a German Expressionist, but a Russian, Chaim Soutine, who was born at Smilovitch in 1894 and went to Paris in 1911. He knew his compatriot Chagall, but his most intimate friend was Modigliani: after Modigliani's death in 1920, he lived the life of a recluse. He died in Paris in 1943, after an unsuccessful operation. Depressive and even suicidal by temperament, colour became for him what it had been for van Gogh—a physical extension of exacerbated nerves. The carcass of an ox, the flesh of a plucked fowl, even the red robe of a choir-boy, any object is transformed into a translucent diaphragm through which his own life-blood seems to flow.[12]

Georges Rouault is another artist for whom colour has its own evocative power, deliberately symbolic as it had been in the stained-glass windows of the Middle Ages. But Rouault, like Pechstein, Kirchner, Heckel, and Schmidt-Rottluff, continued to use his painting for the communication of a message—in his case religious rather than social or political. The motivation, we might say, is collective, directed to a social conception of the function of art. Rouault's clowns and prostitutes, his judges and his Christ, are figures in a raucous fair, a carnival through which stride death and desolation, but again the colours, leaded in black strips, glow with an essentially symbolic significance.

The artist who, more completely and more persistently than any other in our time, has embodied in his painting a visionary and symbolic humanism is Oskar Kokoschka, who was born at Pöchlarn on the Danube in 1886. Kokoschka received a formal education in his craft at the Vienna Arts and Crafts School from 1904 onwards, but he himself has described the influence, literary as well as plastic, that fed his nascent sensibility:

'I was impressed by the Expressionists of the eighteenth century, Büchner's *Wozzeck*, Heinrich von Kleist's *Penthesilea*, Ferdinand Raimund's moralistic plays, Nestroy's satirical works. To recount one man's literary experiences when he was born in the late nineteenth century, and in Austria, one ought to set out the

OSKAR KOKOSCHKA *Dents du Midi. 1909*

finality of the moral and social struggle which had just begun. . . .
It was the Baroque inheritance I took over, unconsciously still.
Just as it offered itself to my dazzled eyes as a boy singing in choir
in the Austrian cathedrals, I saw the wall-paintings of Gran, of
Kremser Schmidt, and of the outspoken extremist amongst them,
Maulpertsch. I especially loved the last artist's work, because of
the fascination of Maulpertsch's super-cubist disposition of space
and volume. His emotions woke in me something of a conscious
grasp of the problems of the art of painting. First becoming con-
scious of the near-ugliness of reality compared with the illusionist's
magic colour, born in the master's unbound imagination, I soon
became aware of and was caught by the Austrian Baroque artist's
indocility to the classicist Italian conventions of harmony. It was
my fate to share also their lack of appeal to my contemporaries
who were repelled by "vision" in art, everywhere, all over
Europe.'[13]

 There are two significant affirmations in this confession: first,
a deliberate rejection of 'classicist Italian conventions of harmony',

which implies an affirmation of 'the transcendentalism of the gothic world of expression'; and then an insistence on the place of "vision" in art. What Kokoschka meant by these phrases was from the beginning made clear in his work (which included dramatic pieces like *Sphinx und Strohmann* and *Hoffnung der Frauen* as well as paintings, book illustrations, posters, sculpture and decorative panels). In a series of portraits painted between 1908 and 1914 he was a merciless analyst of the human personality; in landscapes of the same period he re-created, but with new impressionistic vigour, the romantic pantheism of Caspar David Friedrich and Turner; and finally, in a painting like *The Tempest* (*Die Windsbraut*, 1914; now in the Kunstmuseum, Basle) he created one of those great symbolic works which epitomize an age. It is a portrait of the artist himself and the woman he loves, cast adrift in a boat, 'the woman peacefully resting on the man's shoulder, while he is alert and wears the expression of one who is aware but powerless. These two seem to be driven along as the angels and saints of baroque paintings are wafted through the skies by some irresistible force. In the world of modern painting this depiction of passion, at once concrete and symbolic, was new: there is no other painting that attempts so direct a representation of human destiny'. I quote from Edith Hoffmann's excellent description of this painting,[14] of which she further observes that 'imagination and reality are so closely combined in this work that any attempt at exact interpretation will inevitably fail. But it certainly demonstrates that the artist had, at the moment of the greatest turbulence in his personal life, achieved the artistic powers which enabled him to exorcise the chaos of his own emotions by transferring them to a general, more abstract plane.'

What is perhaps significant for the future is once again the fusing of the colours (symbolic greys and blues, with flecks of red and yellow) into a swirling but coherent mass; and as Kokoschka's work develops, this fusing process intensifies until the life of the colours is the sole *raison d'être* of the painting. This is perhaps most obviously illustrated in his *natures mortes*, particularly those of shellfish and turtles, but the *Woman in Blue* of 1919 (*p. 242*) now in the

OSKAR KOKOSCHKA *Sketch*

Württemberg State Gallery, Stuttgart, serves better still. The model was a life-size doll which Kokoschka had had made for himself at the end of the war, at a time when he hoped 'to go to the mountains where I want to hide, to forget disgusting reality and to work. And as I can bear no living people but am often delivered to despair when alone, I beg you again (he wrote to the woman who was making the doll) to use all your imagination, all your sensitiveness for the ghostly companion you are preparing for me and to breathe into her such life that in the end, when you have finished the body, there is no spot which does not radiate feeling, to which you have not applied yourself to overcome by the most complex devices the dead material: then will all the delicate and intimate gifts of nature displayed in the female body be recalled to me in some desperate hour by some symbolic hieroglyph or sign with which you have secretly endowed that bundle of rags'.[15]

OSKAR KOKOSCHKA
Woman in Blue. *1919*

Kokoschka devoted great care to the painting he made of this inanimate object—he is said to have made some 160 preliminary sketches between April and June 1919.[16] The point I wish to make is that in his disgust with humanity, the direct result of his war experiences, he decided that he would himself create an ideal figure, devoid of human passions and failings, with whom he could live in unearthly solitude; but when he came to depict this lifeless doll, to pay his tribute to her unearthly stillness, the result was a projection of colour of such vital intensity that one might say that though the subject was inanimate, the painting had life. There is a coherent composition—a reclining figure with the lifeless gesture of a doll; there is the blue sky and green foliage; but these are not represented as objects of nature: the nature is in the harmony of the colours, the life is in the traces left by the movement of the painter's brush, and once more the autonomy of the work of art is vindicated. Kokoschka himself has said: 'For the creative man the problem is, first, to identify and define what darkens man's intellect; secondly, to set the mind free'.[17] It is true that he is here speaking in a political context, but the whole of Kokoschka's art is created in a political context; modern painting is only explicable in its political context. Kokoschka has described consciousness as 'a sea ringed about with visions', and what floats into this sea is beyond our control. Whether the image that takes shape suddenly is of a material or an immaterial character, figurative or non-figurative, that too is beyond our control. It is the psyche which speaks, and all the artist can do is to bear witness to the vision within himself. But the vision itself is fed by images from all human experience, as a lamp with oil, and the flame leaps before the artist's eyes as the oil feeds it. 'Thus in everything imagination is simply that which is natural. It is nature, vision, life.'[18]

I hope I am not reading into Kokoschka's paintings and writings a justification for the developments which have followed the Second World War, developments for which he has not been responsible and of which he may not approve. Nevertheless, if we affirm what Kokoschka calls the autonomy of vision, or the

interpretation of consciousness and imagination, we have then returned to Kandinsky's law of internal necessity. Art is simply the correspondence effected between this internal necessity, this clamant vision, and certain gestures, movements, colour compositions, unified as a structure of two or three dimensions—the word becoming flesh and dwelling among us.

The actual transition from the figurative Expressionism of painters like Kokoschka, Soutine, and Nolde to the abstract Expressionism which has been the characteristic style of the period since the Second World War does not possess the chronological continuity which makes for tidy history; nevertheless, the elements are there—in the early improvisations of Kandinsky, in Kokoschka's visionary transformation of reality, in Soutine's stretched membrane of paint, in Rouault's and Nolde's glowing encrustations of colour—a gradual approach to a mode of communication relying entirely on autonomous formations of outline and colour: symbols as automatic and as expressive as a signature.

OSKAR KOKOSCHKA
Murder Hope of Women. 1910

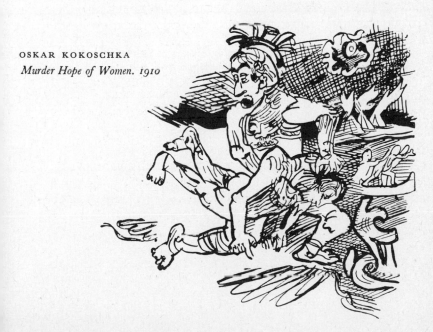

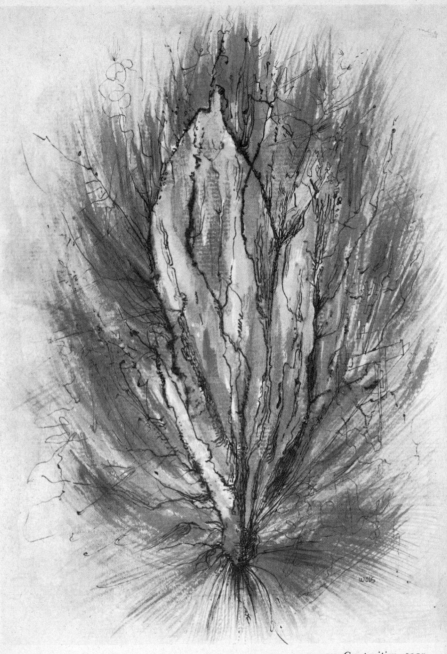

WOLS *Composition. 1950*

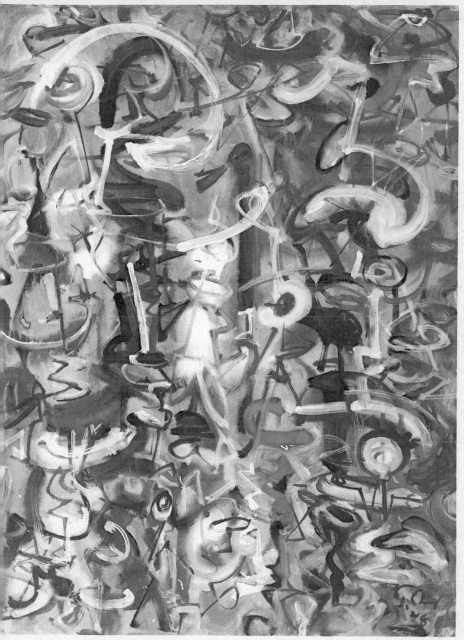

MARK TOBEY *Tropicalism. 1948*

The belief that the *facture* or handwriting of the artist is an essential clue to his identity and quality had been the basis of the methodical criticism of the arts from the beginning of such criticism in the 'seventies of the nineteenth century (Morelli and Cavalcaselle). Fenellosa and other exponents of Oriental art had later drawn attention to the high aesthetic value assigned to calligraphy in China and Japan. The present appreciation of such artists as Sesshu (c. 1420–1506), with his 'flung-ink' technique, no doubt has come about as a result of the discovery of similar techniques by modern artists; but the whole impact of Oriental art was such as to create an appreciation of the abstract qualities in works of art generally.

The priority of Kandinsky's discovery of 'pure composition' is not in question, but Kandinsky approached the whole problem in a most cautious way. He realized that 'the emancipation from dependence on nature is just beginning':

'If until now (i.e. 1910–12) colour and form were used as inner agents, it was mainly done subconsciously. The subordination of composition to geometrical form is no new idea (cf. the art of the Persians). Construction on a purely spiritual basis is a slow business, and at first seemingly blind and unmethodical. The artist must train not only his eye but also his soul, so that it can weigh colours in its own scale and thus become a determinant in artistic creation. If we begin at once to break the bonds that bind us to nature and to devote ourselves purely to combination of pure colour and independent form, we shall produce works that are mere geometric decoration, resembling something like a necktie or a carpet. Beauty of form and colour is no sufficient aim by itself, despite the assertions of pure aesthetes or even of naturalists obsessed with the idea of "beauty". It is because our painting is still at an elementary stage that we are so little able to be moved by wholly autonomous colour and form composition. The nerve vibrations are there (as we feel when confronted by applied art), but they get no farther than the nerves because the corresponding vibrations of the spirit which they call forth are weak'.[19]

If, in the next fifty years, these words of Kandinsky's had been

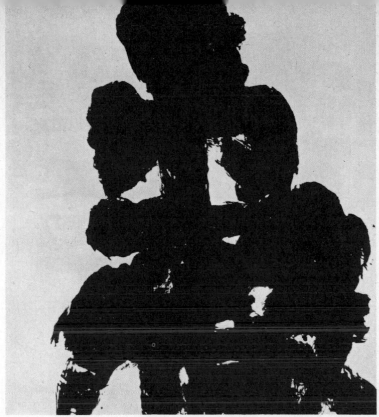

YOUICHI INOUE *Drawing. 1956*

remembered, there would have been much less confusion of thought and of practice. We are nowadays a little shy of using the word 'soul', or phrases like 'vibrations of the spirit', but it is not difficult to substitute the terminology of the psychology that has developed since 1912, and then we see that the point Kandinsky is making is obvious enough. It is not sufficient in an art of pure composition to appeal to sensation: the work of art must evoke a response at a deeper level, the level we now call unconscious; and the 'vibrations of the spirit' that then take place are either personal, in that they effect some kind of mental integration, or perhaps supra-personal, in that they assume the archetypal patterns into which mankind projects an explanation of its destiny.

Implicit in these premonitions of Kandinsky is a distinction which was to separate his early experiments in pure composition from his later abstractions, and these later abstractions from the

JEAN PAUL RIOPELLE *Encounter. 19*

PIERRE SOULAGES *Painting. 1954*

abstract expressionism that is our present concern. If one compares the *Compositions* of 1910–14 with the work Kandinsky did after his return from Russia in 1922, it might seem at first that he had succumbed to the 'mere geometric decoration' of whose superficiality he had been so fully aware in 1910. Kandinsky was always conscious of the mathematical basis of aesthetic form. *'The final abstract expression of every art is number'*, he declared with emphasis in his book, and for this reason if no other he could not finally surrender himself to any form of automatism. The work of art must have a 'hidden construction'; not an obvious geometrical construction, but nevertheless one with 'calculated' effects. He ended his treatise of 1912, as I have already pointed out, with the claim that we were approaching 'a time of *reasoned* and *conscious* composition, in which the painter will be proud to declare his work *constructional'*. The significance of the words I have emphasized is inescapable, and nothing in the future work of Kandinsky was to contradict them.

A comparable theorist of the opposing school of abstraction has not yet arisen, though one may find psychological justifications of it,[20] and the surrealist theories of 'automatism' were perhaps an inspiration to the movement. But here the distinction that has to be made is between the spontaneous projection of unconscious (more properly speaking, pre-conscious) imagery, and the recognition, in chance effects or spontaneous gestures, of forms that have an uncalculated and indeterminate significance. A graphologist will find a person's handwriting significant, and will generally prefer to look at it upside down in order not to be distracted from a contemplation of its form as distinct from its literal meaning. Abstract Expressionism, as a movement in art, is but an extension and elaboration of this calligraphic expressionism, and that is why it has a close relationship to the Oriental *art* of calligraphy.

A direct influence of Oriental calligraphy is seen in the work of Henri Michaux, who travelled in the Far East in 1933,[21] and has since become a somewhat esoteric master of calligraphic painting in Europe; and in the work of Mark Tobey (b. 1890) an

HENRI MICHAUX *Drawing*

American artist who visited the Far East in 1934, when he made
a special study of Chinese calligraphy. Another American artist
associated with Tobey who sometimes works in a calligraphic
style (though never with an abstract intention) is Morris Graves
(b. 1910). He too visited the Far East (Japan) in 1930.

The calligraphic style of these Pacific Coast artists penetrated
to Europe and reinforced the 'orientalism' of Michaux—the
influence of Tobey in Paris has been profound. Nevertheless one
must point out that even now Tobey is not strictly speaking an
abstract expressionist—his art does not spring spontaneously from
'inner necessity'. He is usually inspired by an external *motif*, an
atmospheric effect of nature or of cities, and though the final
picture surface (usually, as in Klee, of a miniature scale) may be
completely non-objective in effect, in origin such an art is still
analytical of nature rather than expressive of an inner necessity.
Tobey has said: 'Our ground today is not so much the national
or the regional ground as it is the understanding of this single
earth. . . . Ours is a universal time and the significances of such a
time all point to the need for the universalizing of the conscious-
ness and the conscience of man. It is in the awareness of this that

ALFRED MANESSIER *Night. 1956*

our future depends unless we are to sink into a universal dark age'.[22] A metaphysical point of view, but Tobey does not imply, as Kandinsky does, that the inner world has its own internal harmony, its own necessity, its own formative processes. Tobey speaks of 'universalizing', whereas expressionism of any kind, and especially at its abstract extreme, implies a process of individuation.

Tobey did not reach a stage of development which could be called 'abstract' (even in this universal sense) before 1940. Meanwhile in Paris two artists, Jean Fautrier (b. 1897) and Wols (Alfred Otto Wolfgang Schulze, 1913–51) had evolved, from quite different sources, a completely abstract type of expressionism. Fautrier began to experiment with informal abstractions in the early 'twenties. Both artists again work usually on a miniature scale, but their sources of inspiration are quite distinct. Wols, who was born in Germany but lived in France from 1932 until his death,

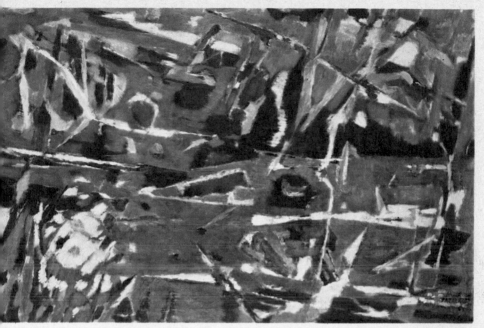

JEAN BAZAINE *Low Tide. 1955*

is an example of an artist who returns to what has been called 'multi-evocative' forms—that is to say, the kind of forms we discover, under the microscope, in the cellular structure of living organisms, in the atomic structure of matter, and in malignant growths.[23] He himself has written in a poem:

> 'A Cassis les pierres, les poissons
> les rochers vue à la loupe
> le sel de la mer et le ciel
> m'ont fait oublier l'importance humaine
> m'ont invité à tourner le dos
> au chaos de nos agissements
> m'ont montré l'éternité
> dans les petits vagues du port
> qui se répètent
> sans se répéter. . . .'

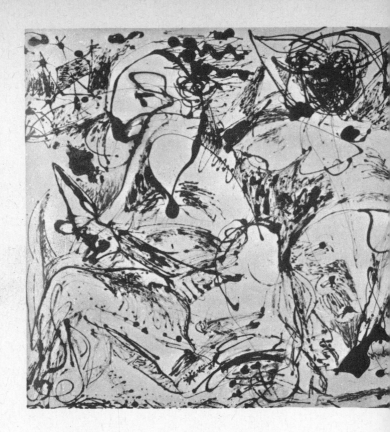

('At Cassis the pebbles, the fish
rocks under a magnifying-glass
sea-salt and the sky
have made me forget human pretensions
have invited me to turn my back
on the chaos of our goings-on
have shown me eternity
in the little waves of the harbour
which repeat themselves
without repeating themselves. . . .')

It is the same microscopic point of view as Blake's

'To see a World in a Grain of Sand
And Heaven in a Wild Flower. . . .'

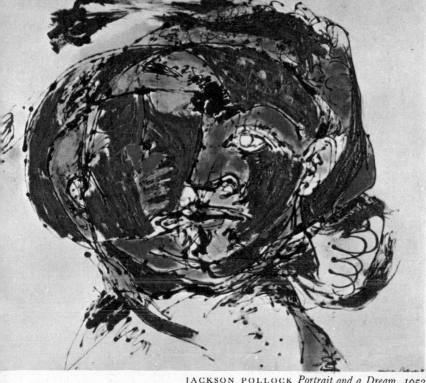

JACKSON POLLOCK *Portrait and a Dream. 1953*

'Il faut savoir que tout rime', Wols has also written in this same
poem, and his paintings are a demonstration of this truth: the
forms that the artist creates derive their significance from the fact
that they are forms that are echoed throughout the cosmos—in
the structures of metals, fibres, organic tissues, electron diffraction
patterns, frequency modulations, detonation patterns, etc. What
is significant about such forms is that they are not necessarily
precise or regular: 'Quantity and measurement are no longer the
central preoccupations of mathematics and science . . . structure
emerges as the key to our knowledge and control of our world—
structure more than quantitative measure and more than relation
between cause and effect',[24] and it is this indeterminacy or

irregularity that is reflected in the forms created by artists like Wols and Fautrier.

Fautrier's style leads gradually towards 'action painting', a phrase invented by the American critic, Harold Rosenberg. In this connexion the arrival as refugees in America in 1941 of certain French artists seems to have been a significant event. Breton himself was there, but it was not Breton, or even Yves Tanguy or Max Ernst, also 'on location', who was destined to be the catalytic agent, but their rebellious friend, André Masson. Masson himself has defined his position *vis-à-vis* Surrealism in his *Entretiens avec Georges Charbonnier*,[25] but from the beginning this Nietzschean spirit had resisted Breton's 'methodical' conception of automatism, and had practised a trancelike automatic writing (or painting) in which there was no element of calculation. Already in the 1920's Masson's work was distinguished by its nervous linear intensity, never geometrical but rather organic, resembling in some paintings the latest works of Franz Marc, and Kandinsky's compositions of the same time. By 1940 he had developed a whole mythology of the unconscious, and this was the style he transported to America. In such works the whole canvas is a linear paroxysm, an electric discharge of vibrant colours.

When Masson arrived in the United States he found himself on prepared ground. Marcel Duchamp had been there since 1915. Amédée Ozenfant came to the United States in 1938, Yves Tanguy in 1939, and in this same year Matta Echaurren, who had been born in Chile in 1911, came to New York via Paris bringing with him a dynamic form of Surrealism which in its linear intensity anticipates some of the characteristics of action painting. Matta had probably been influenced by Miró, and so had Arshile Gorky, who came to the United States in 1920, but did not develop his characteristic style before the early 'forties. Miró's influence is apparent above all in the 'mobiles' of Alexander Calder (b. 1898). Nevertheless, the American artist with whom in retrospect we associate the whole concept of 'action painting', Jackson Pollock (1912–56), was inspired directly by Masson (the influence begins before Masson's arrival in the United States, about 1938, and is

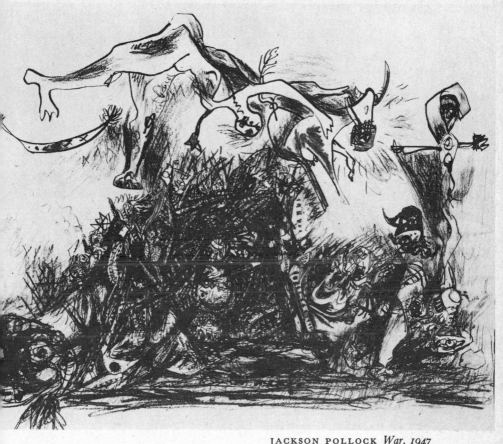

JACKSON POLLOCK *War. 1947*

still very evident in his later works, such as *Sleeping Effort* of 1953).
The influence of Picasso and Miró is also apparent, but does not
seem to be so stylistically significant. Pollock's origins can be
traced fairly precisely, and they are formed in that rebellious
phase of Surrealism best represented by Masson. That they owe
something to the remoter 'dynamism' of the Futurists is possible,
but such an influence could have been more directly transmitted
through Masson and Miró.

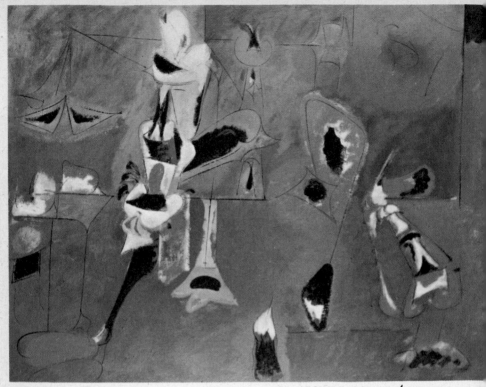

Pollock's transition to a more personal conception of painting has been well described by Sam Hunter. After recognizing that Pollock owed his 'radical new sense of freedom' to the unpremeditated and automatic methods of the Surrealists, artists like Ernst, Masson and Matta who had 'circumvented the more rigid formalisms of modern art . . . by elevating the appeal to chance and accident into a first principle of creation', Mr Hunter observes that:

'Such paintings of 1943 as *The She-Wolf* and *Pasiphaë* and *Totem I* of 1944 show Pollock's very personal application of Surrealist devices. He has retained fragments of Picasso's anatomical imagery and distorted memories of the Surrealistic bestiary,[26] all within a scheme of continuous, circulating arabesques which seem to operate automatically and remind us of Miró or Masson. Yet, all Pollock's forms have an evenness of

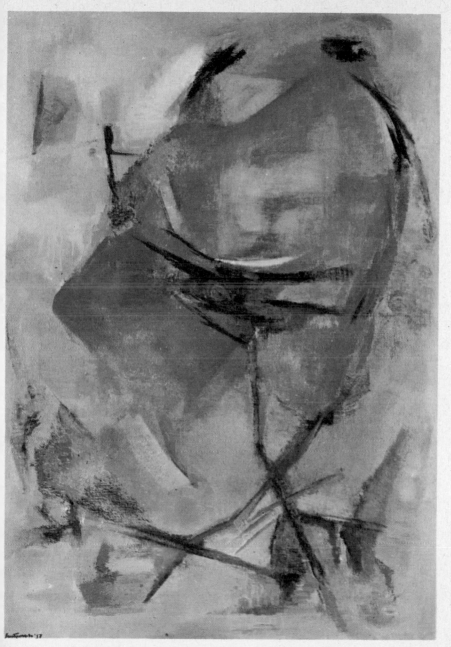

GUISEPPE SANTOMASO *Reds and Yellows of Harvest Time. 1957*

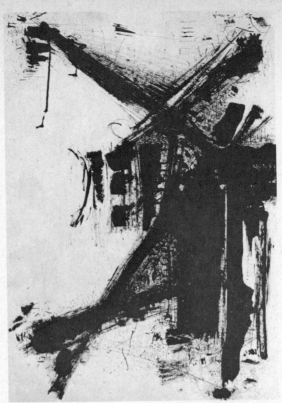

JOHN LEVEE *Drawing. 1955*

expressive emphasis which breaks down their separate identities and robs them of much of their symbolic power; they function finally as pure plastic signs. Although Pollock and a number of his American contemporaries had been drawn to Surrealism, because its exasperations and climate of crisis seemed to jibe with their own violently rebellious feelings, they were not driven into an art of fantasy or chimerical vision primarily, but one of immediate concrete pictorial sensations. They revealed themselves as sensitive materialists even as they appropriated Surrealism's bizarre dreams in their crusade against the materialism and the pressures toward conformity of shallow, popular culture'.[27]

The clue to Pollock's originality is found in the phrase 'concrete pictorial sensations'. Sensations of this kind are, of course, essential to any plastic work of art, but Pollock's aim was to try

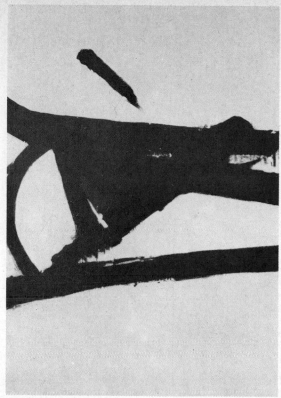

FRANZ KLINE *Accent Grave. 1955*

and isolate these concrete sensations, that is to say, free them from the memory images that inevitably insert themselves into any mode of expression, particularly into any attempt to project images from the unconscious. Answering a questionnaire in 1944, Pollock said that he had been impressed by certain European painters (he mentions Picasso and Miró) because they conceived the source of art as being in the unconscious. To the surrealists the unconscious had been a source of symbolic metaphors—that is to say, of pictorial images that could be identified, recognized, and that differed from normal perceptual images only in their irrational association. The association of an umbrella and a sewing-machine might have a significance that could be explained—interpreted or analysed. Such explanation was none of the painter's business: his only obligation was to project the significant images. But such images, in psychoanalytical terminology, come from a relatively

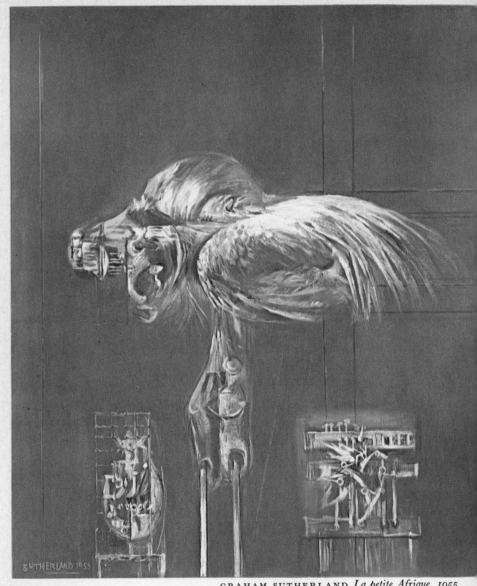

GRAHAM SUTHERLAND *La petite Afrique. 1955*

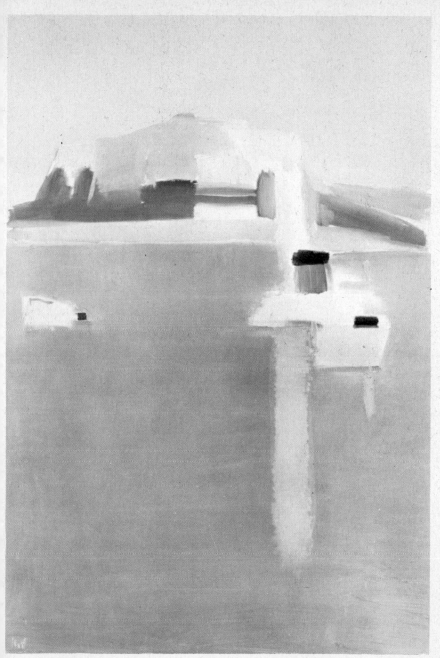

NICOLAS DE STAËL *Le Fort d'Antibes. 1955*

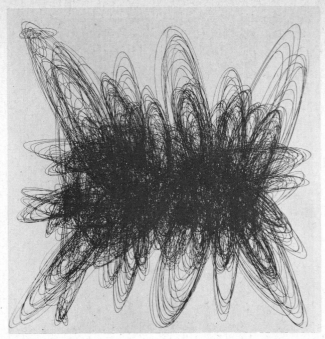

ROBERTO CRIPPA *L'Altro. 1951*

superficial layer of the unconscious, from what Freud called the pre-conscious. There exists another kind of image, not an associated pictorial image, but a sensational image, an image of an indeterminate shape and imprecise colours, which perhaps comes from a deeper layer of the unconscious, with no immediate perceptual associations from the external world.

Before we hasten to identify such images with the kind of images we find in Pollock's paintings, we must pause a moment to consider Pollock's actual practice. His 'method' has become a legend —the unstretched canvas on the floor, the use of sticks, trowels, knives and dropping fluids, the occasional use of sand or broken glass—all these dodges have usually been interpreted as a means to automatism. But Pollock's aim, as he said, was to get *in* his painting, to become part of the painting, walking round it and working from all directions, like the Indian sand painters of the West. 'When I am *in* my painting, I'm not aware of what I'm doing. It is only after a sort of "get acquainted" period that I see what I have been about. I have no fears about making changes,

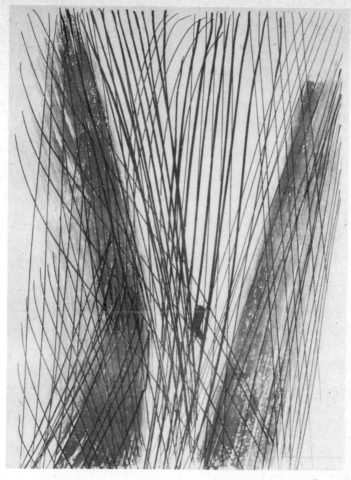

HANS HARTUNG *Composition I*

destroying the image [my italics H.R.] etc., because the painting has
a life of its own. I try to let it come through. It is only when I lose
contact with the painting that the result is a mess. Otherwise
there is pure harmony, an easy give and take, and the painting
comes out well'.[28]

'The painting comes out well'—by what standards? Pollock
probably did not ask himself such a tiresome question, but it is a
vital one for the history of art. Phrases like 'concrete pictorial
sensations', 'the painting has a life of its own', suggest that *vitality*
is the criterion; but Pollock also speaks of 'pure harmony', of 'an
easy give and take', phrases reminiscent of Matisse's 'art of

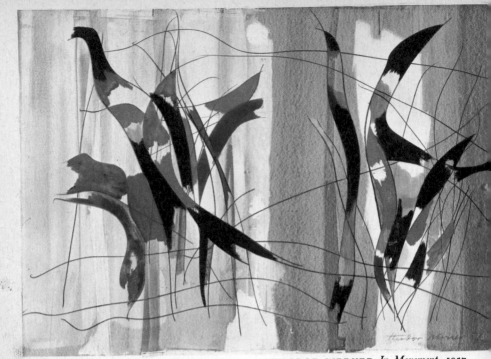

THEODOR WERNER *In Movement. 1957*

balance', his 'mental soother', his 'good armchair to rest in'—in other words, a criterion of pleasure or *beauty*. But of symbolism there is no suggestion; on the contrary, a desire to destroy the image and its symbolic associations.

One should not force a unity of aim on Pollock which his painting does not uphold. Over the twenty years of his development he experimented widely, and he never wholly deserted an expressionistic aim. The painting I have chosen for reproduction, *Portrait and a Dream*, 1953 (*p. 257*), illustrates obviously the continuous dichotomy between the desire to give direct expression to a feeling and the desire to create a pure harmony, and this is a conflict inherent in the whole development of modern art. On the one side a coherent image, a more or less precise configuration with its spatial envelope; on the other side only the tracks left by the painter's gestures, the internal dynamics of the painted area. 'From 1946 to 1951', Mr Hunter observes in the article already quoted from, 'he painted entirely non-objective works [not quite true, as our illustration shows]. The painting was now conceived

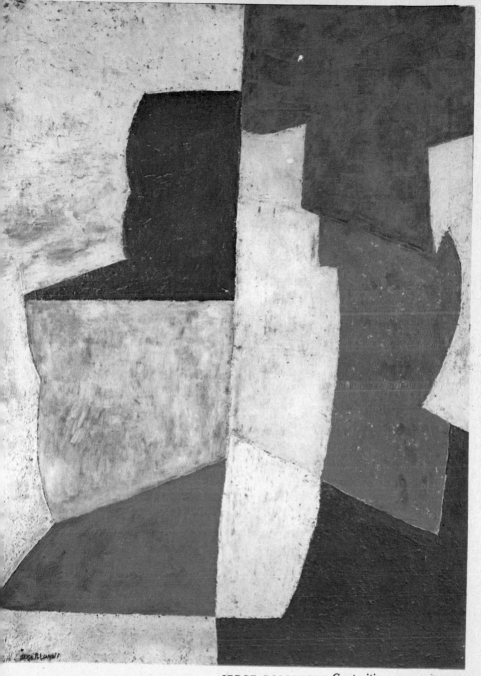

SERGE POLIAKOFF *Composition. 1949*

as an intrinsic creation, a work that should stand by a miracle, like a house of cards, "sustained by the internal force of its style", in Flaubert's phrase. All emotion, no matter how extravagant, was translated into convincing pictorial sensation'.

Pollock was killed in an automobile accident in 1956. Since his death he has become a symbolic figure, representative of a whole movement that has given American painting an international status it never enjoyed before. But this movement cannot be confined to America, nor did it originate there: as I have repeatedly said in this volume, it is impossible to establish national boundaries for modern painting. Pollock himself said: 'the idea of an isolated American painting, so popular in this country during the 'thirties, seems absurd to me just as the idea of a purely American mathematics or physics would seem absurd . . . the basic problems of contemporary painting are independent of any country'.[29]

The American painters themselves sometimes reside for long periods in Europe, and certainly the European painters feel a

ANTONIO TAPIES *Yellow Painting. 1954*

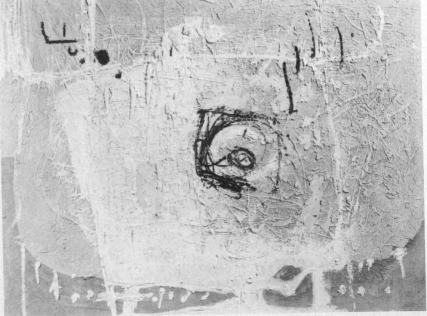

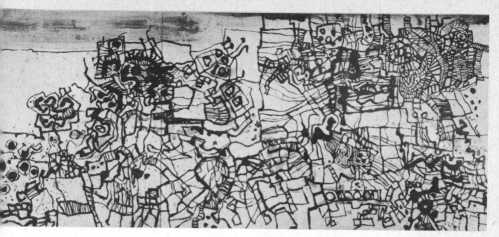

CORNEILLE *Drawing in Colour. 1955*

community of interest, and even a continuity of tradition, with their American contemporaries. A painter like Hans Hofmann who has been a focus round which the contemporary movement in the East of the United States has developed, was born in Germany (in 1880) and was already fifty-one and imbued with the Expressionist (or Fauvist) tradition when he came to America. Of the more outstanding American painters, Willem de Kooning was born in the Netherlands (b. 1904—in the United States since 1926), Arshile Gorky (1904–48) was born in Turkish Armenia, Mark Rothko was born in Russia (1903) and Jack Tworkov in Poland (1900). It is not possible to make any significant distinction between these painters and those, such as Bradley Walker Tomlin (b. Syracuse, N.Y., 1899), Adolf Gottlieb (b. New York, 1903), Clyfford Still (b. North Dakota, 1904), Barnett Newman (b. New York, 1905), James Brooks (b. St. Louis, 1906), Franz Kline (b. Pennsylvania, 1911), Philip Guston (b. Montreal, Canada, 1912), Robert Motherwell (b. Aberdeen, Washington, 1915), Grace Hartigan (b. New Jersey, 1922), Theodoros Stamos (b. New York, 1922), and William Baziotes (b. Pittsburg, 1912), who might claim to be indigenous. A shift of our attention to Europe would reveal a similar international distribution—Jean Bazaine, Alfred Manessier (b. 1911), Pierre Soulages (b. 1919), and Georges Mathieu (b. 1922), all born in France, Jean Paul

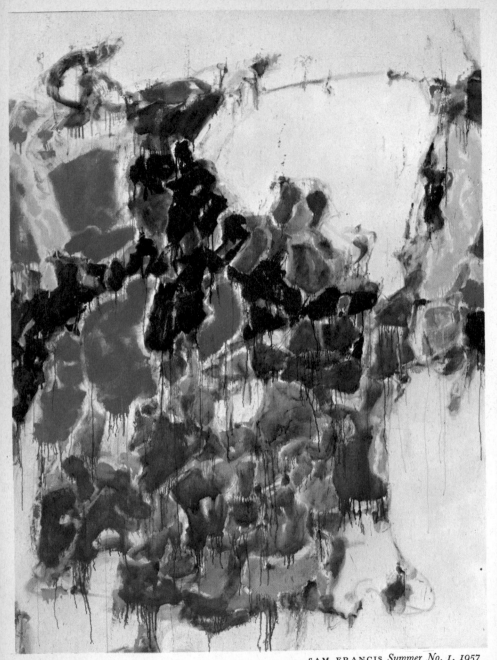

SAM FRANCIS *Summer No. 1. 1957*

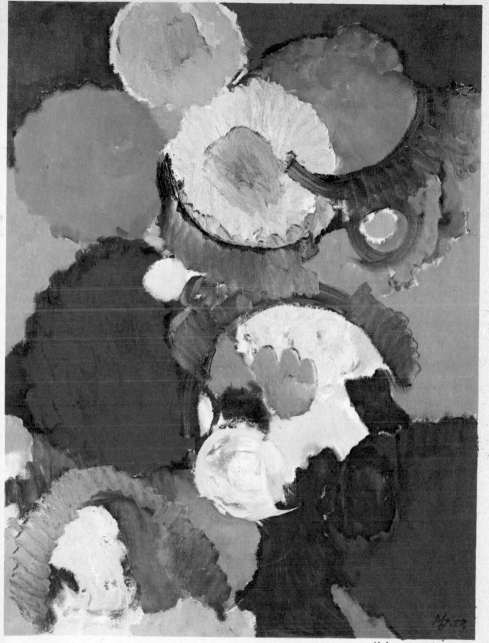

ERNST WILHELM NAY *Alpha. 1957*

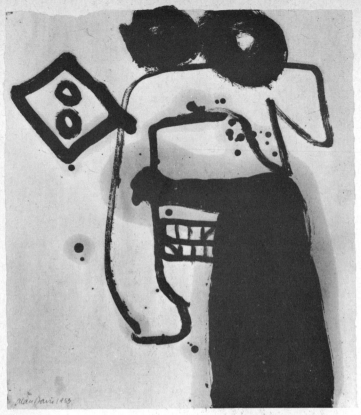

ALAN DAVIE *Fish God Variation No. 2. 1953*

Riopelle in Canada, Asger Jorn (b. 1914) and K. R. H. Sonder-
borg (b. 1923) in Denmark, Bram van Velde (b. 1895), Geer van
Velde (b. 1898), and Karel Appel (b. 1921) in Holland, Hans
Hartung (b. 1904), Emil Schumacher (b. 1912), and Josef Fuss-
bender (b. 1903) in Germany, Corneille (Cornélis van Beverloo, b.
1922) in Belgium, Alan Davie (b. 1920) in Scotland.

There are artists who transform the real into plastic images—
Giuseppe Santomaso (b. 1907), Antonio Corpora (b. 1909), Afro
(Afro Basaldella; b. 1912), Emilio Vedova (b. 1919), Graham
Sutherland (b. 1903), William Scott (b. 1913)—and there are
artists who transform the plastic material itself into a real object
—sculptors for the most part, but also painters such as Jean
Dubuffet (b. 1901) and Alberto Burri (b. 1915), and the Spaniards
Antonio Tapies (b. 1923) and Modesto Cuixart (b. 1924).

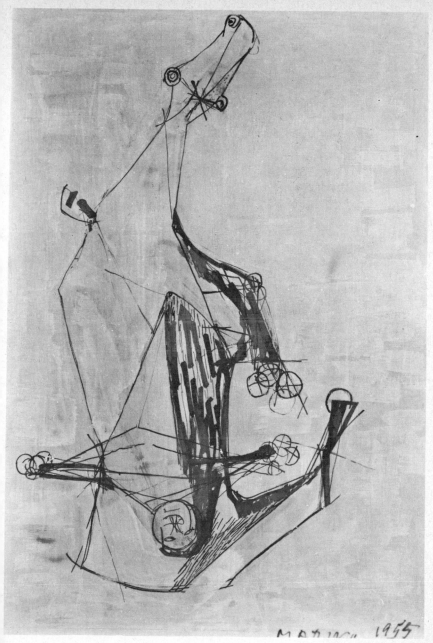

MARINO MARINI *Falling Horse and Rider. 1955*

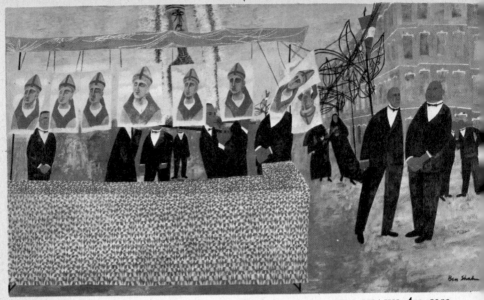

BEN SHAHN *Ave. 1950*

Dubuffet's plastic images suggest the spontaneous pleasure with which a child manipulates paint, or the use of natural features in prehistoric cave drawings or contemporary *graffiti* (street drawings). Quite distinct from such transformations, but still depending on a sensuous manipulation of paint, are the abstract compositions of Nicolas de Staël (1914–55), in which the *motif* remains luminously present. The informal abstractions of Sam Francis (b. 1923) seem to condense space itself into a luminous substance.

To attempt a classification of all this immediate ferment would be a critical rather than a historical task, but one may suspect that to the future historian the similarities will be more striking than the present differences. There is an endless counterchange between the real and the superreal, between the image and the concept, and in infinite scale of forms dissolving into the informal. But the informal is not to be confused with the formless. Only vacancy is formless. The distinction is between forms that have significance —and only such significance can be vital, magical or harmonic— and forms that are insignificant. But it can still be asked: significant for whom?

This question poses the whole problem of communication, which is perhaps the final problem confronting the modern artist.

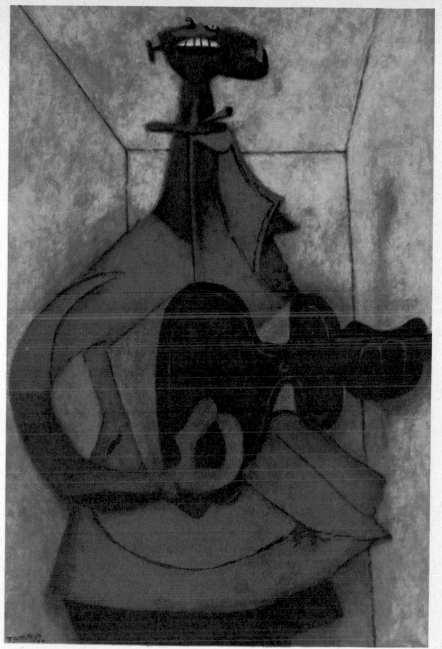

RUFINO TAMAYO *The Singer. 1950*

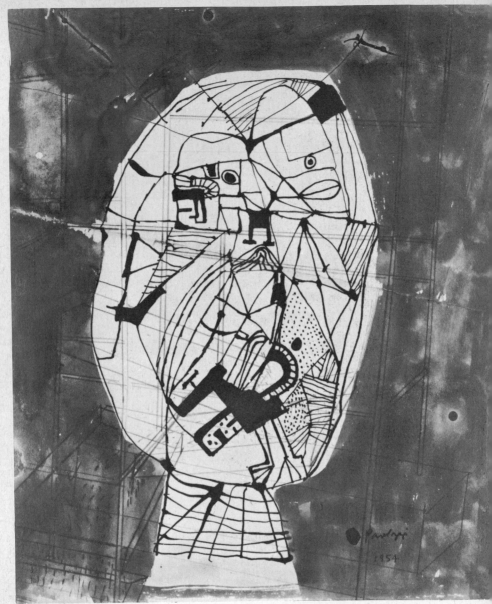

EDUARDO PAOLOZZI *Head I. 1954*

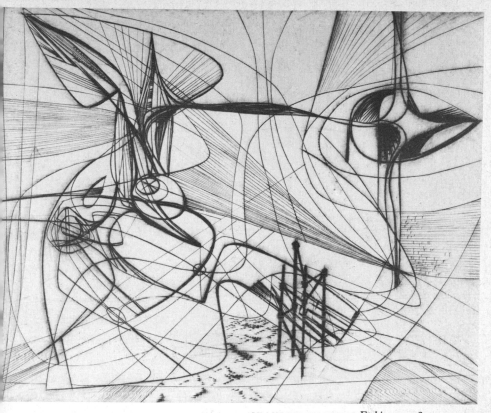

STANLEY HAYTER *Etching. 1946*

Modern art is often condemned for its subjectivity, its individualism, its solipsism. Expressionism itself (and the whole of this movement is often somewhat loosely described as abstractly expressionistic) can be condemned as an activity that has nothing in common with art, in the proper sense of that word. Art has always been a process of reification, a making of things with an independent and 'worldly' existence. 'This inherent worldliness of the artist', observes Hannah Arendt, 'is not changed if a "non-objective art" replaces the representation of things; to mistake this non-objectivity for subjectivity, where the artist feels called upon to "express himself", his subjective feelings, is the mark of charlatans, not of artists. The artist, whether painter or sculptor or poet or musician, produces worldly objects, and his reification has nothing in common with the highly questionable and, at any rate,

ASGER JORN *Letter to my Son. 1956–7*

wholly inartistic practice of expressionism. Expressionist art, but not abstract art, is a contradiction in terms'.[30]

This is a severe judgement, but coming from a philosopher of great distinction, we must give it due consideration. As we have seen the aim of a painter like Jackson Pollock is not primarily expressionistic—'the painting has a life of its own'; exists therefore as a thing, independent of the artist's subjective feelings. We, the spectators, react to its 'pure harmony' with appropriate feelings, but the painting does not 'express' these feelings—it merely provokes them, and in this sense is an object in the world, as impersonal as an apple or a mountain.

Such is the test we must apply to informal art, as to all kinds of art. It is a test that would exclude many contemporary artists. The notion of an absolute standard, to which all artists should conform, has been lost, or deliberately sacrificed; and with this goes the *competitive* sense of craftsmanship, a deprivation which is one of the most dubious aspects of this whole development. An artist's standards become his own sense of release, and whatever aesthetic values may exist in the work of art, of beauty or vitality,

WILLEM DE KOONING *Woman II. 1952*

are merely incidental, or accidental. But there is always a chance that the accidental is also the archetypal—that the spontaneous gesture is guided by archaic instincts.

The artist's own sense of release has in recent years expressed itself in manifestations that are too confused to be convincingly classified, but within this confusion two stylistic extremes may be discerned—the one selective, severe, indifferent to the arbitrary phenomena of visual experience, essentially *inventive*; the other inclusive of whatever visual experiences seem to the artist to be representative of popular taste, permissive, arbitrary, essentially *reproductive*. Neither development is characterized by creative imagination, and the kind of sensibility involved (by comparison with the kind we associate with painters such as Cézanne, Matisse or Picasso) is either timid or baffled. Nevertheless, the achievements that emerge from these two stylistic trends do represent the spiritual ferment of a younger generation and cannot be loftily dismissed as insignificant.

The two trends have been called (in slang terms in keeping with their deliberate informality) *op-art* and *pop-art*. Op(=optical)-art is geometrical, usually confined to patterns of black and white, and usually productive of an illusion of movement or instability. Its 'old master' is the French artist Victor Vasarely (b. 1908) and it now has many devotees throughout the world. The British artist Bridget Riley (b. 1931) is perhaps the most ingenious of such pattern-makers, and her work, when carefully placed in an architectural setting, has a vitalizing effect. It is not concerned with the kind of problem that obsessed Mondrian or the Constructivists (to which it may some time have a superficial resemblance); it is an art of linear movement, of visual excitation, and its significance remains relatively superficial. A logical development of this kind of art abandons the two-dimensional plane and suspends geometrical elements that move (agitated either by chance currents of air or by an invisible motor) against a fixed background. The best of these precise and elegant constructions (e.g. those of the Venezuelan artist Jesus-Raphael Soto) are not merely decorative; they express the mental preoccupations of a

WILLIAM SCOTT *Drawing. 1959*

technological civilization, and are in harmony with its typical architecture.

Pop-art is said to have made its first appearance in England, but perhaps it was only first given its name by an English critic, Lawrence Alloway. It has been a world-wide phenomenon since Dada, and Kurt Schwitters, John Hartfield, Picabia and above all Marcel Duchamp made use of the same 'popular' elements. Nevertheless, especially in the United States, this revival of the Dada spirit has produced some extravagant variations.

Duchamp long ago discovered (see pages 117–20) that a ready-made object, if taken out of its normal context and presented as a 'thing-in-itself', could compete for attention with a work of art. It has shape, it has colour, it has associations which can shock or outrage the spectator. A urinal, for example, is normally a utilitarian object serving a necessary function in a somewhat

GEER VAN VELDE *Les Outils Naturels. 1946*

ALBERTO BURRI *Sacco 4. 1954*

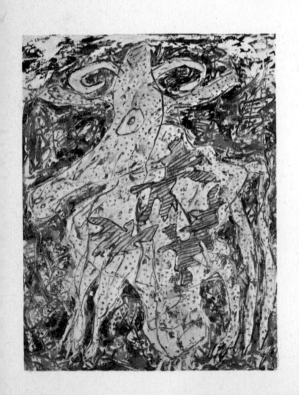

PATRICK HERON
Manganese in Deep Violet: January 1967

JEAN DUBUFFET
Vache la Belle Allegre. 1954

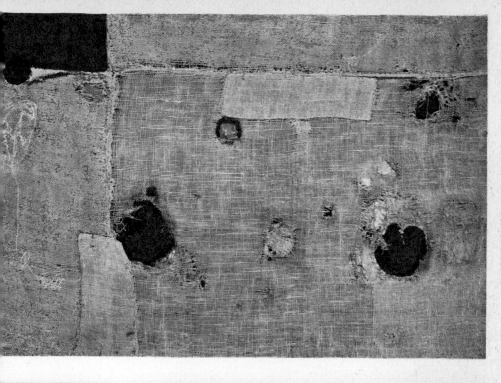

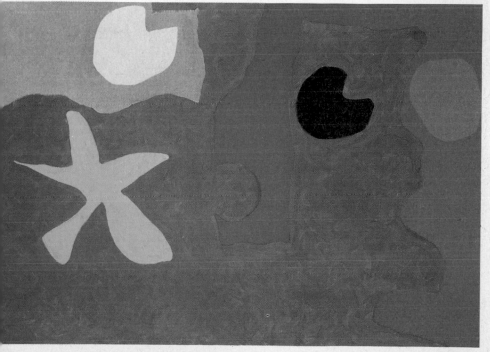

private environment (a public lavatory). Remove it from its functional situation, reverse its usual placement, isolate it in an environment where the public expect to find a work of art, and the possibility is that it will then produce an aesthetic sensation, or at least, some feeling that can be confused with an aesthetic sensation. Duchamp's original purpose was not to deceive the spectator: he is an iconoclast and his purpose is to destroy the whole academic concept of a 'work' of art. Art is any object that can function as a symbol of feeling, and there is no need for the feeling to be refined or socially exclusive. A urinal, from this point of view, is just as valid as the Venus de Milo.

It is a perverse but not an illogical argument. Its motive is to awaken rather than destroy aesthetic sensibility. It clears the mind of intellectual cant and allows the object to serve as a direct symbol of feeling. In this sense the development from Dada to pop-art is a coherent manifestation of revolt and as such its significance is social rather than artistic. Nevertheless, it leaves behind it, when the dust has settled, a few genuine works of art.

It is characteristic of such a manifestation that it has no respect for the traditional categories of art—painting is confused with sculpture and ready-made objects are freely combined with the traditional materials of art. In choosing illustrations for a volume devoted to such a traditional category as painting, I have limited myself to examples which keep to a two-dimensional framework, allowing for a few extrusions in the nature of the now traditional collage. But pop-art in a more restricted sense must be distinguished from the traditional collage in that it takes its motives direct from the cinema and supermarket, and merely isolates or enlarges these images for our inescapable attention. Just as the aural 'image' becomes supersonic, so the pictorial image becomes supervisual. Luckily we can still close our eyes.

'Sheer size' is a characteristic of all these recent trends—expanses of canvas twenty or more feet long and eight or ten feet high. Such proportions exclude the canvases from the normal art gallery (and certainly from the normal house or apartment) and special arrangements have to be made for their exhibition. It is

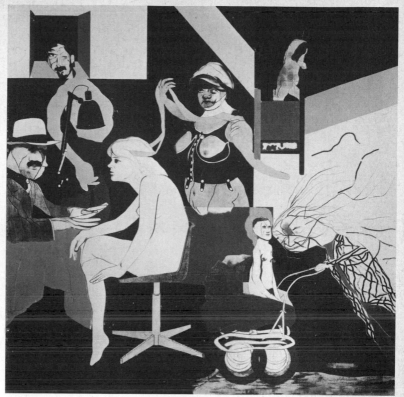

PETER BLAKE
l She Devil of Naked
Madness. 1955

R.B. KITAJ
The Ohio Gang. 1964

then claimed that they create an 'environment'—usually an
environment of one colour and a minimum of design. Since the
work of art has hitherto been based on a principle of selectivity
and concentration (with a few exceptions such as Monet's
Nymphéas series, the work of an old man incapable of visual con-
centration), environmental art is essentially another manifestation
of the anti-art motives of the Dadaists. The next step—and it has
already been taken—is the systematic destruction of the work of
art. A movement has been found in England and the United States
called DIAS (the Destruction in Art Symposium), comprising such
activities as 'Destruction Happenings', 'Destruction Concerts and
Realizations', 'Cosmetic Destructions', 'Destruction Events' and
'Glass Deformations'. It is significant that Richard Huelsenbeck,

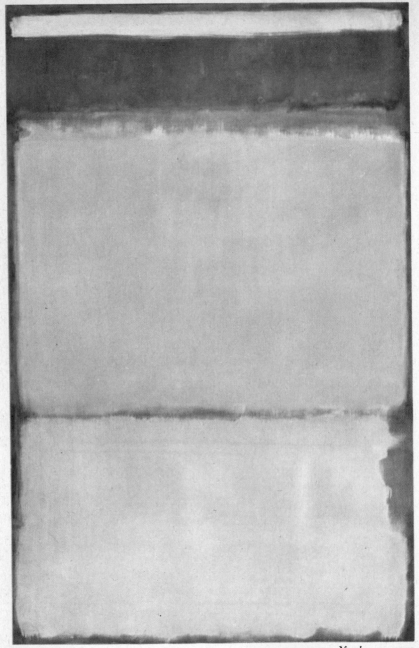

MARK ROTHKO *Number 10. 1950*

'Co-founder of Dada and Existential Psychiatrist', is on the American Executive Advisory Committee of this movement.

Before concluding that DIAS is a final demonstration of the cultural decadence of the Western World, one should reflect that the aims of the Red Guards in renascent China are not essentially different. The whole world seems to anticipate a cataclysm in which art, as we have known it, will be destroyed. It is still possible to believe, however, that it is humanity itself that would perish in such a cataclysm: still possible to believe that human civilization, in any acceptable sense, is not endurable without the kind of art that has sanctioned its evolution since prehistoric times.

I began this book with a quotation from Collingwood and I may appropriately end it with another. At the end of his own book, *The Principles of Art*, a book in which he had defined more clearly than anyone else of his time the true characteristics of the experience we call art, he suggested that there was still one he had not hitherto mentioned—art must be prophetic. 'The artist must prophesy not in the sense that he foretells things to come, but in the sense that he tells his audience, at the risk of their displeasure, the secrets of their own hearts. His business as an artist is to speak out, to make a clean breast. But what he has to utter is not, as the individualistic theory of art would have us think, his own secrets. As spokesman of his community, the secrets he must utter are theirs. The reason why they need him is that no community altogether knows its own heart; and by failing in this knowledge a community deceives itself on the one subject concerning which ignorance means death. For the evils which come from that ignorance the poet as prophet suggests no remedy, because he has already given one. The remedy is the poem itself. Art is the community's medicine for the worst disease of mind, the corruption of consciousness.[31]

The modern movement in art has so often been presented as in itself corrupt[32] that it may seem paradoxical to represent it as a purifying influence. But such it is and has been from the moment that Cézanne resolved to 'realize his sensations in the presence of nature'. In retrospect the whole of this movement, in spite of its

JESUS-RAPHAEL SOTO
Horizontal Movement. 1963

deviations and irregularities, must be conceived as an immense effort to rid the mind of that corruption which, whether it has taken the form of fantasy-building or repression, sentimentality or dogmatism, constitutes a false witness to sensation or experience. Our artists have often been violent or destructive, inconsiderate and impatient, but in general they have been aware of a moral issue, which is the moral issue facing our whole civilization. Philosophy and politics, science and government, all rest finally on the clarity with which we perceive and conceive the facts of experience, and art has always been, directly through its artists and poets and indirectly through the use which other people make of the signs and images invented by these poets and artists, the primary means of forming clear ideas of feelings and sensations. Individual artists may have introduced confusion into the general aim, but in the minds of the great leaders of the modern movement in painting—Cézanne, Matisse, Picasso, Kandinsky, Klee, Mondrian, and Pollock—there was always a constant awareness of the problem of our age, always a constant alertness to false solutions. To present a clear and distinct visual image of sensuous experience—that has always been the undeviating aim of these artists, and the rich treasury of icons they have created is the basis upon which any possible civilization of the future will be built.

Pictorial Survey of
MODERN PAINTING

The following survey is not comprehensive, and could not be so within the compass of a volume of this size. It is intended as an appendix to the preceding text and plates. The reproductions are in chronological order.

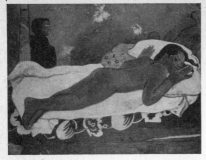

1 Paul Gauguin
The Spirit of the Dead Watches. 1892

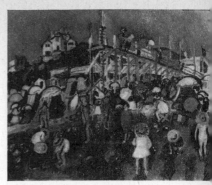

2 Raoul Dufy *Ste-Adresse. 1906*

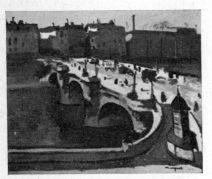

3 Albert Marquet *The Pont Neuf. 1906*

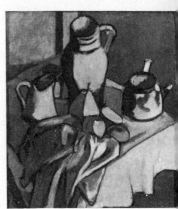

4 André Derain *Still-life.* c. *1907*

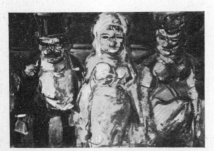

5 Georges Rouault *Aunt Sallies. 1907*

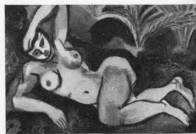

6 Henri Matisse *The Blue Nude. 1907*

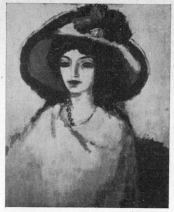

7 Paula Modersohn-
Becker
Self-portrait. 1907

8 Kees van Dongen
Woman with Hat. 1908

9 Wassily Kandinsky
Landscape with Tower. 1908

10 Pablo Picasso
Nude in a Forest. 1908

11 František Kupka
The First Step. 1909

12 Oskar Kokoschka
Portrait of Mme Franzos. 1909

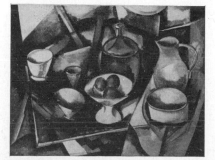

13 Maurice de Vlaminck
Still-life with White Pottery. 1909

14 Erich Heckel *Fasanenschlösschen. 1910*

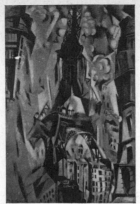

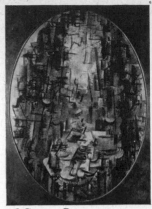

15 Robert Delaunay
La Tour Eiffel. 1910

16 Georges Braque
The Violinist. 1911

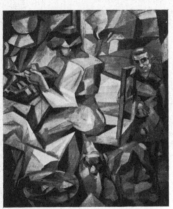

17 Albert Gleizes *The Kitchen. 1911*

18 Wassily Kandinsky *Circumscribed. 1911*

19 André Lhote *Nude: Flute Player. 1911*

20 Max Pechstein *Under the Trees. 1911*

21 Luigi Russolo *Houses and Light. 1912*

22 Michael Larionov *Rayonnist composition. 1911*

23 Roger de la Fresnaye *Emblems.* c. *1912*

24 Henri Le Fauconnier
The Huntsman. 1912

25 Giacomo Balla
Automobile and Noise. 1912

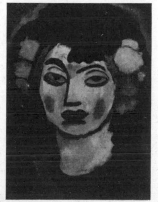

26 Alexei von Jawlensky
Spanish Girl. 1912

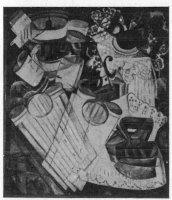

27 Nathalie Gontcharova
The Laundry. 1912

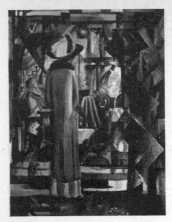

28 August Macke
The Shop-window. 1912

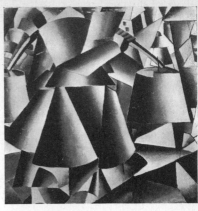

29 Kasimir Malevich
Woman with Water Pails. 1912

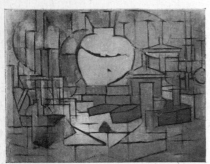

30 Piet Mondrian
Still-life with Ginger-pot II. 1912

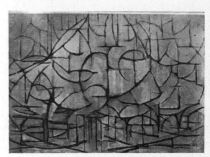

31 Piet Mondrian *Flowering Trees. 1912*

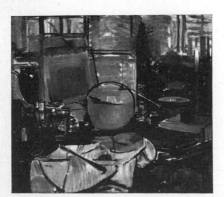

32 Piet Mondrian
Still-life with Ginger-pot I. 1912

33 Morgan Russell
Synchromy No. 2 to Light. 1912

34 Jean Metzinger
Dancer at the Café. 1912

35 Karl Schmidt-Rottluff
Woman with Bracelets. 1912

36 Jacques Villon *Young Girl. 1912*

37 Gino Severini
Spherical Expansion of Light. 1913

38 Umberto Boccioni
Dynamism of a Cyclist. 1913

39 Antoine Pevsner
Abstract Forms. 1913

40 Alfred Reth
Corner of the Studio. 1913

41 Marcel Duchamp
Chocolate Grinder No. 2. 1914

42 Enrico Prampolini
Lines of Force in Space. 1914

43 Franz Marc *Fighting Forms. 1914*

44 Paul Klee *Red and White Domes. 1914*

45 Paul Klee *Homage to Picasso. 1914*

46 Piet Mondrian *The Sea. 1914*

47 Sonia Delaunay-Terk *Portuguese Market. 1915*

48 Pablo Picasso
Woman with Guitar. 1915

49 Georges Ribemont-Dessaignes
Young Woman. c. *1915*

50 Giorgio de Chirico
Regret. 1916

51 Carlo Carrà
Composition with T.A. 1916

52 Bart van der Leck
Geometrical Composition. 1917

53 Francis Picabia
Parade Amoureuse. 1917

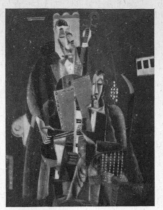

54 Max Weber
The Two Musicians. 1917

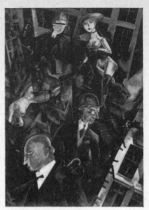

55 George Grosz
Metropolis. 1917

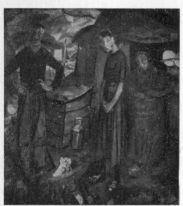

56 Jan Sluyters
The Peasants of Staphorst. 1917

57 Stanton Macdonald Wright
Synchromy. 1917

58 Alexander Rodchenko
Composition. 1918

59 Giorgio Morandi
Metaphysical Still-life. 1918

60 Henri Hayden
Still-life. 1919–20

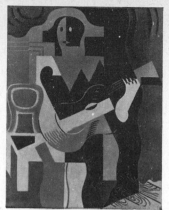
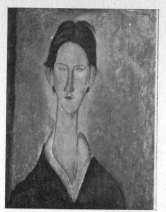

61 Juan Gris
Harlequin with Guitar. 1919

62 Amedeo Modigliani
Portrait of a Student

63 Georges Valmier
Figure. 1919

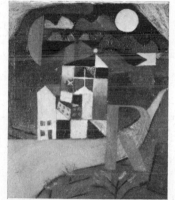
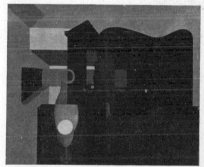

64 Paul Klee *Villa R. 1919*

65 Amédée Ozenfant *Still-life. 1920*

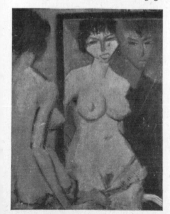
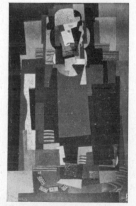
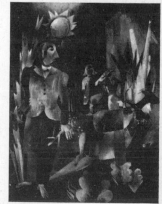

66 Otto Mueller
Self-portrait with Nude. 1920

67 Louis Marcoussis
The Frequenter. 1920

68 Heinrich Campendonk
Listening. 1920

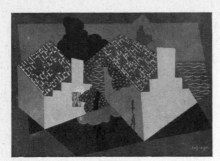

69 Léopold Survage *Landscape*. *1921*

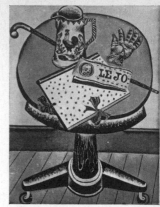

70 Joan Miró
Glove and Newspaper. *1921*

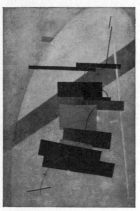

71 El Lissitzky
Composition. *1921*

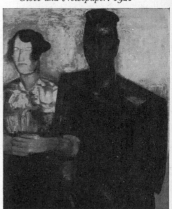

72 Constant Permeke *The Betrothed*. *192*

73 Victor Servranckx *Opus 47*. *1923*

74 William Roberts *The Game of Chess*. *192*

75 Willi Baumeister
Men and Machines. 1925

76 Kurt Schwitters
Merz 1003: Peacock's Tail. 1924

77 Laszlo Moholy-Nagy *A 11. 1924*

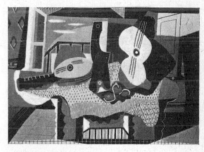

78 Pablo Picasso
Mandolin and Guitar. 1924

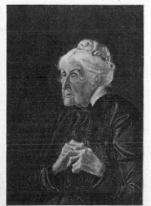

79 Otto Dix *Frau Lange. 1925*

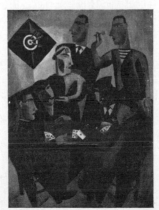

80 Gustave de Smet *The Estaminet. 1925*

81 Lyonel Feininger *Village. 1927*

82 Jean Lurçat *Smyrna. 1927*

83 Max Ernst *The Bride of the Winds. 1927*

84 Piet Mondrian
Composition in a Square. 1929

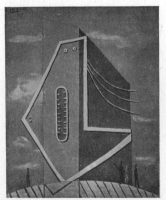

85 Pablo Picasso
Monument: Woman's Head. 1929

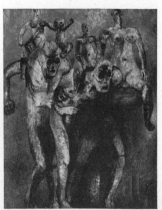

86 Fritz van den Berghe
Genealogy. 1929

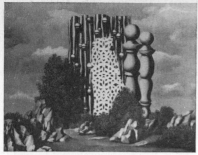

87 René Magritte *The Annunciation. 1929*

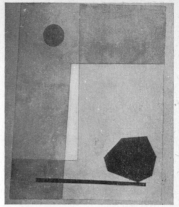

88 Paul Klee *Calmly Daring. 1930*

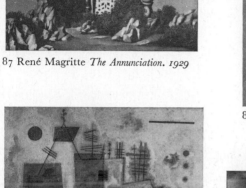

89 Wassily Kandinsky
Angular Structure. 1930

90 Emil Nolde *Landscape. 1931*

91 Joaquin Torres Garcia
Symmetrical Composition. 1931

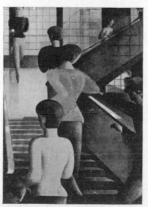

92 Oskar Schlemmer
Bauhaus Stairway. 1932

93 Hans Arp *Constellation. 1932*

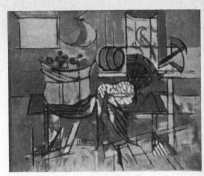

94 Karl Knaths *Harvest. 1933*

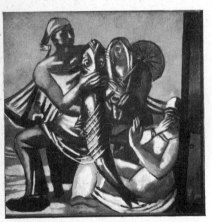

95 Max Beckmann *Man with Fish.* c. *1934*

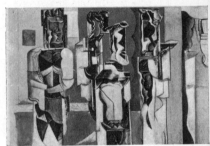

96 Wyndham Lewis *Roman Actors. 1934*

97 Jean Helion *Painting. 1935*

98 Edward Wadsworth
The Perspective of Idleness. 1936

100 Arthur Dove *Rise of the Full Moon. 1937*

99 Jack Levine
The Feast of Pure Reason. 1937

101 Paul Nash *Event of the Downs. 1937*

102 Mario Sironi *Mural Painting. 1938*

103 Paul Klee *Fruits on Blue. 1938*

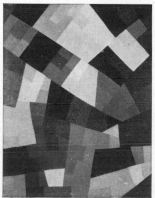

104 Yves Tanguy
Sun on Cushion. 1937

105 Otto Freundlich
Unity of Life and Death. 1936–8

106 Chaim Soutine
Flayed Ox

107 Karl Hofer
Girls playing Cards. 1939

108 Graham Sutherland
Landscape with Estuary

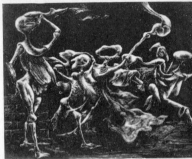

109 Kurt Seligmann *Sabbath Phantoms. 193*

110 Jean Brusselmans
Large Winter Landscape. 1939

111 Balcomb Greene *The Ancient Form. 19*

112 Ben Nicholson
White Relief. 1942

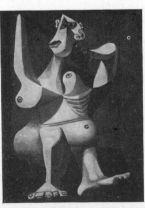

113 Pablo Picasso
Nude dressing her Hair. 1940

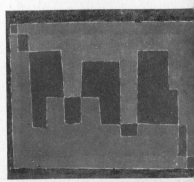

114 Josef Albers *Study for Painting
Mirage A of 1940*

1940–2 **309**

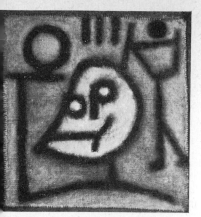

115 Paul Klee *Death and Fire. 1940*

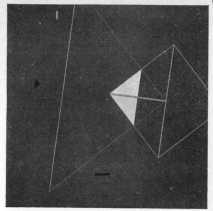

116 Fritz Vordemberge-Gildewart
Composition No. 126. 1941

117 Rufino Tamayo *Animals. 1941*

118 Ivon Hitchens *Damp Autumn. 1941*

119 Pavel Tchelitchew *Hide and Seek. 1940–2*

120 Marsden Hartley *Evening Storm. 1942*

121 Piet Mondrian
Broadway Boogie Woogie. 1942-3

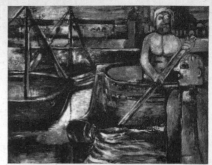

122 Paul Berçot *The Tritons. 1942*

123 Jackson Pollock *The She-Wolf. 1943*

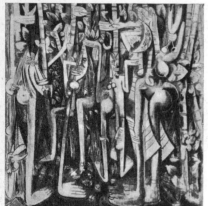

124 Wilfredo Lam *The Jungle. 1943*

125 Robert Motherwell
Pancho Villa, Dead and Alive. 1943

126 Charles Lapicque *Canal in Champagne. 1943*

127 Loren MacIver *Red Votive Lights. 1943*

128 Alfred Wols
Long Vertical Rods. 1943

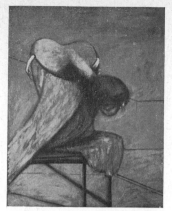

129 Francis Bacon *Study. 1944*

130 Wolfgang Paalen
Fumage. 1944–5

131 André Masson
The Sioux Cemetery. 1944

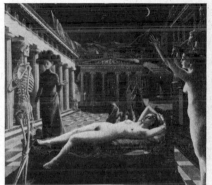

132 Paul Delvaux *Venus Asleep. 1944*

133 Matta *The Vertigo of Eros. 1944*

134 Charles Seliger *The Kiss. 1944*

135 Robert MacBryde
Emotional Cornish Woman

136 Jean Fautrier *The Woman's Body. 1945*

137 Marcel Gromaire
Purple Roof. 1945

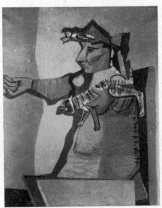

138 Robert Colquhoun
Seated Woman with Cat. 1946

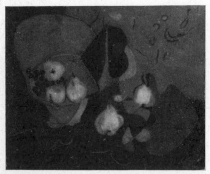

139 André Marchand *Quinces. 1946*

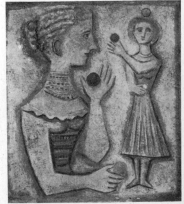

140 Massimo Campigli *Ball Game. 1946*

141 Pablo Picasso *Reclining Nude. 1946*

142 Francis Tailleux *Young Girl on Beach. 1946*

143 John Tunnard *Project. 1946*

144 Arshile Gorky *The Betrothal II. 1947*

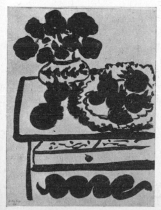

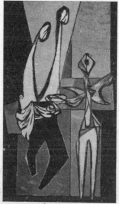

145 Henri Matisse
Dahlias and Pomegranates. 1947

146 Jankel Adler
Tremblinka. 1948

147 Theodoros Stamos
World Tablet. 1948

148 Charles Howard *The Amulet. 1947*

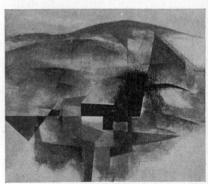

149 Fritz Glarner *Relational Painting. 1947–8*

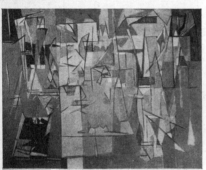

150 Geer van Velde *Composition. 1948*

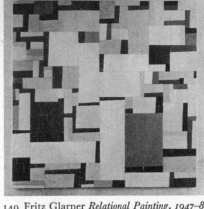

151 John Wells *Landscape under Moors. 1948*

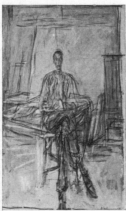

152 Alberto Giacometti
Seated Man. 1949

153 Stanley William Hayter
Orpheus. 1949

154 Bradley Walker Tomlin
Number 20. 1949

155 Roy de Maistre
The Green Shade. 1949

156 Georg Meistermann *The New Adam. 1950*

157 Fernand Léger
Still-life with Knife. 1950

158 Jimmy Ernst *A Time for Fear. 1949*

159 Simon Hantai *Cut Emerald Eye. 1950*

160 Patrick Heron
Kitchen at Night. 1950

161 Morris Graves *Spring. 1950*

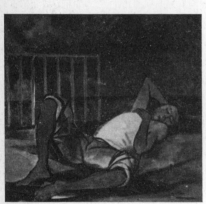

162 Renato Guttuso
The Sleeping Fisherman. 1950

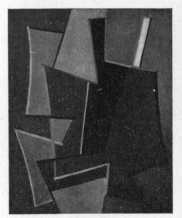

163 Alberto Magnelli
Composition No. 6. 1950

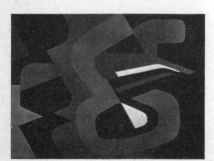

164 Jean Dewasne *Operacash. 1951*

165 Alfred Manessier
Variation of Games in the Snow. 1951

166 Clyfford Still *Painting. 1951*

167 Theodor Werner *Astral Flowers. 1951*

168 Hans Eltzbacher
Magical Mirror. 1951

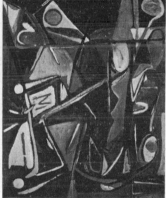

169 Bram van Velde
Composition. 1951

170 Atanasio Soldati
Composition. 1952

171 Lucien Freud
Cock's Head. 1952

172 Heinz Troekes *Staccato. 1952*

173 Georges Mathieu *Painting*. *1952*

174 Petar Lubarda *Mediterranean*. *1952*

175 Fritz Winter *Earthbound*. *1952*

176 Mattia Moreni *Return at Night*. *1952*

177 Franz Kline *Painting No. 7*. *1952*

178 Nicolas de Staël *Les Martigues*. *1952*

179 Gianni Dova *Painting*. *1952*

181 Gustave Singier *Dutch Town. 1952–3*

180 Alexander Camaro *Scenic Railway. 1952*

182 George Morris
Receding Squares. 1951–3

183 Pierre Soulages
Painting. 1953

184 Afro *Ballet. 1953*

185 Giuseppe Santomaso
Wedding in Venice. 1953

186 Roger Hilton *June. 1953*

187 Ad Reinhardt
*Abstract Painting
no 7A. 1953*

188 William Scott
Composition. 1953

189 Karel Appel
Two Heads. 1953

190 Irene Rice Pereira
Spirit of Air. 1953

191 Alberto Burri *Sacco 3. 1953*

192 Ceri Richards
Blue Vortex in the Primaries. 1952–3

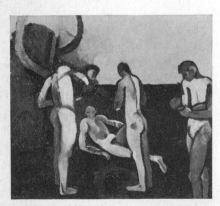

193 Keith Vaughan
Small Assembly of Figures. 1953

194 Peter Lanyon
Farm Backs. 1953

195 Richard Diebenkorn
Berkeley No. 2. 1953

196 Lismonde *Ruines I. 1953*

197 Vieira da Silva *Painting. 1953*

198 Eduardo Paolozzi *Head. 1953*

199 Leonardo Cremonini
Three Women in the Sun. 1954

200 Carl Morris *Brown Painting. 1954*

201 Kenzo Okada *Solstice. 1954*

202 Le Corbusier
Taureaux V. 1953–4

203 William Gear
Sculpture Project. 1954

204 Mark Tobey *Canals. 1954*

205 K. R. H. Sonderborg
6.XI.54. 19.05—20.30 h.

206 Adolf Fleischmann
Op. No. 24. 1954

207 Serge Poliakoff
Composition. 1954

208 Jack Tworkov
Pink Mississippi. 1954

209 Bernard Buffet
*Flowers in a
Milk-jug. 1954*

210 Peter Kinley
*Painting Blue
and Brown. 1955*

211 Adrian Heath
*Composition
Curved Forms. 1945–55*

212 Karl Goetz *Painting. 1955*

213 Antonio Music *Landscape. 1955*

214 Auguste Herbin *Nest. 1955*

215 Terry Frost *Yellow, Red and Black. 1955*

216 Victor Brauner
Displayed Head. 1955

217 Richard Mortensen
Avignon. 1955

218 Hann Trier *Nest Construction I. 1955*

219 Francis Salles *Negative Contingency. 1955*

220 Alan Davie *Painting. 1955*

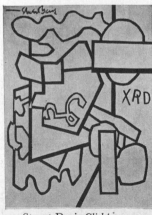

221 Stuart Davis *Cliché. 1955*

222 Willem de Kooning
Composition. 1955

223 Ruth Francken *Ardent. 1955*

224 Ben Shahn
The Defaced Portrait. 1955

225 Renato Birolli *Agricultural Machine. 1955*

226 Abraham Rattner *Prairie Sky No. 6. 1955*

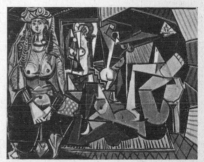

227 Hans Hofmann *Exuberance. 1955*

228 Pablo Picasso *Women of Algiers. 1955*

229 Bernard Schultze
The Organs of a Landscape. 1955

230 Jean Deyrolle *Sydney. 1955*

231 Tancredi *Painting. 1955*

232 Zao Wou-ki
Cathedral and its Surroundings. 1955

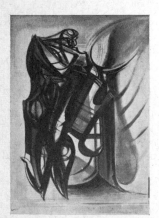

233 Merlyn Evans
Standing Figure. 1955

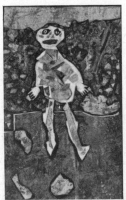

234 Jean Dubuffet
*Georges Dubuffet
in the Garden. 1956*

235 Camille Bryen
Floral Envelope. 1956

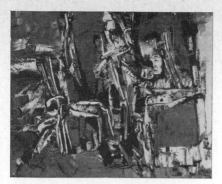

236 Jean Paul Riopelle *Purple Track*

237 René Pierre Tal Coat
Composition. 1955-6

238 Jean Plaubert *Brown Rhythm. 1956*

239 Antoni Tapies *Painting. 1956*

240 Raoul Ubac *Autumn. 1956*

241 Pierre Alechinsky
Dragon Anemone. 1956

242 Philippe Hosiasson
Red and Black. 1956

243 Louis le Brocquy
Male Presence. 1956

244 Alva *Trio. 1956*

245 Gaston Bertrand *Italy. 1956*

246 Maurice Estève *Tacet. 1956*

247 Roland Berthon *Man with Stick. 1957*

248 Grace Hartigan *The Creeks: Interior. 1957*

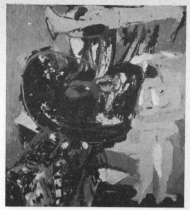

249 Asger Jorn *The Defender. 1957*

250 Sidney Nolan *Glenrowan. 1956–7*

251 Hans Jaenisch *Miniature Garden*

252 Bryan Wynter *Source. 1957*

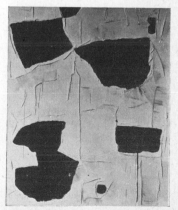

253 Paul Borduas *Magnetic Silence. 1957*

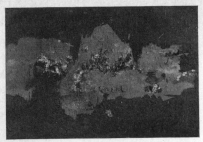

254 Juan Vila Casas *Painting. 1957*

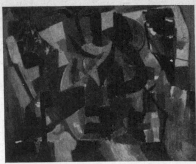

255 Bruno Cassinari *Landscape. 1957*

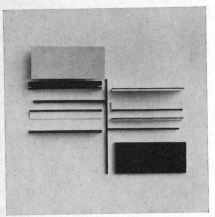

256 Victor Pasmore
Relief Construction. 1956–7

257 John Levee *April 1. 1957*

258 Philip Guston *The Mirror. 1957*

259 André Lanskoy *Composition*

260 Juan Tharrats *Painting. 1957*

261 Giuséppe Capogrossi *Surface. 1957*

262 Marc Chagall
The Circus Rider. 1957

263 Léon Zack
Géèrbé. 1957

264 Adolf Gottlieb
Blast II. 1957

265 Mario Prassinos
Moon and Tree. 1957

266 Emilio Vedova
Open Letter. 1957

267 Enrico Donati
Mother and Child No. 2. 1957

268 Gérard Schneider
Composition. 1957

269 J. L. Shadbolt *Medieval Landscape. 1957*

270 Manolis Calliyannis *The Yellow Hill I. 19*

271 Harold Town *The Spectre. 1957*

272 Victor de Vasarely *100 F. 1957*

273 Mark Rothko *Black over Reds. 1957*

274 Francisco Borès *Beach. 1957*

275 Fritz Hundertwasser
Cette Fleur aura raison des Hommes. 1957

276 Claude Bellegarde *White Ecstasy. 1957*

277 Paul Jenkins *To Queequeg. 1957*

278 Sam Francis *Watercolour. 1957*

279 Giosetta Fioroni
The Flame. 1957

280 Joan Mitchell
To the Harbourmaster. 1957

281 Jean Bazaine *L'Eau. 1957*

282 Fred Thieler *Painting. 1957*

283 Pablo Palazuelo *Rima IV. 1958*

284 E. Tabara *El Machufichu. 1958*

285 Corneille *Spanish Town. 1958*

286 Jean Le Moal
L'Archèche. 1957

287 Marlow Moss *Composition. 1957*

288 Roberto Crippa *Assured Consistency. 1958*

289 Alexander Istrati *Autumn. 1958*

290 Alfonso Mier *Painting. 1958*

291 Modesto Cuixart
Occult Necessity. 1958

292 Frank Avray Wilson
Offering. 1958

293 René Guiette
Trigramme. 1958

294 Claude Georges *July. 1958*

295 Natalia Dumitresco *The Forest. 1958*

296 Iaroslav Serpan *Painting. 1958*

297 Adja Yunkers
Tarrassa XIII. 1958

298 Ernst Wilhelm Nay
Red Diamond. 1958

299 Josef Istler *Painting. 1958*

300 Wojciech Dlugosz *Pra-Entelechy. 1958*

301 Man Ray *Through the Luxembourg. 1958*

302 Edouard Pignon *Olive Tree Trunk. 1958*

303 Antoni Clavé
Still-life with Table-cloth. 1958

304 Rupprecht Geiger *OE 247. 1958*

305 Antonio Corpora *Painting. 1958*

306 Sandra Blow *Rock Surface*. *1957–8*

307 William Baziotes *Dusk*. *1958*

308 Jan Kotik *Botanical Table*. *1958*

309 Emil Schumacher *Gonza*. *1958*

310 Hans Hartung *T*. *1957–8*

311 Léon Gischia *Le Bilboquet*. *1958*

312 Tony Stubbing *Ceremonial*. *1959*

313 Barnett Newman
Fifth Station. 1962

314 John Hoyland
22.11.61. 1961

315 Robyn Denny *Life Line II. 1903*

317 Richard Smith *Surfacing. 1963*

316 Joe Tilson *A-Z. 1963*

318 Jim Dine *Self-portrait next
o a Coloured Window. 1964*

319 Harold Cohen *Conclave. 1963*

320 Gillian Ayres *I.C.A. Screenprint. 1964*

321 David Hockney
Still-life with Figure and Curtain. 1963

322 Kenneth Noland *Via Blues. 1967*

324 Bridget Riley *Arrest I. 1965*

323 Jasper Johns *Untitled. 1964-5*

325 Bernard Cohen
Floris. 1964

326 Allen Jones *Woman. 1965*

327 Ellsworth Kelly
Orange and Green. 1966

328 Al Held *Bastion. 1966*

329 Roy Lichtenstein
Modern Painting with Arc. 1966

330 Norman Bluhm
Perwinkle Cove. 1967

331 James Rosenquist
Study for Expo 67. 1967

332 Cy Twombly *Untitled. 1967*

Text References

Chapter One

1 R. G. Collingwood, *Speculum Mentis, or The Map of Knowledge.* Oxford (Clarendon Press), 1924, p. 82.

2 *Ibid.*, p. 236.

3 Conrad Fiedler, *Über den Ursprung der künstlerischen Thätigkeit,* 1887.

4 From a conversation with Cézanne reported by Émile Bernard, *Mercure de France*, tome CXLVIII, No. 551, 1 June 1921. Cf. Gerstle Mack, *Paul Cézanne*, London (Jonathan Cape), 1935, p. 315.

5 *Letters*, ed. John Rewald, London (Cassirer), 1941, p. 203.

6 *Ibid.*, p. 228.

7 *Ibid.*, p. 234.

8 *Ibid.*, p. 239 (Letter to Émile Bernard, 25 July 1904).

9. Cf. Letter to Bernard, 23 December 1904. Rewald, *op. cit.*, p. 243.

10 Cf. Letter to Bernard, 23 October 1905, Rewald, *op. cit.*, pp. 251–2.

11 Preface to *Cézanne: son art—son oeuvre.* Paris (Paul Rosenberg), 2 vols., 1936.

12 Quoted in *op. cit.*, p. 15: 'L'artiste ne relève que de lui-même. Il ne promet aux siècles à venir que ses propres oeuvres; il ne cautionne que lui-même. Il meurt sans enfants. Il a été son roi, son prêtre et son Dieu.'

13 *Op. cit.*, p. 45.

14 *Pioneers of the Modern Movement*, by Niklaus Pevsner, London, 1936, covers the ground for architecture and the applied arts.

15 Alfred H. Barr notes (*Picasso: Fifty Years of his Art.* New York (Museum of Modern Art), 1946, p. 17, that *Joventut*, the Catalan weekly to which Picasso contributed illustrations in 1900, 'turned more towards England and Germany' and reproduced Beardsley and Burne Jones.

16 Cf. *Camille Pissarro: Letters to his son Lucien.* Edited by John Rewald. London, 1943.

17 The actual print in this painting has been identified by Douglas Cooper. 'Two Japanese Prints from Vincent van Gogh's collection', *Burlington Magazine*, vol. XCIX (June 1957), p. 204. Van Gogh also made direct copies (in oil) of Japanese prints. Cf. J. B. de la Faille, *Vincent van Gogh*, London, n.d. pl. II: '*Japonaiserie': The Tree* (after Hiroshige), 1886.

18 Cf. John Rewald: *Post Impressionism from van Gogh to Gauguin.* New York (Museum of Modern Art), 1956, p. 224. But Mr Rewald goes on to suggest that in spite of his use of these pens, van Gogh's drawings 'scarcely have an oriental flavour; they are in no way elegant, fluid or deft, nor do they have the decorative qualities found in Japanese brush drawings'. It depends on which Japanese brush drawings one has in mind for comparison: van Gogh might have seen prints or drawings of landscapes by Hokusai or Kunoyoshi that are as forceful as any of his own pen draw-

ings. Admittedly they are always more decorative than van Gogh's drawings.

19 *Further Letters to his Brother.* London (Constable), 1929. No. 554, p. 234.

20 Cf. R. Rey: *Gauguin*, Paris, 1928, p. 25. Quoted by Rewald, *op. cit.*, p. 308.

21 Cf. G. Kahn: 'Seurat', *L'Art Moderne*, 5 April 1891. Quoted by Rewald, *op. cit.*, p. 99.

22 Rewald, *loc. cit.*

23 Originally a letter to his friend Beaubourg, dated 28 August (1890).

24 *Letters*, ed. Rewald, p. 158.

Chapter Two

1 First written as a thesis and circulated among a few people in 1906; then published in book form by the Piper Verlag, Munich, 1908. Between 1908 and 1951 there were eleven editions. An English translation by Michael Bullock did not appear until 1953, though Worringer's main ideas had been introduced by T. E. Hulme (1883–1917) (*Speculations*, edited by Herbert Read, 1924) and his second important book, *Formprobleme der Gothik*, appeared in an English translation in 1927 (*Form in Gothic*, edited by Herbert Read).

2 First translated (by M. T. H. Sadler) as *The Art of Spiritual Harmony* (London, 1914). Retranslated (by Ralph Manheim) as *Concerning the Spiritual in Art* (New York, 1947).

3 Georges Duthuit: *The Fauvist Painters* (Trans. Ralph Manheim), New York, 1930, p. 57.

4 Duthuit, *op. cit.*, p. 59n.

5 *Ibid.*, pp. 22–3.

6 Cf. Alfred H. Barr, Jr. *Matisse—his Art and his Public.* New York (Museum of Modern Art), 1951, p. 40.

7 Trans. by Margaret Scolari, Barr, *op. cit.*, p. 119.

8 Barr, *ibid.*, p. 52

9 Barr, *ibid.*, p. 561. Trans. by Esther Rowland Clifford.

10 Barr, *ibid.*, p. 121.

11 *Le Point*, No. 21, July 1939, vol. 4, pp. 99–142, 'Notes d'un peintre'. Quoted by Barr, *op. cit.*, p. 42.

12 Foreword to the New Impression, 1948. Cf. *Abstraction and Empathy: a Contribution to the Psychology of Style.* Trans. by Michael Bullock. London and New York, 1953, p. vii.

13 *Form in Gothic.* English trans. edited by Herbert Read. London, 1927, pp. 75–6.

14 *Form in Gothic.* Chap. XXII.

15 *Das eigene Leben*, 1913; *Jahr der Kämpfe*, 1934; *Briefe aus den Jahren 1894–1926.* Ed. Max Sauerlandt, 1927.

16 *Ein selbsterzähltes Leben*, 1928. 2nd ed., 1948.

17 *Alpha and Omega*, published 1909.

18 Published in C. A. Loosli, *F. Hodler: Leben, Werk und Nachlass*, 4 vols. Berne, 1924.

19 An interesting anthology of 'artists' confessions' which includes statements by most of the Expressionists, was made by Paul Westheim. *Künstler–Bekentnisse*, Berlin, 1925.

Chapter Three

1 Answer to a questionnaire. Cf. Alfred H. Barr, *Picasso: Fifty years of his Art*, New York (Museum of Modern Art), 1946, p. 257.

2 Cf. Christian Zervos, *Pablo Picasso*, Paris (Cahiers d'Art), vol. II, 1942, p. 10.

3 'The "Demoiselles d'Avignon".' *Burlington Magazine*, vol. c, No. 662 (May 1958), pp. 155–63.

4 Cf. J. J. Sweeney: 'Picasso and Iberian Sculpture', *Art Bulletin*, vol. 23, no. 3 (1914); cf. also Golding, *loc. cit.*

5 Cf. Golding, *loc. cit.*, where they are illustrated (Figs. 21, 23, 24).

6 Cf. Venturi, *op. cit.*, Bibliographie, items 89, 106, 107, 123. Also Ambrose Vollard, *Paul Cézanne*, Paris, 1914.

7 Cf. Zervos, *op. cit.*, nos. 629, 632–44, with Venturi, *op. cit.*, nos. 264–76, 542–3, 580–2, 719–21, and especially 726 (much nearer than 542, the comparison given by Mr Golding).

8 Cf. James Johnson Sweeney, *Plastic Redirections in 20th Century Painting*, Chicago, 1934, p. 17.

9 Originally an interview (in Spanish) translated by Forbes Watson and published in *The Arts*, May 1923. Cf. Barr, *op. cit.*, 270–1.

10 *The Changing Forms of Art*. London, 1955, p. 81.

11 Phrases suggested to me by Jean Cassou, preface to *Le Cubisme*, catalogue of an exhibition held at the Musée National d'Art Moderne, Paris, 30 January–9 April 1953, p. 16. This catalogue includes a valuable documentation of the movement by Bernard Dorival.

12 *The Cubist Painters: aesthetic meditations*. Trans. by Lionel Abel, New York, 1944, p. 23.

13 This occurs in a letter of 15 April 1904, to Émile Bernard which was published in the catalogue of the retrospective exhibition of Cézanne's works which formed part of the Salon d'Automne in October 1907. Cézanne's actual words were:

'Permettez-moi de vous répéter ce que je vous disais ici:
traiter la nature par le cylindre, la sphère, le cône, le tout mis en perspective. . . . Les lignes parallèles à l'horizon donnent l'étendue, soit une section de la nature. Les lignes perpendiculaires à cet horizon donnent la profondeur. Or la nature, pour nous hommes, est plus en profondeur qu'en surface.'

14 Quoted and translated by Douglas Cooper: *Fernand Léger et le nouvel espace*. Geneva and London, 1949, p. viii. The original French text, p. 76.

15 Cooper, *op. cit.*, pp. vii and 74.

16 William Roberts in England has been the most consistent of these.

17 *Op. cit.*, p. 15.

18 *Op. cit.*, p. 84.

19 *The Cubist Painters*, p. 33.

20 Cf. Ernst Cassirer, *The Philosophy of the Enlightenment*, Boston, 1955, Chap. VII.

21 See my *Art of Sculpture* (New York and London, 1956) for a discussion of this question.

Chapter Four

1 If we recall Coleridge's distinction between imagination and fantasy (*Biographia Literaria*, Chap. IV), then strictly speaking most of these forms of art would be determined by fantasy, and 'Fantastic Art' is often the general name given to these developments (e.g. in *Fantastic Art, Dada, Surrealism*, a publication of the Museum of Modern Art, New York, edited by Alfred H. Barr Jr., 1936). In my own

critical theories (cf. *Collected Essays in Literary Criticism*—U.S.A. title *The Nature of Literature*—London [1951] and New York [1956], p. 31) I have tried to relate *imagination* to what is known in psychoanalysis as the pre-conscious, *fancy* to the unconscious. This distinction seems to be well borne out in the varieties of plastic art to be discussed in this chapter and the next. I would suggest that *in general* the present chapter is concerned with works of imagination, the next chapter with works of fancy, but it is impossible to maintain the distinction because the boundaries themselves are vague and fluctuating. It should perhaps be noted that the degrees of *depth* which psychoanalysis finds in the human psyche do not imply any concepts of *value* for art: they merely provide different types of *motif*.

2 F. T. Marinetti, *Manifesto technique de la littérature futuriste* (11 May 1912); *L'Imagination sans fils et les morts en liberté* (11 May 1913); C. Carrà, *La pittura dei suoni dei rumori, degli, odori*, The Painting of Sounds, Noises, Smells (11 August 1913); *Zang Tumb Tuuum: Parole in Libertà*, Milan (1914); F. T. Marinetti, *La Splendeur géometrique et mécanique de la nouvelle sensibilité numérique* (18 March 1914); Antonio Sant' Elia, *Manifesto dell'architettura* (9 July 1914). Some of these details of the Futurist movement have been taken from a contribution by Marinetti's widow, Benedetta Marinetti, to *Collecting Modern Art: Paintings, Sculpture and Drawings from the Collection of Mr and Mrs Harry Lewis Winston*, The Detroit Institute of Arts, 1957. But see the next footnote.

3 *Pittura, scultura futuriste*, Milan, 1914. For a complete documentation of the movement, see *Archivi del Futurismo*, Rome, 1955.

4 It was this word which gave a name to the English branch of the Futurist movement: the short-lived Vorticist movement led by Wyndham Lewis. William Roberts, Frederick Etchells, Edward Wadsworth, Jacob Epstein, C. R. W. Nevinson, and for a short time before he was killed early in the war, the French artist Henri Gaudier-Brzeska (1891–1915) were associated with this 'Great English Vortex'.

5 *Collection of the Société Anonyme: Museum of Modern Art, 1920*. New Haven (Yale University Art Gallery), 1950, p. 148.

6 *En avant Dada: die Geschichte des Dadaismus;* translation by Ralph Manheim in *The Dada Painters and Poets: an Anthology*, edited by Robert Motherwell, New York, 1951, pp. 21–47.

7 *Ibid.*, p. 26.

8 For further precise details of the events of these years, see *Dada: Monograph of a Movement*, edited by Willy Verkauf. London, New York, etc., 1957.

9 It is significant that de Chirico also wrote a dream-novel, *Hebdomeros* (1929).

10 *Nostalgia of the Infinite* is the title of a painting (1911).

11 Waldemar George: *Giorgio de Chirico*, Paris, 1928.

12 *Marc Chagall*, by Walter Erben, London, 1957, p. 124.

13 *Ibid.*, p. 149.

14 *Les pas perdus*, Paris, 1924. Trans. by Ralph Manheim in Motherwell, *op. cit.*, p. 204.

15 Cf. Georges Ribemont-Dessaignes: *History of Dada*, in Motherwell, *op. cit.*, pp. 99–120. Originally published in *La Nouvelle Revue Française*, Paris, 1931.

16 'The Dada Spirit in Painting.' Trans. by Ralph Manheim from *Cahiers d'Art*, vols. 7–9, 1932–4, Motherwell, *op. cit.*, p. 187.

17 André Breton: *Manifeste du Surréalisme–Poisson Soluble*, Paris, 1924. New edition, Paris, 1929, pp. 41–3. Trans. by David Gascoyne, *A Short Survey of Surrealism*. London, 1935, pp. 46–7.

18 *Manifeste*, pp. 45–6.

19 The first chapters of *Champs Magnétiques*, written by Breton by 'automatic' methods in collaboration with Philippe Soupault, appeared in the review *Littérature*.

20 *What is Surrealism?* Trans. David Gascoyne. London, 1936, pp. 50–1.

21 Georges Hugnet: Introduction to *Petite Anthologie Poétique du Surréalisme*, Paris, 1934, p. 41.

22 *Littérature*, October 1922. Trans. Ralph Manheim, Motherwell, *op. cit.*, pp. 209, 211.

23 'Genesis and Perspective of Surrealism' in *Art of this Century*, edited by Peggy Guggenheim, New York, 1942, p. 16. This important survey of the Surrealist movement was subsequently published by Breton in *La Surréalisme et la peinture*, New York, 1945.

24 *Art of this Century*, p. 21.

25 *Ibid.*, p. 20.

26 *Art of this Century*, p. 24.

27 The final organized manifestation of the movement was the Exposition Internationale du Surréalisme, presented by André Breton and Marcel Duchamp at the Galerie Maeght in Paris in 1947. Cf. *Le Surréalisme en 1947*, Paris, 1947.

28 *From Baudelaire to Surrealism*, by Marcel Raymond. Trans. by G.M. of the 1947 French edition, New York, 1950, pp. 293–4.

29 *Manifeste* (1924), p. 13. Cf. *Situation du Surréalisme entre les deux Guerres*, Paris, 1945: 'Cette exaltation m'est restée'.

30 *Ibid.*, pp. 13–14.

Chapter Five

1 *L'Intransigeant* (Paris), 15 June 1932.

2 This list is based mainly on Alfred H. Barr, Jr. (*Picasso: Fifty Years of his Art*, 1946.)

3 In the conversation with Tériade (see footnote 1).

4 *Picasso: Fifty Years of his Art* (1946), p. 143.

5 Indeed, ambiguity may be the essence of the method, 'a means of approaching the truth', as suggested by Roland Penrose (*Picasso, his Life and Work*, London, 1958, p. 270).

6 From an interview given to Jerome Seckler in 1945. Quoted from Barr, *op. cit.*, p. 202.

7 *London Bulletin*, October 1938. Reprinted in *A Coat of Many Colours*, London, 1945, pp. 317–19.

8 Cf. Lorenz Eitner, *Burlington Magazine*, vol. XCIX, pp. 193–9 (June 1957). Also: Johannes Eichner, *Kandinsky und Gabriele Münter*. Munich, n.d. (?1957).

9 *Burlington Magazine*, loc. cit.

10 *Concerning the Spiritual in Art* (ed. Motherwell), pp. 23–4n.

11 *Wassily Kandinsky*. Edl. Max Bil. With contributions from Jean Arp, Charles Estienne, Carola Giedion-Welcker, Will Grohmann, Ludwig Grote, Nina Kandinsky and Alberto Magnelli. Paris, 1951, p. 165.

12 *Paul Klee*. By Will Grohmann. English edn., London, 1954. I have relied on this authoritative work for most of the facts recorded here.

13 'Quantitatively speaking, roughly half of Klee's total *œuvre* was produced during the years he taught.' Grohmann, *op. cit.*, p. 83.

14 Trans. by Ralph Manheim.

15 'Le mouvement infini, le point qui replit tout, le mouvement de repos: infini sans quantité, indivisible et infini.' (Pascal, fragment 425; Stewart 213.)

16 *On Modern Art*, p. 55. (Trans. revised.)

Chapter Six

1 'Réflexions sur l'art abstrait', *Cahiers d'Art*, no. 7–8, 1931.

2 An exhibition of Chinese, Japanese and Korean art was held in Munich in 1909, and one of Mohammedan art in 1910.

3 *Wassily Kandinsky Memorial*, New York (Solomon R. Guggenheim Foundation), 1945, p. 61.

4 Illustrated by Peter Selz in *German Expressionist Painting* (University of California Press, 1957), pl. 82.

5 *Le Néo-plasticisme*. Paris (L'Effort Moderne), 1920. But he had used the Dutch equivalent, Nieuve Beelding, in *De Stijl* from 1917 onwards. A more accurate translation of the phrase in English would be 'new configuration'.

6 From *De Stijl: 1917–31. The Dutch Contribution to modern art*. By Hans Ludwig Jaffé. Amsterdam, 1956, p. 56. The most complete and authoritative work on the *De Stijl* movement.

7 *Op. cit.*, pp. 55–6

8 *Ibid.*, p. 61.

9 *Op. cit.*, p. 30.

10 In the last number of *De Stijl*. Cf. Jaffé, *op. cit.*, p. 89.

11 *Plastic art and pure plastic art* (1937). New York, 1945, p. 54.

12 'Piet Mondrian To-day'—preface to *Piet Mondrian: Life and Work*. By Michel Seuphor. London, 1957.

13 He is not likely to have read Edward Bullough's famous essays on 'The "perceptive problem" in the aesthetic appreciation of single colours', *Brit. J. Psych.*, II, 406 ff. (1906 8), but Bullough was representative of much current discussion of such problems.

14 *Die gegenstandslose Welt: Begründung und Erklärung des russischen Suprematismus*. Munich, 1927. *Bauhausbücher 11*. A few paragraphs are translated in R. Goldwater and M. Treves, *Artists on Art*, New York, 1945, pp. 452–3, from which I quote.

15 *Naum Gabo: Antoine Pevsner*. New York (Museum of Modern Art), 1948, p. 53.

16 *Gabo: Constructions, Sculpture, Paintings, Drawings, Engravings*. London and Cambridge (Mass.), 1957, p. 156.

17 *Ibid.*, pp. 17–18.

18 'Russia and Constructivism.' Interview, 1956, in *Gabo* (*op. cit.*, 1957), p. 157.

19 *Ibid.*, p. 158.

20 Quoted in *Naum Gabo: Antoine Pevsner* (p. 57) from René Drouin Galerie, Paris, *Antoine Pevsner*, Paris, 1947.

21 *Bauhaus, 1919–28*. Edited by Herbert Bayer, Walter Gropius, Ise Gropius. New York and London, 1939, p. 18.

22 Paris, 1918.

Chapter Seven

1 English trans. *Form in Gothic* (edited with an Introduction by Herbert Read), London, 1927.

2 Cf. the passage from Worringer's *Form in Gothic* already quoted on p. 54.

3 I select these names deliberately: there is another element in modern architecture, represented by Mies van Rohe and Gropius, which is more rational, serene and classical. Walter Gropius, significantly, is the architect of the new American Embassy in Athens.

4 Oddly enough, the word 'expressionism', as a name for the new movement, seems to have originated in Paris. It was used by Matisse, and Theodor Däubler, in his book *Im Kampf um die moderne Kunst* (Berlin, 1920), claims that a French critic, Louis Vauxcelles, was the first critic to give it currency. The term was taken up by the German (Berlin) periodical *Der Sturm* from 1911 onwards, first in relation to French painters who exhibited in the Berlin Secession of 1911, and then indiscriminately to describe German artists in sympathy with them. In an essay which appeared in *Der Sturm* in 1911 (vol. II, pp. 597–8) Worringer gave the first clear definition of the term, at the same time relating its contemporary manifestations to manifestations of the same 'will to form' in the past. Cf. Peter Selz, *German Expressionist Painting* (Univ. California Press, 1957), pp. 255–8.

5 '. . . we both loved blue, Marc—horses, I—riders. Thus the name arose by itself.' Statement of 1930 attributed to Kandinsky. Cf. *Cicerone* (1949), No. 3, p. 111. Quotation from Myers, *op. cit.*, p. 206, n. 124.

6 G. F. Hartlaub in 'The Arts', January 1931. Myers, p. 280.

7 Quoted from Selz, *op. cit.*, 219–20.

8 August Macke. Quoted from Selz, *op. cit.*, p. 220.

9 By Dr Hartlaub. See footnote 6 above.

10 See p. 236 below.

11 From the open letter inviting all artists to join the November Group, sent out by the executive committee in December 1918. Cf. Myers, *op. cit.*, p. 278.

12 Cf. Jean Leymarie: 'Meglio di qualsiasi altro artista, Soutine, secondo il detto di Millet, che sembra l'epigrafe dell'espressionismo moderno, "ha messo la propria pelle nella sua opera".' XXVI Biennale di Venezia (1952), *Catalogo*, p. 179.

13 From *Kokoschka: Life and Work*, by Edith Hoffmann, London, 1947, p. 33. This authoritative monograph contains several important statements by the artist himself.

14 *Op. cit.*, pp. 118–19.

15 Trans. E. Hoffmann, *op. cit.*, p. 147.

16 Cf. Hans Maria Wingler, *Introduction to Kokoschka*, London, 1958, p. 112.

17 'A Petition from a Foreign Artist to the Righteous People of Great Britain for a Secure and Present Peace', humbly tendered and signed by Oskar Kokoschka, London, December 1945. Appendix to Hoffmann, *op. cit.*, pp. 247–84.

18 'On the Nature of Visions.' Trans. by Hedi Medlinger and John Thwaites. Cf. Hoffmann, *op. cit.*, pp. 285–7.

19 *Concerning the Spiritual in Art*, pp. 67–8.

20 In particular Anton Ehrenzweig: *The Psychoanalysis of Artistic Vision and Hearing. An Introduction to a Theory of Unconscious Perception.* London, 1953.

21 Cf. *Un Barbare en Asie.* Paris, 1945.

22 *Fourteen Americans.* Edited by Dorothy C. Miller. Museum of Modern Art, New York, 1946, p. 70.

23 Magnificently demonstrated by Gyorgy Kepes in *The New Landscape in Art and Science*, Chicago, 1956.

24 Kepes, *op. cit.*, p. 173.

25 Paris, 1958.

26 But these fragments might equally well have come from Masson.

27 Introduction to the Catalogue of the Jackson Pollock Exhibition circulated under the auspices of the International Council at the Museum of Modern Art, New York, in 1958.

28 'My painting.' *Possibilities*, New York, 1947, no. 1: p. 79. Winter, 1947–8. Quoted in the catalogue of the Jackson Pollock exhibition circulated by the International Council at the Museum of Modern Art, New York, in 1958.

29 From the answer to a questionnaire, written by Jackson Pollock and printed in *Arts and Architecture*, vol. LXI, February 1944.

30 *The Human Condition*, New York, 1958, p. 323 n.
But it is possible to argue that Action Painting is not 'expressionistic'. Cf. Harold Rosenberg:
'Action never perfects itself; but it tends toward perfection and away from the personal. This is the best argument for dropping the term "Abstract Expressionism", with its associations of ego and personal *Schmerz*, as a name for the current American painting. Action Painting has to do with self-creation or self-definition or self-transcendence; but this dissociates it from self-expression, which assumes the acceptance of the ego as it is, with its wound and its magic. Action Painting is not "personal", though its subject matter is the artist's individual possibilities.'
From 'A dialogue with Thomas B. Hess'. *Catalogue of the Exhibition: Action Painting, 1958.* The Dallas Museum for Contemporary Arts. Reprinted in *The Tradition of the New*, New York, 1959, p. 28 n.

31 *The Principles of Art*, Oxford (Clarendon Press), 1938, p. 336.

32 The latest attempt was made by Hans Sedlmayr: *Art in Crisis: the Lost Centre.* London, 1958.

Bibliography

This List is arbitrary and is confined to books which are essential for consultation and further study. For a more comprehensive bibliography the reader is recommended to Mr Bernard Karpel's *Art of the Twentieth Century—a Bibliography* (New York, Wittenborn & Co.). Most of the monographs on individual artists listed below contain detailed bibliographies of their subjects.

Documents of Modern Painting

FIEDLER, Conrad: *On Judging Works of Visual Art.* Trans. Henry Schaefer-Simmern and Fulmer Mood. University of California Press, 2nd edn., 1957.

VAN GOGH, Vincent: *The Complete Letters of Vincent van Gogh.* 3 vols. London (Thames and Hudson), 1958.

CÉZANNE, Paul: *Letters.* Edited by John Rewald. London (Bruno Cassirer), 1941.

WORRINGER, Wilhelm: *Abstraktion und Einfühlung.* München (R. Piper & Co. Verlag), 1908. Neudruck, 1948. Trans. Michael Bullock: *Abstraction and Empathy.* London (Routledge and Kegan Paul), 1953.
Formprobleme der Gothik. München (Piper), 1912. Trans. *Form in Gothic.* London (G. P. Putnam's Sons), 1927.

KANDINSKY, Wassily: *Über das Geistige in der Kunst.* Munich (R. Piper & Co. Verlag), 1912.
Trans. (1) *The Art of Spiritual Harmony.* Trans. with an Introduction by M. T. H. Sadler. London (Constable & Co.), 1914.
(2) *Concerning the Spiritual in Art.* Revised trans. by Francis Golffing, Michael Harrison and Ferdinand Ostertag. New York (Wittenborn, Schultz, Inc.), 1947.

GLEIZES, Albert et METZINGER, Jean: *Du 'Cubisme'.* Paris (Figuière), 1912.
Trans. *Cubism.* London (T. Fisher Unwin), 1913.

APOLLINAIRE, Guillaume: *Les Peintres Cubistes.* Paris (Eugène Figuière et cie), 1913.
Trans. Lionel Abel: *The Cubist Painters: Aesthetic Meditations.* New York (Wittenborn), 1944. New edn. 1949.

KLEE, Paul: *Über die moderne Kunst* (1924). Bern-Bümpliz (Verlag Benteli), 1945.
Trans. Paul Findlay: *On Modern Art.* London (Faber & Faber), 1948.
Das bildnerische Denken. Ed. Jürg Spiller. Basel/Stuttgart (Benno Schwabe & Co. Verlag), 1956.

MONDRIAN, Piet: *Plastic Art and Pure Plastic Art 1937 and other Essays, 1941–1943.* New York (Wittenborn), 1945.

Archivi del Futurismo. Raccolti e ordinati da M. Drudi Gambillo e T. Fiore. Vol. 1 (1957). Vol. 2 in preparation. Roma (De Luca).

Histories of Modern Painting

History of Modern Painting. Geneva (Albert Skira):
(1) *From Baudelaire to Bonnard. The*

Birth of a New Vision. (The Honfleur school—Impressionism—Neo-Impressionism Symbolism —Post - Impressionism.) Text by Maurice Raynal. Introduction by Herbert Read. Historical and Biographical notes by Jean Leymarie. Trans. Stuart Gilbert, 1949.

(2) *Matisse Munch Rouault. Fauvism Expressionism.* Text and documentation by Maurice Raynal, Arnold Rüdlinger, Hans Bolliger, Jacques Lassaigne. Trans. Stuart Gilbert. Introduction by George Schmidt. 1950.

(3) *From Picasso to Surrealism.* Cubism—Futurism—The Blue Rider—Metaphysical painting —Dada—Abstract Art—Purism —The Realist Reaction—The Bauhaus — Poetic Painting — Surrealism —Texts and documentation by Maurice Raynal, Jacques Lassaigne, Werner Schmalenbach, Arnold Rudlinger, Hans Bollinger. Trans. Douglas Cooper, 1950.

DORIVAL, Bernard: *Les Etapes de la peinture française contemporaine:* Tome I—De l'Impressionisme au Fauvisme (1889–1905). Tome II—Le Fauvisme et le Cubisme (1905–1911). Tome III—Depuis le Cubisme (1911–1944). Paris (Gallimard), 1943–6.

HUYGHE, René: *Histoire de l'art Contemporaine: la peinture.* In collaboration with G. Bazin. Paris, 1935.

ZERVOS, Christian: *Histoire de l'art Contemporaine.* Paris (Cahiers d'Art), 1938.

Monographs

(a) MOVEMENTS

REWALD, John: *The History of Impressionism.* New York (Museum of Modern Art), 1946.
Post-Impressionism — From Van Gogh to Gauguin. New York (Museum of Modern Art), 1956.

PEVSNER, Nikolaus: *Pioneers of the Modern Movement—From William Morris to Walter Gropius.* London (Faber & Faber), 1936.

DUTHUIT, Georges: *Les Fauves.* Geneva (Trois Collines), 1949. Trans. by Ralph Manheim: *The Fauvist Painters.* New York (Wittenborn, Schultz, Inc.), 1950.

BARR, Alfred H.: *Cubism and Abstract Art.* New York (Museum of Modern Art), 1936.

MOTHERWELL, Robert (ed.): *The Dada Painters and Poets.* New York (Wittenborn, Schultz, Inc.), 1951

VERKAUF, Willy (ed.): *Dada—Monograph of a Movement.* New York (Wittenborn), 1957.

BARR, Alfred H. Jr.: *Fantastic Art, Dada, Surrealism,* with essays by Georges Hugnet. New York (Museum of Modern Art), 1936.

JAFFE, H. L. C.: *De Stijl—1917–1931: The Dutch Contribution to Modern Art.* Amsterdam (J. M. Meulenhoff), 1956.

SELZ, Peter: *German Expressionist Painting.* Berkeley & Los Angeles (University of California Press), 1957.

MYERS, Bernard S.: *Expressionism.* London (Thames and Hudson), 1957.

SEUPHOR, Michel: *L'Art Abstrait, ses origines, ses premiers maîtres.* Paris (Galerie Maeght), 1949.
Dictionnaire de la peinture abstracte. Paris (Fernand Hazan) and London (Methuen), 1957.

BRION, Marcel: *Art Abstrait.* Paris (Albin Michel), 1956.

(b) ARTISTS

MALINGUE, Maurice: *Gauguin—Le Peintre et son Oeuvre.* Paris (Les Presses de la Cité), 1948.

DE LA FAILLE, J. B.: *Van Gogh.* Trans. Prudence Montagu-Pollock, London and Toronto (Wm. Heinemann, Ltd.), n.d.

VENTURI, Lionello: *Cézanne.* 2 vols. Paris (Paul Rosenberg), 1936.

FRY, Roger: *Cézanne, a Study of his Development.* London (Hogarth Press), 1927.

REWALD, John: *Seurat.* New York (Museum of Modern Art), 1943, 1946.

HODIN, J. P.: *Edvard Munch, der Genius des Nordens.* Stockholm, 1948.

BARR, Alfred H. Jr.: *Matisse—His Art and his Public.* New York (Museum of Modern Art), 1951. *Picasso—Fifty Years of his Art.* New York (Museum of Modern Art), 1946.

BOECK, Wilhelm and SABARTES, Jaime: *Picasso.* London (Thames and Hudson), 1955.

ZERVOS, Christian: *Pablo Picasso.* Vol. I (1895–1906); Vol. II (in two parts —1906–1912 and 1912–1917), Paris (Cahiers d'Art), 1932–42.

ELGAR, Frank and MAILLARD, Robert: *Picasso.* Paris (Hazan) and London (Thames and Hudson), 1955.

PENROSE, Roland: *The Life of Picasso.* London (Gollancz), 1958.

EINSTEIN, Carl: *Georges Braque.* Paris (Editions des Chroniques du Jour), 1934.

HOPE, Henry R.: *Georges Braque.* New York (Museum of Modern Art), 1949.

KAHNWEILER, Daniel-Henry: *Juan Gris—His Life and Work.* Trans. Douglas Cooper—London (Lund Humphries), 1947.

BILL, Max: *Wassily Kandinsky* (avec la participation de Jean Arp, Charles Estienne, Carola Giedion-Welcker, Will Grohmann, Ludwig Grote, Nina Kandinsky, Alberto Magnelli), Paris (Maeght), 1951.

GROHMANN, Will: *Kandinsky.* Cologne (Du Mont Schauberg), 1958.

GROHMANN, Will: *Paul Klee.* London (Lund Humphries), 1954.

COOPER, Douglas: *Fernand Léger et le nouvel espace.* Geneva (Trois Collines), 1949.

SWEENEY, James Johnson: *Joan Miró.* New York (Museum of Modern Art), 1941.

VENTURI, Lionello: *Georges Rouault.* New York, 1940. Paris, 1948.

SOBY, James Thrall: *Georges Rouault.* New York (Museum of Modern Art), 1945.

HOFFMANN, Edith: *Kokoschka, Life and Work.* London (Faber & Faber), 1947.

WHEELER, Monroe: *Soutine.* New York (Museum of Modern Art), 1950.

SWEENEY, James Johnson: *Marc Chagall.* New York (Museum of Modern Art), 1946.

ERBEN, Walter: *Marc Chagall.* London (Thames and Hudson), 1957.

SEUPHOR, Michel: *Piet Mondrian.* London (Thames and Hudson), 1957.

READ, Herbert: (ed.): (1) *Ben Nicholson—Paintings, reliefs, drawings.* London (Lund Humphries), 1948. (2) *Ben Nicholson—Work since 1947.* London (Lund Humphries), 1956.

List of Works Reproduced

Entries are listed alphabetically under the artists' names giving the artists' data, the title and date of each work, their mediums, dimensions and present locations. Every effort has been made to establish complete and accurate information but there are a few details which could not be traced, such as the present whereabouts of works which may have changed hands since the original publication of this book. All works are oil on canvas unless otherwise stated. Measurements are given first in inches and then in centimetres within brackets. Height precedes width. The figures set in bold type refer to the pages on which the reproductions appear. The italic figures are the numbers of the reproductions appearing in the *Pictorial Survey*.

373

Index

Italic figures denote the illustrations apppearing in the *Pictorial Survey*